THE ART OF SKIING

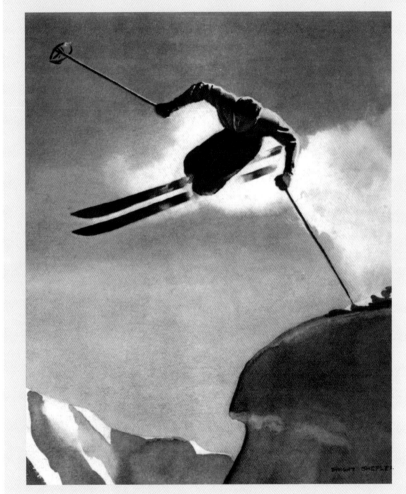

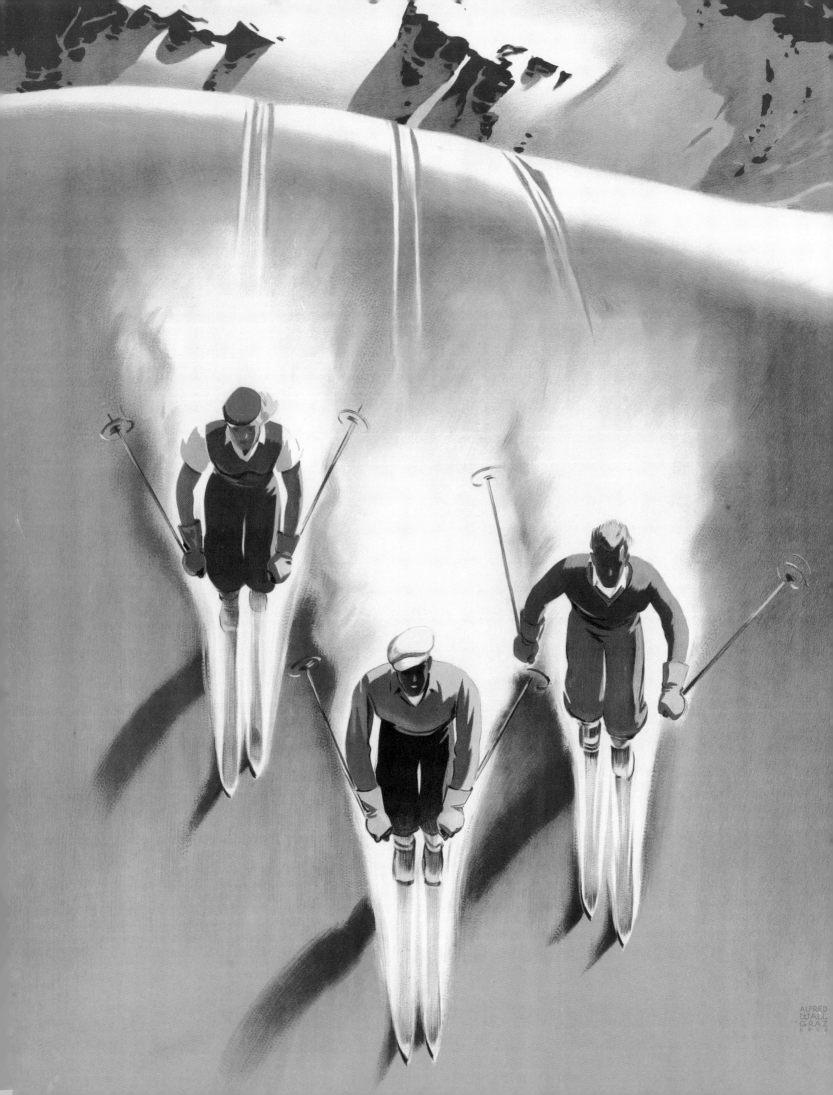

THE ART OF SKIING

Vintage Posters from the Golden Age of Winter Sport

Jenny de Gex

PALAZZO

This edition published in Great Britain in 2014 by
PALAZZO EDITIONS LTD
2 Wood Street
Bath, BA1 2JQ

www.palazzoeditions.com

Design and layout © 2014 Palazzo Editions Ltd.
Text © 2014 Jenny de Gex
Beekley Collection text © 2014 Nicolette Tomkinson

Art Director: Bernard Higton
Picture Research and Compilation: Jenny de Gex

A CIP catalogue record for this book is available from the
British Library.

ISBN: 978-0-9571483-7-6

Printed and bound in Malaysia by Imago.

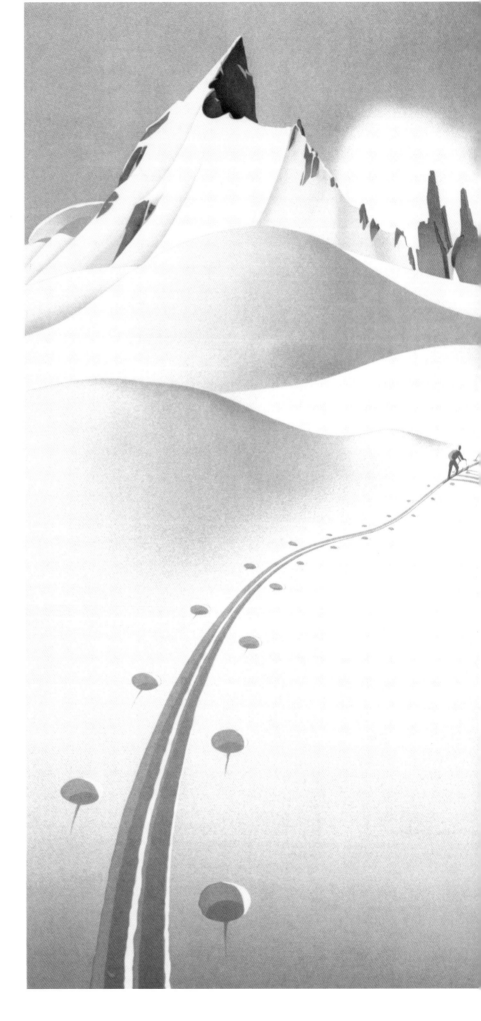

Illustrations

Page 1: Dwight Shepler, *Cornice Jumper*

Frontispiece: Detail of a poster titled *Austria* by an artist
known only as B.P.

Right: Samivel, *Club Alpin Français*

CONTENTS

'Ski-ing is not merely means of locomotion. It is an art, and a beautiful art.'
Arnold Lunn, *A History of Ski-ing*, 1927

The phrase "the art of skiing" has more than one interpretation. To watch expert skiers weaving or leaping down a mountain at high speed in a shower of snow is breathtaking and exciting for the viewer, as well as for the participant. The achievement of seemingly impossible physical feats, combining speed, grace, and balance, is nothing short of an art form.

Since the late nineteenth century, the different shapes, forms, and movements of skiing have inspired graphic artists and photographers working in a variety of designs, reflecting changing artistic movements and styles. The posters were designed to lure people to enjoy winter sports, by celebrating the sheer fun they offered. These images cover a span of 60 years, from the 1890s to the 1950s, encompassing two world wars and the economic depression that followed the Wall Street Crash of 1929. As part of rebuilding and recovery, it was a natural reaction to celebrate freedom both in play and in vacations, whether at the coast or in the mountains. The emergence of the Alps as a tourist attraction transformed the landscape from a wilderness to a playground. Posters from the beginning of the twentieth century exude the elegance associated with the best resorts, as they started to exploit the increasing enthusiasm for snow sports and associated pleasures. Those from the 1920s and 1930s convey a carefree attitude, and are oblivious of the gathering storm clouds over Europe. The post-World War II years brought skiing to a far wider public, as cheaper travel and package holidays made the sport affordable for all.

The use of skis has a history predating Western civilization. Archaeological evidence from about 2500 B.C. has identified early skis, in the form of rock carvings at Rödöy, a Norwegian island just north of the Arctic Circle. A prehistoric wooden ski, preserved by having fallen into a bog, was found at Hoting, Sweden. In the area around Lake Onega and the White Sea in northwestern Russia, rock carvings dating from around 1000 B.C. depicting skiers have been found. Although skiers have played their part in northern myths and legends, and in military history, it is only in the last hundred years or so that skiing has been an organized sport.

Well before people started skiing down mountains, they began to climb them. The first successful ascent of Mont Blanc, the highest peak in the Alps, was made by Jacques Balmat, a collector of crystals, and Michel-Gabriel Paccard, a physician, in 1786 and introduced mountaineering as a legitimate scientific pursuit. The Romantic movement of the early nineteenth century celebrated the awesome grandeur of mountains, which found expression in the works of such painters and poets as Turner, Ruskin, Wordsworth, Byron, Shelley, Goethe, and Caspar David Friedrich. When visiting mountains became fashionable, around 1850, it was the British who took the lead—not only in sightseeing but also in mountaineering. Thomas Cook, with his "Cook's Tours," beginning in the 1860s, was the first to exploit this popularity by making the experience available to the public, providing travel by railway, coach, and mule. Advances in engineering made it possible to tunnel through the Alps, so that these imposing natural barriers were at last breeched and open to all visitors.

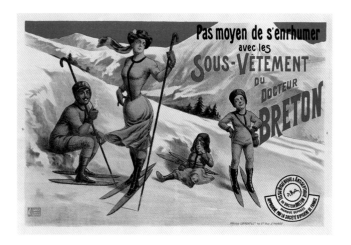

Left: The message of this advertisement for late nineteenth-century thermal underwear suggests you would not catch a cold if you wore Dr. Breton's warm combination garments. Artistic licence shows a family on skis, wearing only these—omitting outer windproof garments!

Right: In Albert Muret's only known poster, a trail of monks, skiing down from their ancient hospice on top of the Great St. Bernard pass, advertised the railway from Martigny to Orsières. At an altitude of 8,114 feet (2,473 metres), the hospice, with its famous St. Bernard dogs, rescued lost travelers.

INTRODUCTION

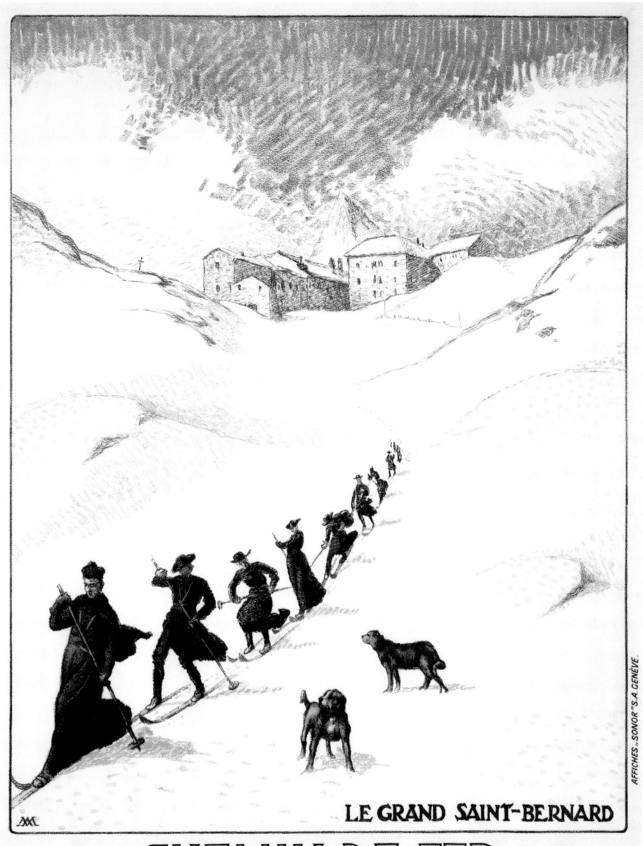

LE GRAND SAINT-BERNARD

❀ CHEMIN-DE-FER ❀
MARTIGNY-ORSIERES

Four main categories of the sport evolved: ski mountaineering, ski touring, racing, and jumping. There was no downhill skiing as we recognize it today, for to come *down*hill, first you had to climb *up* the mountain. The sport of skiing began when there were no ski lifts, no piste-makers (or markers), no safety bindings, no ski school, few guides, and even fewer mountain restaurants.

It was the Scandinavians, especially the Norwegians, who first developed the sport and took it abroad. The discovery of gold in California, in 1848, and in Australia, in 1851 brought an influx of Scandinavian (and other) miners and laborers to these regions, and they brought their knowledge of skiing with them. In the 1860s, ski (or "snow shoe") clubs were opening: the Kiandra Snow Shoe Club was formed in Australia in 1876. In 1867 the first American club was inaugurated at La Porte, California.

Norwegian Sondre Norheim, the first person to make a binding with a heel strap and to give skis a waisted shape, left Morgedal in Telemark in 1868 for Christiania (the old name for Oslo), where he amazed skiers by his skills, technique, and equipment, and won newly devised competitions, thereby influencing advances in the sport. The first Norwegian club, the Christiania Ski Club, was formed in 1877, and in 1879 a jumping competition was held at nearby Husebybakken. It was there, in 1883, that the Norwegian Ski Association held its first meeting.

As with mountaineering, the British were quick to respond to the new sport of skiing. Prominent among the early British enthusiasts were Henry Lunn and his son Arnold. In 1891, Henry Lunn, then a Methodist minister, organized an ecumenical conference, held in Grindelwald Switzerland, the following January. Encouraged by the success of this, he repeated it the following year, charging participants £10.50 ($18.30) each for return fare from England and two weeks' room and board. Finding himself £500 ($870) in pocket, he recognized his ability to organize travel; and having seen the potential for wintertime trips, he left the ministry and used his newfound skills as a travel agent. In 1898 he took his first winter group to Chamonix, in France.

Lunn soon learned that the wealthy clients he sought to attract considered it beneath them to travel in what would now be called "package tours." To have commercial luggage labels identifying them was not the done thing. So, in 1903, he founded the Public (in U.S. parlance "private") Schools Alpine Sports Club (PSASC) to give his enterprise social cachet. The club took over whole hotels in the Swiss Alps, where *après-ski* was equally as enjoyable as the sport itself. This élite club, with a membership of similar background, not only worked on the social level but also played an important role in the development of downhill and slalom racing.

From 1894, two English brothers, C. W. R. and E. C. Richardson, spent winter holidays in Norway, learning the local traditions of ski

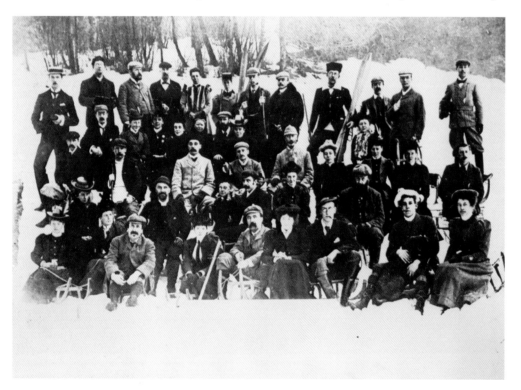

The first winter sports package tour, to Chamonix in the winter of 1898-99. Henry Lunn is seated on a toboggan, front row center.

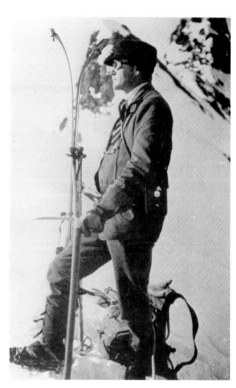

Sir Arnold Lunn, pioneer of early skiing, photographed by Walter Amstutz in 1924. Amstutz was influential in the development of Swiss tourism.

running and ski jumping. During the winter of 1902, they introduced Norwegian skis to Davos, in Switzerland, where they founded the first English ski club in 1903. That same year, along with W. R. Rickmers, they founded the Ski Club of Great Britain at an inaugural dinner at the Café Royal, in London. Rickmers believed the Norwegian ski was "one instrument which has come as a revelation" and would "promise new life … beyond our most hopeful expectations." The Ski Club of Great Britain has since continued its role in the development and promotion of skiing for all, establishing standards at competition level and providing resort representatives.

Also in the eventful year of 1903, the newly formed Public Schools Winter Sports Club sponsored a competition; its Challenge Cup was awarded on combined results of skiing, skating, and tobogganing. In 1911, this combination was abandoned, and separate trophies were awarded for each category. Lord Roberts of Kandahar, vice president of the PSASC, gave his name to a challenge cup for skiing. The first race for the Kandahar Cup was held at Montana, in Switzerland. It was a "course for heroes," involving a climb of seven and a half hours to the start and an overnight stay in a mountain hut. The next day the competitors raced over the Plaine-Morte Glacier, climbed some more, descended 5,000 feet, including difficult crust and tricky running through a wood, before descending again to Montana. Ten competitors entered; most fell repeatedly.

In the early 1920s, arguments raged between skiing associations and regulatory bodies about the relative merits of Nordic skiing (cross-country and jumping) compared to Alpine

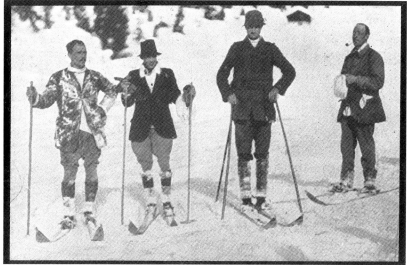

(downhill and slalom). In 1921, Arnold Lunn, Henry's son, suggested that the British championships should include a downhill race and a style competition in addition to jumping, without cross-country. These championships were held at Wengen, Switzerland. The son of a racer from those early days described these somewhat haphazard events bemusedly: "They just lined up and went—some had never skied before." The line-up was known as a *geschmozzle* or "mass start."

The first downhill racing rules were published that same year in the *British Ski Year Book*, but it took longer to persuade the Norwegians to adopt them for international competitions. The first Downhill World Championships were held in 1931 at Mürren, Switzerland; it was not until the 1936 Winter Olympics that

Left: The start of the downhill race in the British Championships in 1921 on the Lauberhorn. This ragged line-up was known as a *geschmozzle* start. Note the length of the skis and–to today's eyes–unsuitable clothing.

Above: In 1911, the first Roberts of Kandahar trophy race was run above Montana. Of the 10 who entered this "course for heroes," only five finished. The contemporary photograph shows the end of the arduous race.

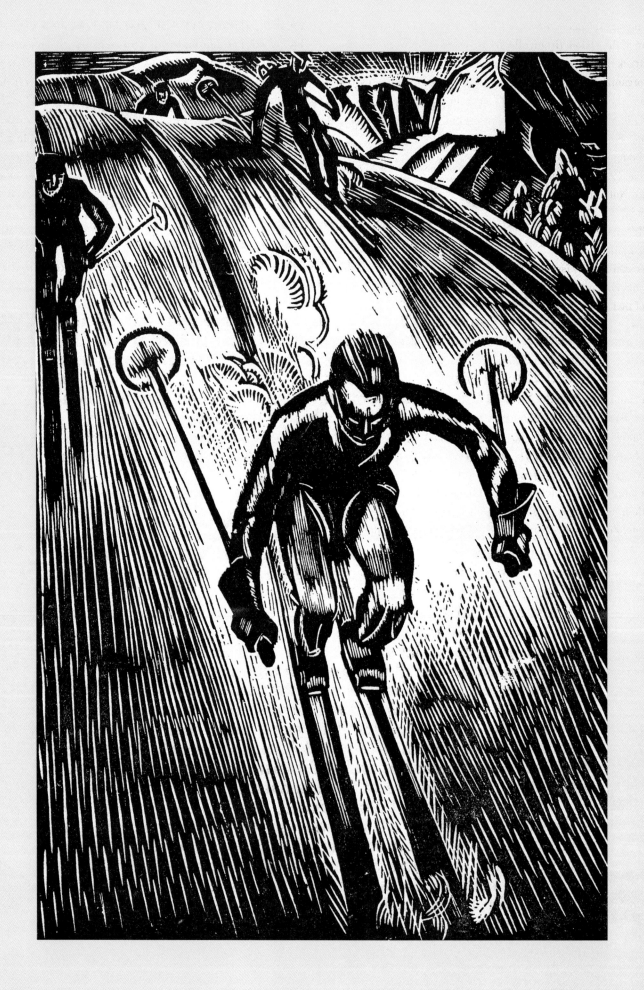

downhill racing was accepted as an Olympic sport. The Alpine innovation of the slalom (ironically, from a Norwegian word meaning "sloping track"), which consists of turning around flags or sticks, was first organized by the Swiss in the 1920s. Lunn's version of slalom, launched in Mürren in 1922 (and later to achieve world championship status) was more a test of overall ability in different conditions, one race on hard, one on soft snow, with the sole criterion being speed.

The year 1924 proved an important milestone in skiing chronology. Not only were the first Winter Olympic Games held at Chamonix but also, a separate body, the Fédération Internationale de Ski (FIS), was formed to regulate all other competitions. That same year Lunn organized the first combined downhill and slalom, which was won by a Swiss; he also founded a club promoting downhill and slalom racing, naming it the Kandahar Ski Club, after the race of that name. In the late 1920s competitive skiing for women was getting underway, and the Kandahar Club trained a group of girl racers, who participated in the 1929 Zakopane (Poland) championships.

Alpine skiing techniques had emerged around the turn of the twentieth century. In the village of Lilienfeld, Austria, in the 1890s, a Moravian-born teacher, artist, and, later, self-sufficient hermit named Mathias Zdarsky became inspired by a book about crossing Greenland on skis, written by Fridtjof Nansen. Thinking that skis might serve as a useful means of transportation into town, he ordered a pair. They were over three feet longer than today's average ski, and their cane bindings offered little support. After some 200 experiments, Zdarsky developed improved skis with steel sole

bindings, which provided lateral stability. He also taught himself how to ski, working out how to turn continuously on steep slopes. He wrote a book describing his skiing techniques and sent it to the Hamburg publishers of Nansen's book. Zdarsky's *Lilienfeld Skilauftechnik*, published in 1896, remained in print for 29 years and proved pivotal in the sport's development. The book's publication ended his solitary life, for it brought people asking for ski instruction and demands for ski courses in other Alpine resorts. During World War I, at the age of 60, Zdarsky became a military instructor. He taught some 20,000 soldiers to ski, with no accidents; yet ironically, on one skiing expedition, he fell victim to an avalanche. He suffered terrible injuries—some 85 fractures and dislocations—but survived.

There were considerable feuds about adopting Zdarsky's new *Lilienfelder* method. Detractors, whether Austrian, Norwegian, or

Left: Skier Adrian Allinson was also an artist. This graphic woodcut from the 1920s sums up the grit and determination needed to maintain speed. A Kandahar member and keen racer himself, Allinson competed in many of Lunn's early races at Mürren.

Right: The FIS championships of February 1939 were the last before the outbreak of World War II in Europe that September. No races were held between 1940 and 1947.

Below: The skiers in the 1927 Kandahar race held at Mürren used different styles to cope with deep snow.

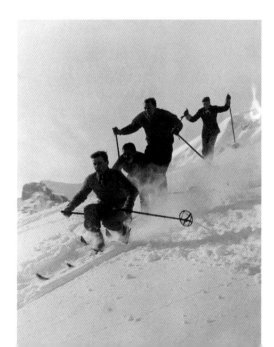

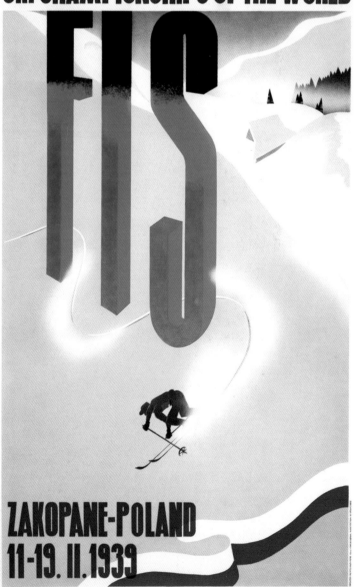

SKI CHAMPIONSHIPS OF THE WORLD

FIS

ZAKOPANE-POLAND
11-19. II. 1939

English, only added fuel to the controversy. Zdarsky was the first to realize that the mountainous Alps demanded a new—and different—approach to equipment and technique from the Nordic, stressing the safety element. Speed was to come later.

Hannes Schneider was a lasting influence on ski technique in the early twentieth century. He had great admiration for Zdarsky, believing he laid the foundations for Alpine skiing. Schneider, born in 1890 at Stuben in the Arlberg region, saw his first skiers in 1900 and in 1903 was given his first proper pair of skis (he had previously made his own out of sledgemaker's scraps and practiced by moonlight, to avoid being teased by other children).

In 1907 he was hired by the Hotel Post in St. Anton to teach guests, and during World War I he became a ski instructor. This provided a good grounding later in his life for running the world-renowned St. Anton Ski School.

Schneider was a highly talented skier and inspired fanatic loyalty. He was tall and good-looking, with a magnetic personality. Arnold Fanck, a German filmmaker, wanted to make a film showing skiing movement. He chose Schneider as one of four skiers in the resulting 1920 film *Das Wunder des Schneeschuhs*. Schneider impressed the public with his graceful turns, and the film made his Arlberg technique internationally famous. His fame thereby reached America,

where the film was shown in lecture halls, to great acclaim. In 1926, a book of the same name was published, translated into English in 1933 as *The Wonders of Skiing*.

Meanwhile, the travel and catering industries were making it easier to visit foreign countries. As early as 1820, a regular steamer service across the English Channel operated between England and France. Road improvements, with accompanying hostelries, enabled more visitors to see the newly fashionable Alpine splendors for themselves. Later transportation improvements, such as railways, funiculars, and cable cars all developed alongside the rising popularity of winter sports. The sporting challenges of the peaks, together with tourism for health reasons, resulted in a building boom of hotels for those seeking the restorative effects of mountain air.

However, the likelihood of transportation difficulties during winter discouraged travel at that time of year. In the mountains the thriving summer business would come to an abrupt halt in the autumn, leaving only locals and a handful of adventurers to await the snow.

This all changed in 1864, when Johannes Badrutt, founding father of one of St. Moritz's great hotel dynasties, invited a party of English who frequented his Kulm Hotel to stay for the winter. He struck a bargain that if they were disappointed by the weather, he would pay for their return journey. They benefited from an enjoyable

Above: Austrian Mathias Zdarsky was the first person to develop techniques for skiing in steeper mountain terrain, compared to the earlier Nordic style. Note the use of the single pole.

Below: One of Erna Low's early tour groups posing proudly for the camera.

Right: Stills from Fanck's film showing Hannes Schneider in action, demonstrating the snow plow Christiania, and on the right, the Telemark. Arnold Lunn wrote after meeting him in 1927: "Schneider's skiing is beautiful with the art which conceals, not only art, but power. Every movement is easy, natural and inevitable."

The Rani of Pudokkottai and companion, St. Moritz, 1926. By the 1920s, foreign nobility and a rich international set enjoyed the winter Alpine season.

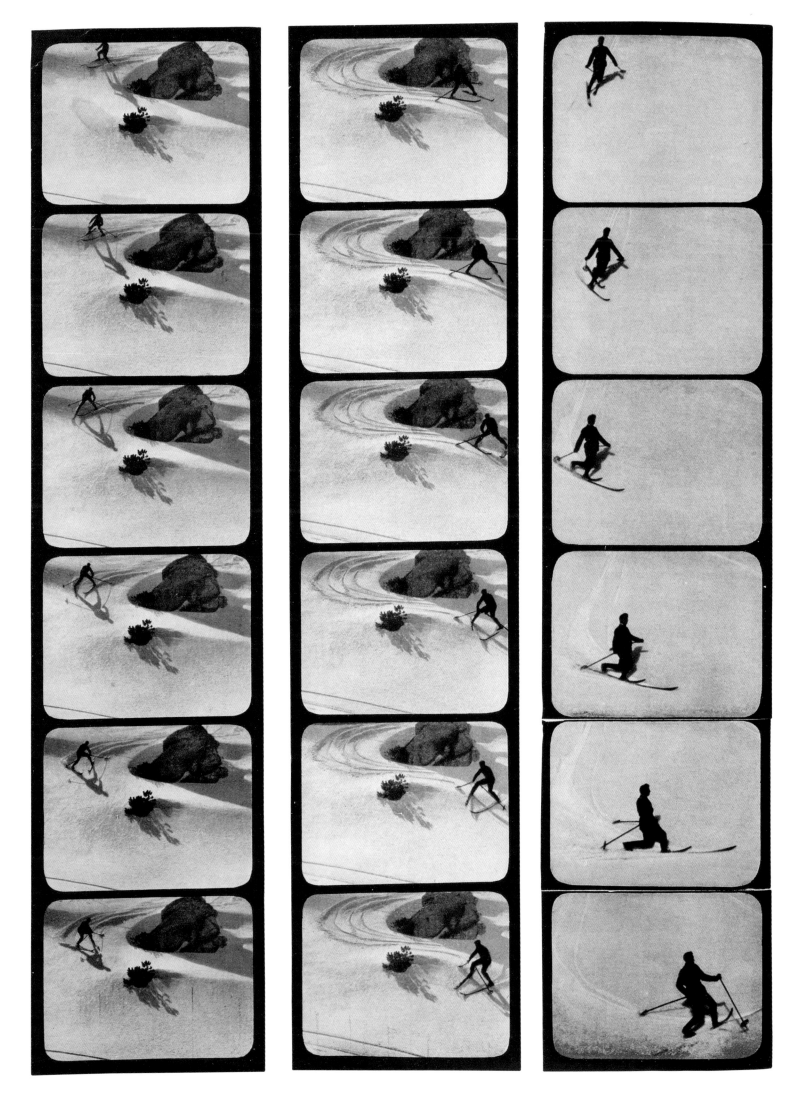

escape from the dismal English winter, so he won his bet. From then on, the hotel was open from January to March. From the 1860s, St. Moritz and Davos had been established as summer health resorts, but by the end of 1873, winter was busier than summer.

After the initial opening up of the Alps, winter sports caught on, and by the 1920s European cities would virtually empty at weekends as the new craze became as contagious as a fever. Throughout the 1930s, special boat-trains would leave London to arrive in Switzerland, offering all-inclusive holidays, including hotel and travel, for under £20. With the advent of special snow trains, the same fever caught on in North America for those close enough to mountain ranges.

In 1901 the first Italian ski club was formed in Turin and the Ski Club Arlberg was founded in Austria. From 1904, there were Swiss, German, and Austrian Ski Associations. By 1909, membership of these and other ski clubs ran into the thousands. Chamonix changed from being merely a mountaineering center to being a major resort, a status boosted through the hosting of the first Winter Olympic Games in 1924. Across Europe and North America, skiing had taken off; barring the interruptions of wars and depressions, it would never look back.

It is throughout this early boom, from the 1920s to the outbreak of World War II in 1939 that poster art most flourished, revealing images of an exciting world few could earlier have afforded. Initial postwar austerity meant Europeans only gradually rediscovered the pleasures of skiing. By the 1950s, tourist boards were colorfully promoting their newly expanding resorts, using more photography. In North America, the skiing bug spread, following European models, with the development of major resorts such as Aspen. The combined entrepreneurial skills of fanatical skiers, financiers, and developers laid foundations for today's multi-million dollar skiing business.

The aim of this selection is to convey the lighthearted pleasures of winter sports, to be enjoyed at every level, whether expert or novice. The ideal state of mind when skiing is perfectly expressed in the following advice on turning, taken from the 1927 classic *Modern Ski-ing*, by A. H. d'Egville, a keen racer and cartoonist:

"When you turn a street corner, you don't gaze at the pavement or your boots. You simply turn, having turned hundreds of times before. Do exactly the same on skis. Think of anything but turning. Think of lunch, love, life or laughter and simply turn. Do be joyous. Be serious about it, too, but do be happy as well. Enjoy it, insist on being delighted. Leap, shout. Even show off."

Above: An early poster for the Kulm hotel, part of the Badrutt family "empire."

Below: This 1935 ski bus had special outside racks for skis and poles, not unlike gondolas or bubbles today. Much of Megève's picturesque chalet architecture has been preserved.

Below: Erna Low was an early pioneer of skiing holidays, placing great value on the personal touch, inspecting hotels, meeting guides and accompanying groups from the 1930s to 1950s

Right: The impression of gathering speed, swooping along uncrowded pistes, is strongly conveyed by this action poster by Villemot, advertising winter sports in France.

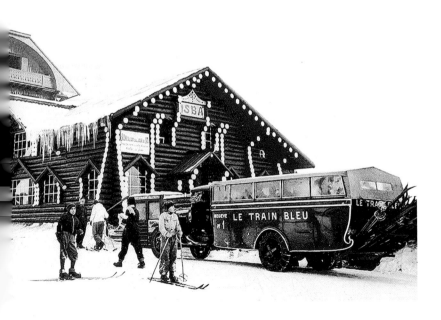

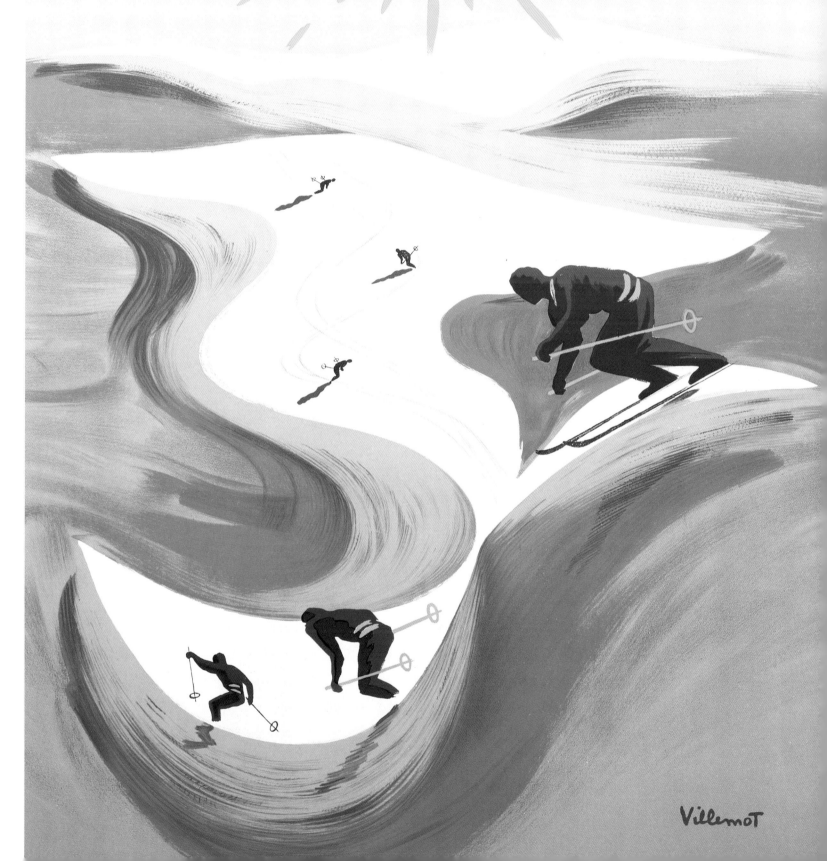

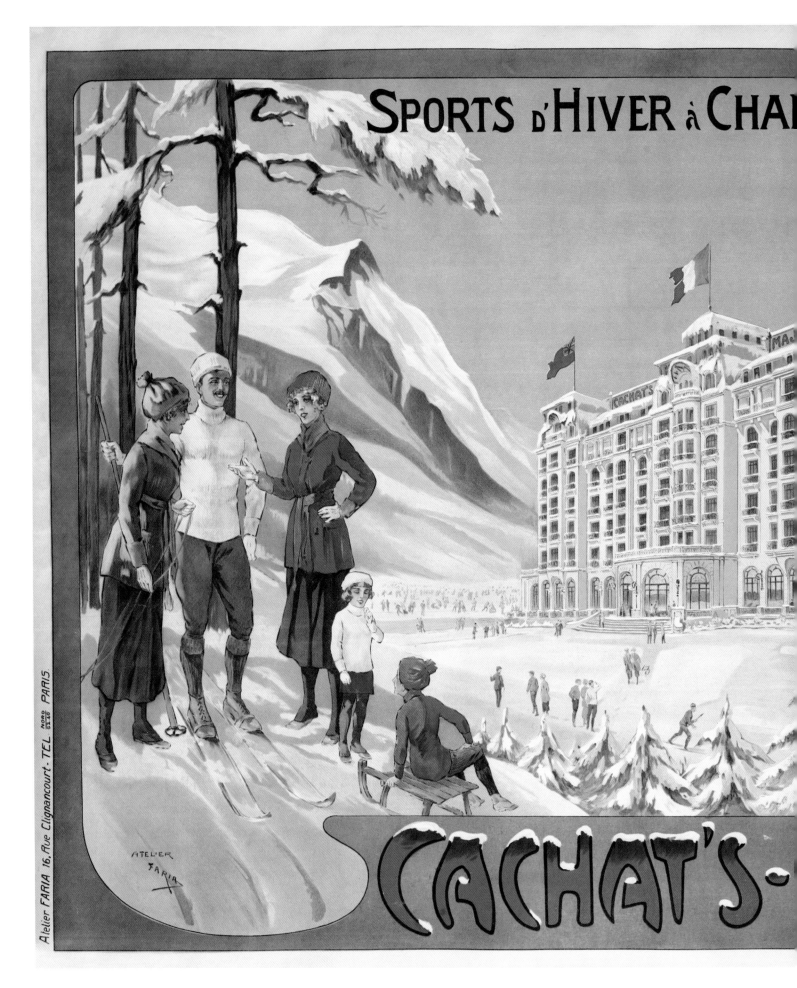

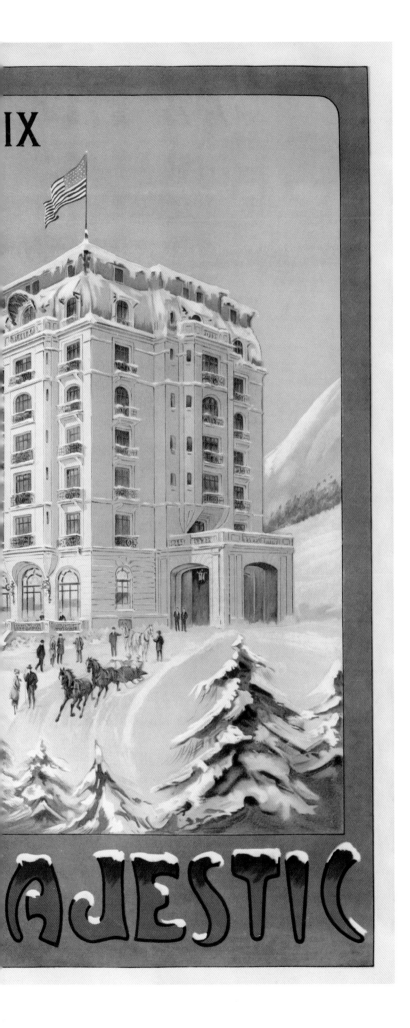

Part One

EUROPE

In 1860—the year that the Savoie became French—Chamonix had nine hotels. By 1919, there were 59. One of the grandest was Cachat's Majestic, visited in 1930 by the Sultan of Morocco with an entire retinue. De Faria made two versions of this poster, one showing winter pleasures, the other summer scenes.

Transportation played a crucial role in opening up the Alps, as engineering defied the mountains. Cog railways, funiculars, and primitive cable cars that swung perilously over rocky chasms were constructed for summer trade and maintained for winter use. They revealed whole new snowy playgrounds for lovers of winter sport—as did T-bars and chairlifts later on.

At the beginning of the twentieth century, Alpine summer resorts were gradually opening for an additional winter season. St. Moritz, Davos, and Grindelwald, in the vanguard of this new winter trade, were alive with visitors skating, curling, *luge*-ing, tobogganing, and experimenting with the newly introduced "Norwegian skis." It was a unique juxtaposition of sport and sophistication. Images of horse-drawn sleighs and sun-sparkled snow were part of the whole romantic mountain experience.

Switzerland was the first to benefit economically from the new craze, but it was not long before other Alpine communities were transformed into stylish resorts catering to an influx of winter-sports enthusiasts. One could be forgiven for thinking that some resorts were owned by a single family, as restaurants, bars, ski schools, equipment-rental shops, and hotels often carried the same name.

Life was lived not only on the pistes. An essential part of the winter wonderland atmosphere in the 1920s was the intense social element—that essential reviving hot chocolate or cocktail, *thé dansants*, dressing up for grand dinners, dances, or balls; it was a nonstop party. The clothes worn on the slopes and for *après-ski* reflected the social climate and period. The posters equally are evocative of this glamorous world full of sunshine and laughter, a winter counterpart to summers on the Riviera.

In terms of the sense of discovery, the exclusivity, and the social life, those early days of skiing were a golden age. As time went on, more practical developments contributed to the skill and safety of the new sport. By the 1930s, engineering enabled increased uphill traffic, while advances in ski equipment and clothing assisted the downhill journey. Principles of making and safeguarding ski trails were established, as were contingency plans for rescue. It was not until after World War II, however, that machines were used to groom pistes: subsequently, people who went off piste were regarded as eccentric or, worse, dangerous.

Beginning in the 1950s, the old-fashioned charm typical of Austrian ski resorts faced increasing competition from the French and the Americans, in terms of both skiing style and the development of purpose-built modern resorts. Soft-snow skiing in the powder of the Rocky Mountain regions of western United States and Canada proved an attraction for Europeans, as did the relatively uncrowded slopes. Inevitably, the package tour spread to skiing.

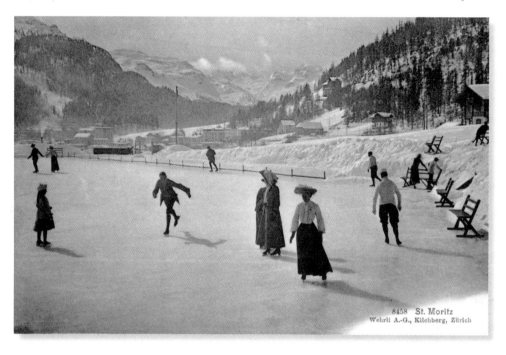

8458 St. Moritz
Wehrli A.-G., Kilchberg, Zürich

Skating became the chief winter sport for the fashionable set by the early twentieth century, when skaters still wore long skirts and hats, as shown in this scene from St. Moritz.

EUROPE

Right: One of Switzerland's foremost poster designers, Hugo Laubi, lightly portrays the swinging movements of skiing in this 1930s scene. The second skier looks almost imp- or elfin-like, wearing one of the curious bobble hats then considered fashionable.

Norway can justifiably claim to be "the cradle of skiing." Long before it became a sport, it was, for the people of northern Scandinavia, simply a part of life. With the region's proximity to the Arctic Circle and severe winter climate, a form of ski had been used out of necessity since prehistoric times. Every valley had its own particular type: long, narrow skis were used on hard, wind-driven slopes, whereas in tree-lined valleys people made use of shorter, broader ones. Skis were used generally throughout Scandinavia for winter travel: 50 miles a day would be a fair distance for a Lapp. An English author writing in 1827 noted, in *A Winter in Lapland and Sweden*, that "skie" or "snow-skaes" are "machines by no means easy of use where the ground is precipitous."

It was in Norway that the sport of skiing first began to develop (the word "ski" itself is of Norwegian origin) and where competition skiing was born. It became the national sport, playing its part in developing the physical fitness of the nation. By the mid-nineteenth century, competitions were well established. Those held at Holmenkollen, from 1892, were accepted as the most important events in the skiing world until the first Winter Olympics, in 1924 in Chamonix, at which medal winners were, unsurprisingly, mainly Scandinavian.

There have been many great Scandinavian skiers, but among the most famous are the Norwegians Sondre Norheim and Fridtjof Nansen. Norheim impressed competitors in Christiania (Oslo) in 1868 with his skill in jumping and cross-country skiing and also on the descent. He moved skis in ways previously unseen, thus capturing the public imagination. A turn Norheim used in cross-country skiing was named after his native district of Telemark; another, used in downhill, was named the *Christiania* (later abbreviated to *christie* by English-speaking skiers). These techniques are Norway's principal legacy to the sport.

Fridtjof Nansen described his epic ski journey across previously unexplored Greenland in his influential book *Paa Ski Over Grønland*, published in 1890. Using skis continuously for 19 days, he covered a distance of 248 miles. The following enthusiastic passage from his book is just as relevant to skiing today:

"Where will one find more freedom and excitement than when one glides swiftly down the hillside through the trees, one's cheek brushed by the sharp cold air and frosted pine branches, and one's eye, brain and muscles alert and prepared to meet every unknown obstacle and danger which the next instant may throw in one's path?"

The posters from the 1930s to the 1950s depicting the frozen wastes of Norway, by artists little known beyond those frontiers, encapsulate that same healthy, outdoor Nordic spirit.

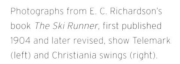
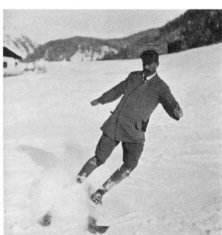

Above: Husky dogs still play an essential role in pulling sleds across Sweden's frozen wastes, as they do in neighboring Finland and Norway.

Left: Knut Yran based his 1951 poster on every Norwegian's belief that they were born with skis on. Skiing is Norway's national sport.

Photographs from E. C. Richardson's book *The Ski Runner*, first published 1904 and later revised, show Telemark (left) and Christiania swings (right).

Richardson and his brother took Norwegian skis to Switzerland and co-founded the Ski Club of Great Britain in 1903.

SCANDINAVIA

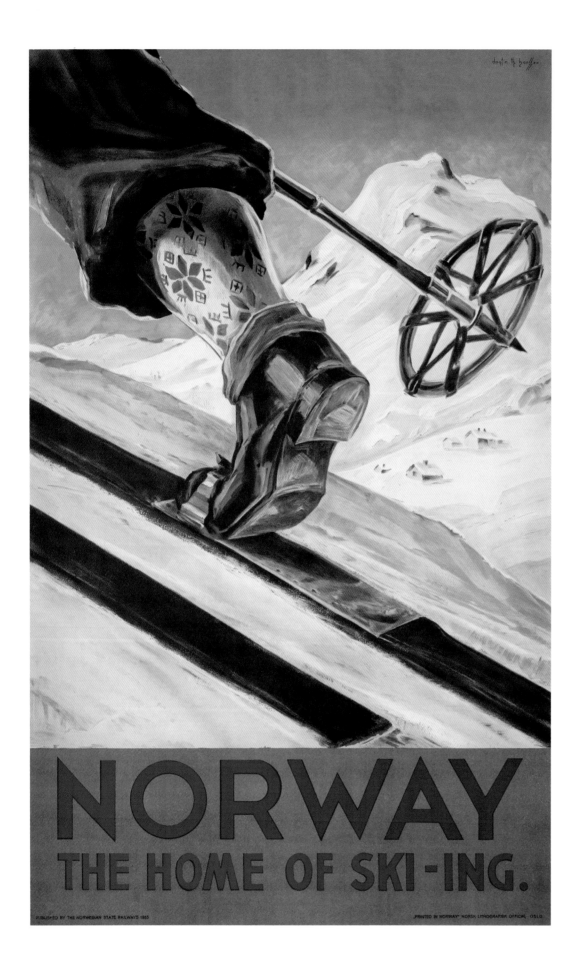

← CROSS-COUNTRY
Norwegians rightly believe
they hold claim to being
the home of skiing. Dagtin
Hanssen's 1935 poster shows
a cross-country ski boot with
the toe strapped into an iron
binding, purposely leaving
the heel free.

→ WINTER IN NORWAY
Shadows turning snow blue
are well-captured in Schenk's
1938 "Winter in Norway," also
printed in Norwegian. Note
the skier's correct hold of
the wooden poles and gloves
placed over empty handles
while fixing bindings, to avoid
losing them in the snow.

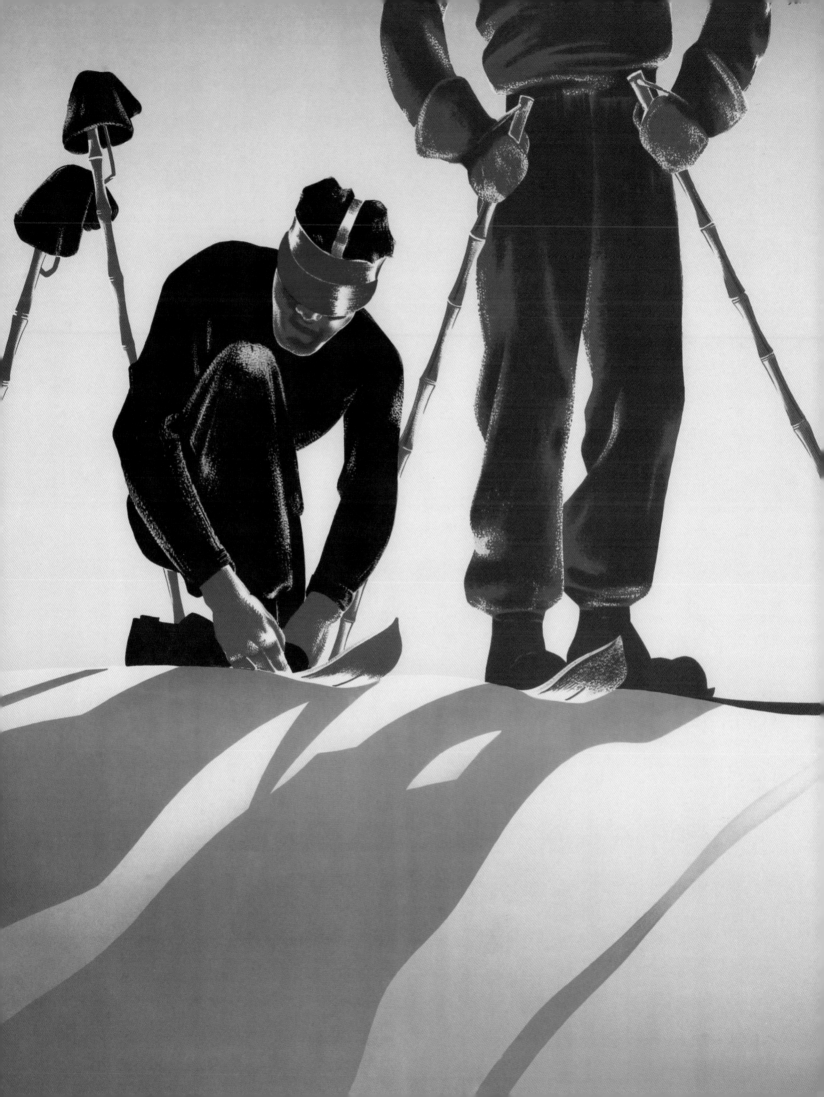

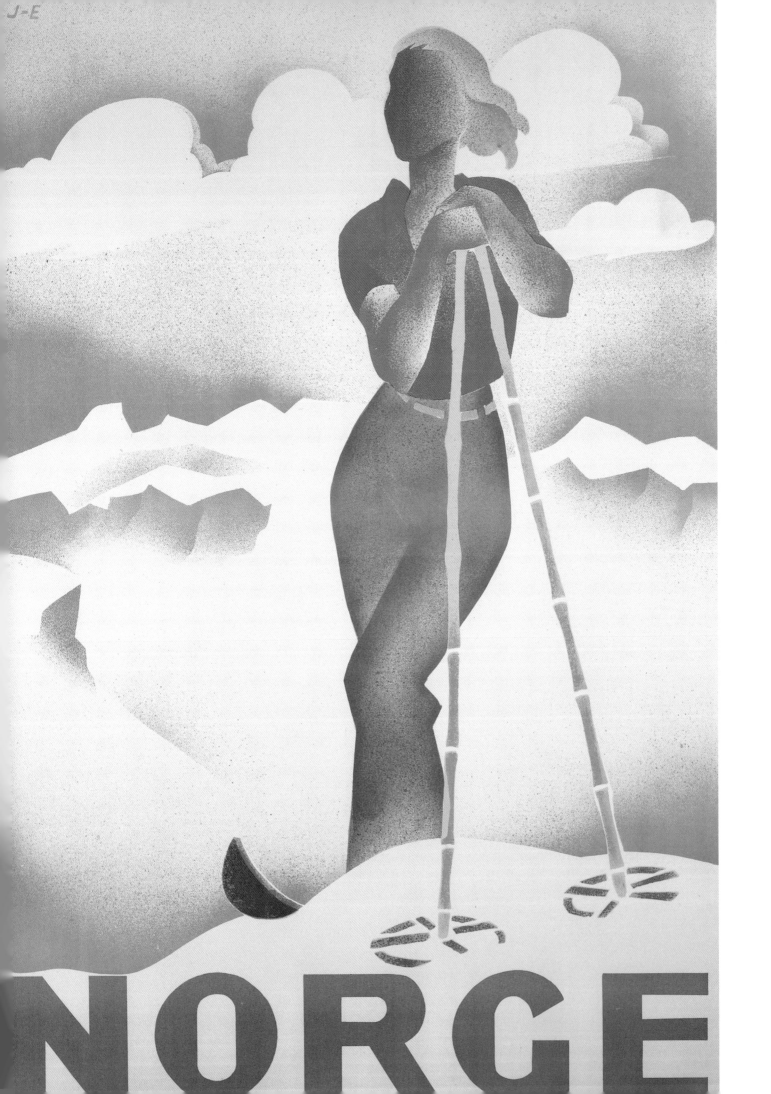

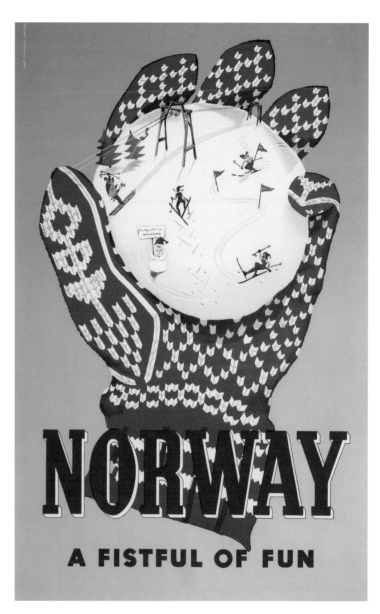

⬅ TOP OF THE WORLD
Although the mountains in Norway are lower than in Alpine Europe, one can still feel on top of the world. This poster by J. E. shows idealized spring skiing. Note the large "baskets" on the ski poles.

⬆ NORWEGIAN SUNSHINE
Scandinavian days are very short, so close to the Arctic Circle, so sunshine is even more precious and to be lapped up at every opportunity. People would also sled or ski by bright moonlight reflecting on the snow.

FISTFUL OF FUN
Traditional patterned Norwegian knitwear, oiled to be water-resistant, became popular among European skiers. Inger Sorsensen's 1956 poster imaginatively lets us look into the snowball as if into a crystal ball.

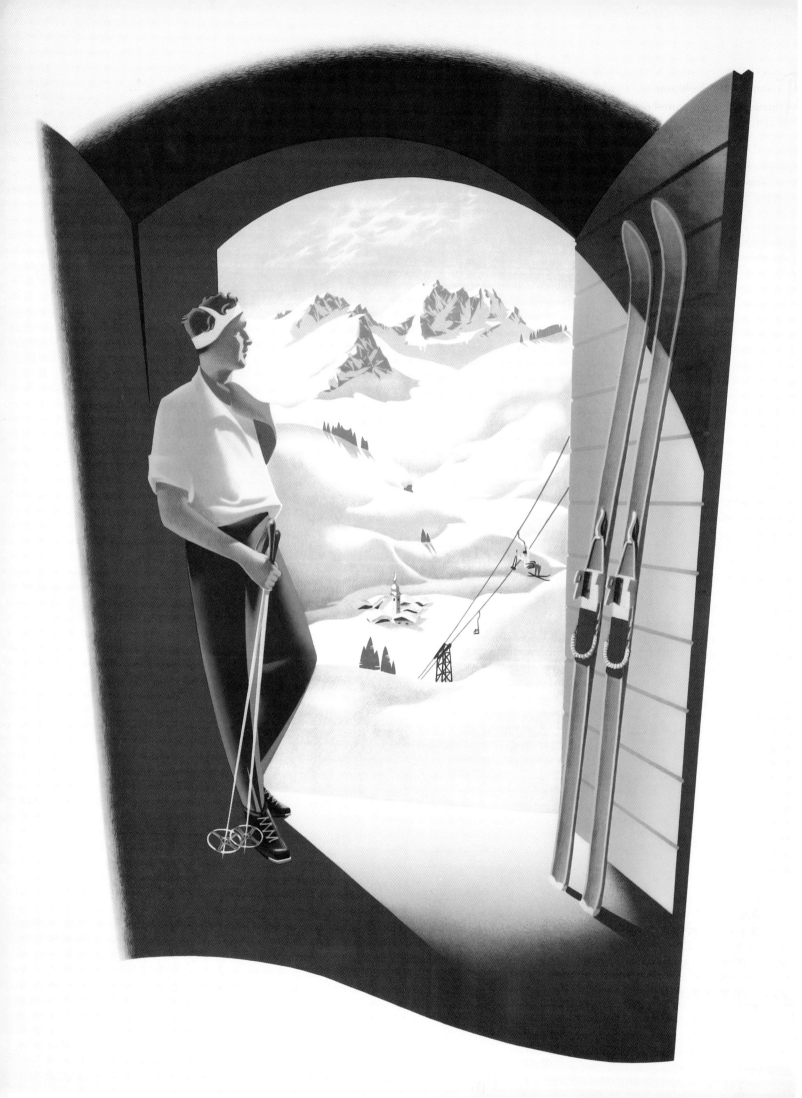

A ustria has a special atmosphere under snow. By day, the beauty of its majestic mountains and picture-book villages, with onion-domed churches and colorfully painted houses, is accentuated. By night, after a day's exhilarating skiing, it offers the legendary *gemütlichkeit* in a warm inn with a glass of *glühwein*.

Of today's elite 11 "Best of the Alps" ski resorts, four are Austrian: St. Anton am Arlberg, Lech Zürs am Arlberg, Kitzbühel, and Seefeld. All are in the Tyrolean Alps, in western Austria, an area known for its picturesque wooden chalets, nestling in thick snow, and a paradise for skiers. With thousands of miles of prepared runs and off-piste opportunities, the Tyrol has about three times the number of resorts of all the combined ski areas in Colorado and Utah.

Capital of the Tyrol's Arlberg region, St. Anton describes itself as the cradle of modern skiing and is to skiing what St. Andrews, in Scotland, is to golf. Skiing arrived at St. Anton soon after 1884, when extraordinary feats of engineering completed the tunnel under the Arlberg Pass on the main Zürich-Vienna railway line. Previously the town had been accessible from the west only with difficulty, the only route being over the perilous pass itself. An Imperial State Railways poster from 1910 shows St. Anton in romanticized light, along with the

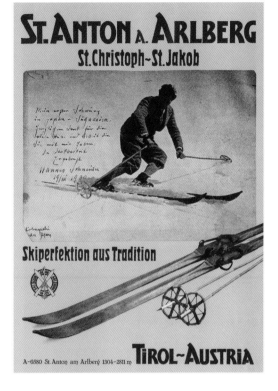

forbidding Pass and the Hospice of St. Christoph, for centuries a refuge to stranded travelers. It was in the hospice kitchens, in January 1901, that a group of hardy Austrians formed the Ski Club Arlberg. Two years later, they held their first competitions.

With its steep, heavily moguled slopes offering a serious challenge to skiers (and a correspondingly high risk of avalanches), St. Anton quickly became famous for winter sports, and also for high living. The surrounding area provides some of the finest terrain in the world, now linking to a vast ski playground with neighboring resorts Lech and Zürs. Lech has a reputation for exclusivity, being frequented by international royalty and celebrities.

St. Anton's preeminence in Austrian skiing owes much to Hannes Schneider, who, in 1922, opened the Arlberg Ski School. Born in the nearby hamlet of Stuben, in 1890, Schneider took up skiing as a child, at first using skis he'd made himself from sleigh-makers' scraps. (To avoid the taunts of other children, he practiced by moonlight.) Later, having perfected his technique on proper skis, he became a ski instructor for Austria's Alpine troops during World War I. This gave him valuable experience in instructing large numbers of beginners—

Left: Ebner's open-door imagery, dating from 1950 and inviting the viewer to step through into the high mountain scenery, instantly makes one think of downhill, rather than cross-country skiing, in view of the steepness of the slopes. Solutions to the terrain created the main differences between Alpine and Nordic skiing techniques.

Below: In 1937, a cabin of the Galzig cable car was towed through St. Anton's streets.

Above: St. Anton used images of famous ski instructor Hannes Schneider in action for this poster by Hans Hofmann. His then-revolutionary methods of instruction became commonplace.

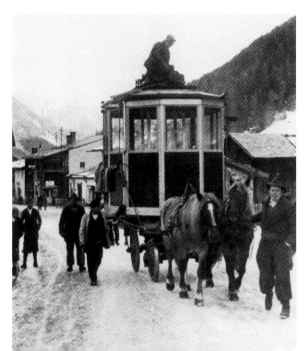

AUSTRIA

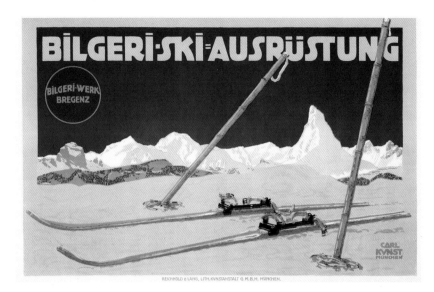

happy circumstances. In 1938, Hitler's troops marched into Austria in the long-feared *Anschluss*, and Schneider, never a Nazi party member, was placed under house arrest. He was transferred to Garmisch-Partenkirchen, near Munich, fearing the worst; however, strings were pulled in high places, and he was released and expelled to the United States. Granted this new beginning, he formed his own ski school at Mount Cranmore, New Hampshire. Among other Austrian skiing pioneers, Mathias Zdarsky is noteworthy partly for having organized the first giant slalom race in 1905 on the Muckenkogel, and other, shorter slaloms in 1906 and 1909.

In 1902, Colonel Georg Bilgeri, an officer in the Austrian army, built the first ski workshop and factory, in Salzburg. Four years later, his factory produced skiing equipment for 1,400 soldiers; this included, for the first time, double ski sticks. Advertisements for this new equipment are collectors' items today (left).

A different kind of equipment, the cable car, played a major part in the skiing offered at Kitzbühel. This attractive Tyrolean town with medieval walls and pastel-colored houses, surrounded by mountains, is famous for the Hahnenkamm downhill race. The Hahnenkamm cable car, known as the "sardine tin," was built here in 1926 and operated for 80 years, until recently replaced by a six-person gondola. A wealthy fur-clad international set have always mingled with less well-heeled but keen downhill skiers here.

Another Austrian skiing center, Alpbach, wins successive awards as the most beautiful village in Austria. Summer and winter tourism began here in the 1930s, since when it has managed to retain its rural charm, thanks to a 1953 building regulation stipulating that all construction be in traditional Tyrolean style.

Although not in the first rank of Austrian ski resorts, the spa town of Badgastein, near Salzburg, achieved renown in the nineteenth century as one of the great watering holes of Europe. Located near a

experience that he applied in the Arlberg Ski School, which he organized so that all of his instructors coached identically. In 1928, due to Schneider's influence, the Austrian State Ski Examination was established; only those who passed this exam were allowed to teach. His meeting with Arnold Lunn in St. Anton in 1927 led to the first Arlberg-Kandahar race in 1928, today one of the most prestigious competitions in the skiing calendar.

Schneider was a highly talented skier. Arnold Fanck's film, *Das Wunder des Schneeschuhs* (1920), brought him wider fame, for he starred in other ski-chase films directed by Fanck, culminating in *White Ecstasy* in 1931. The 1933 book *The Wonders of Skiing* contained film stills and sequence frames from the slow-motion filming. It was widely read and hugely incluential in the international spread of the Arlberg "crouch" technique.

Schneider was invited to visit Japan in 1930. There, he gave lectures and advised on the manufacture of skis. He also made appearances at the first Winter Sports Shows in Boston and New York, in 1936 and 1937. He was to return to the United States within two years, in less

Above: Karl Kunst's 1910 poster shows Bilgeri's new binding, accompanied by two poles.

Right: Countess Lamberg set a record for ladies ski-jumping, at Kitzbühel in 1908. Over 100 years later, at the Winter Olympics in Sochi, Russia, for the first time women were allowed to compete in ski-jumping as an Olympic sport. Germany's Carina Vogt became the first woman ever to win a gold medal in this previously men-only sport.

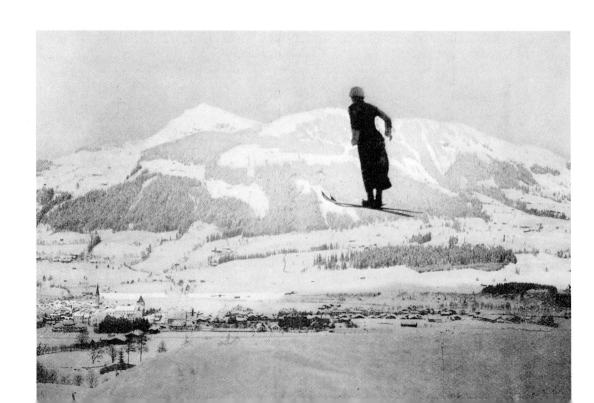

fourteenth-century gold and silver mine, inside the mountain near Dorf Gastein, the spa facilities included water with a temperature of 90°F, high humidity, and low doses of radon gas, which was thought to cure respiratory and muscular ailments. There were natural, sulfur-free springs and public baths, an elegant casino, and assorted grand hotels painted in the imperial yellow of Vienna's Schönbrunn Palace, stacked dramatically up a steep hillside around a waterfall tumbling thousands of feet into the River Ache. The Hotel Grüner Baum, built in 1831 by Archduke Johann as a hunting lodge, became one of Austria's most illustrious hotels. Johann Strauss composed music here, and the guest list often included heads of state. The faded

grandeur of such venerable hotels, along with the town's steep layout, made Badgastein somewhat unfashionable among serious skiers. Today, however, the resort hosts international snowboarding events on the world circuit, as well as skiing.

Now fashion has come full circle, as the latest Austrian tourist boom echoes the style of earlier spa resorts, featuring "wellness," fitness, and baths. Chalet hotels offer meditation, yoga, tai chi, massage … not, perhaps, what the sporting pioneers had in mind when they first forged ways through the mountains. Yet each type of activity perfectly complements the other—relaxation and tranquillity after muscular strain and high adrenaline rushes.

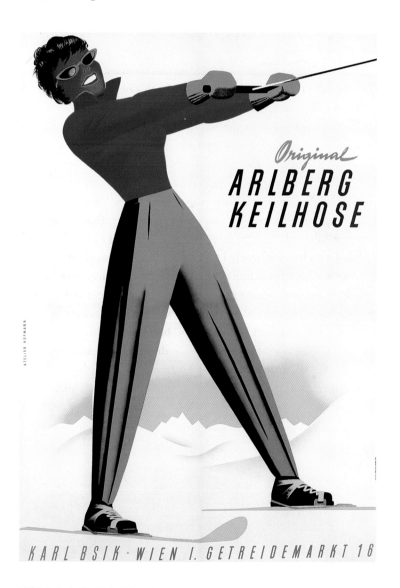

Hofmann's studio produced posters in the early 1950s in distinctive graphic style—as shown in this tailor's advertisement for the new stretch ski pants.

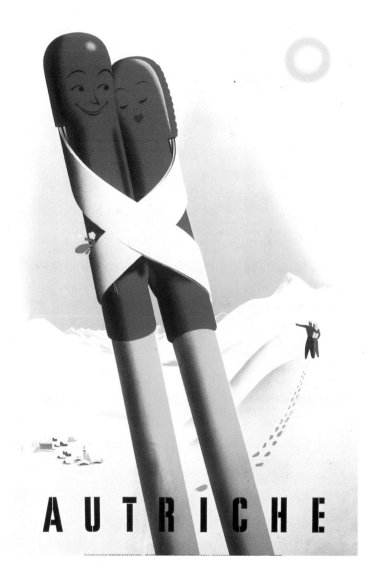

The idea of intertwined ski poles as a romantic couple mimicking their human counterparts was typical of the upbeat humor of Hofmann's studio posters.

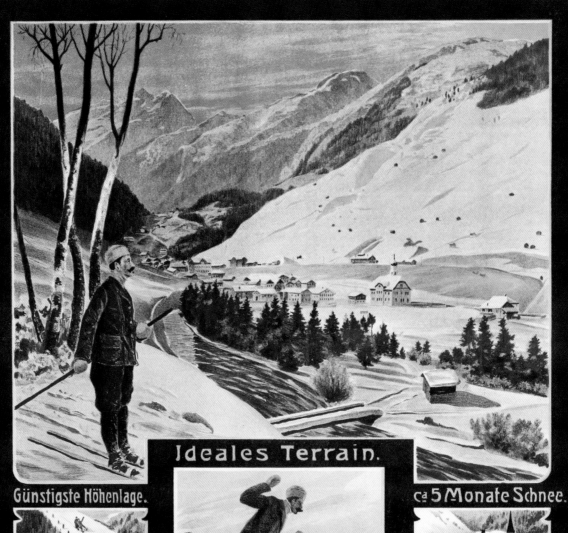

Ideales Terrain.

Günstigste Höhenlage.

ca 5 Monate Schnee.

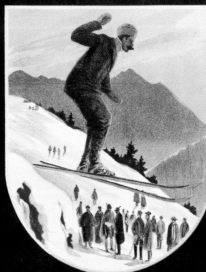

I·Tiroler Winter-

Sport-platz.

S¹ ANTON
AM ARLBERG 1300 <u>Meter</u>

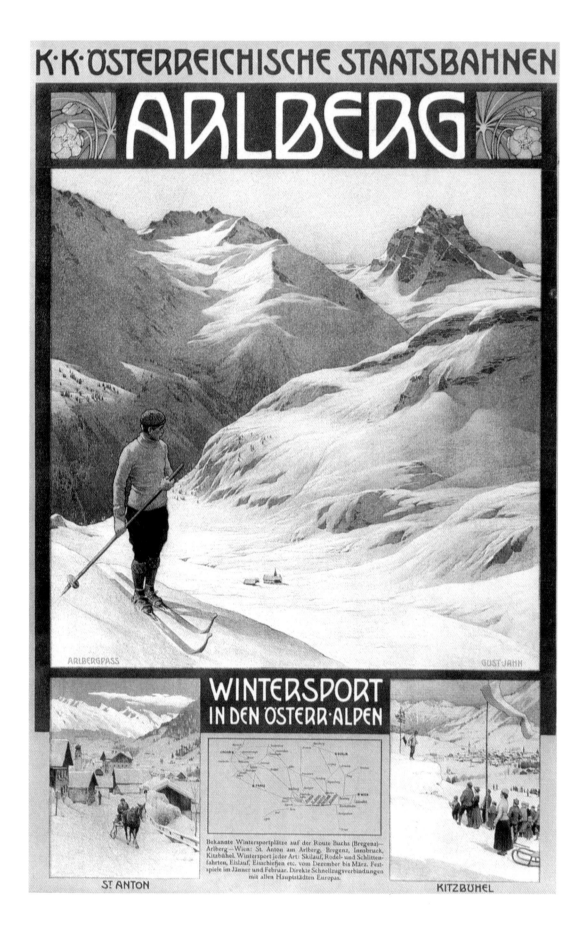

← ST. ANTON

The first advertisements for St. Anton appeared in 1908– this poster from around 1910 proudly boasts five months of snow and claims it is the number-one Tyrolean sports resort. Today it remains Austria's best for good skiers.

→ ARLBERG

Aware of the connection between railway access and winter sports, this 1910 Imperial State Railways poster shows the high route over the Arlberg pass, St. Anton as the village it then was, and a jumping event at Kitzbühel.

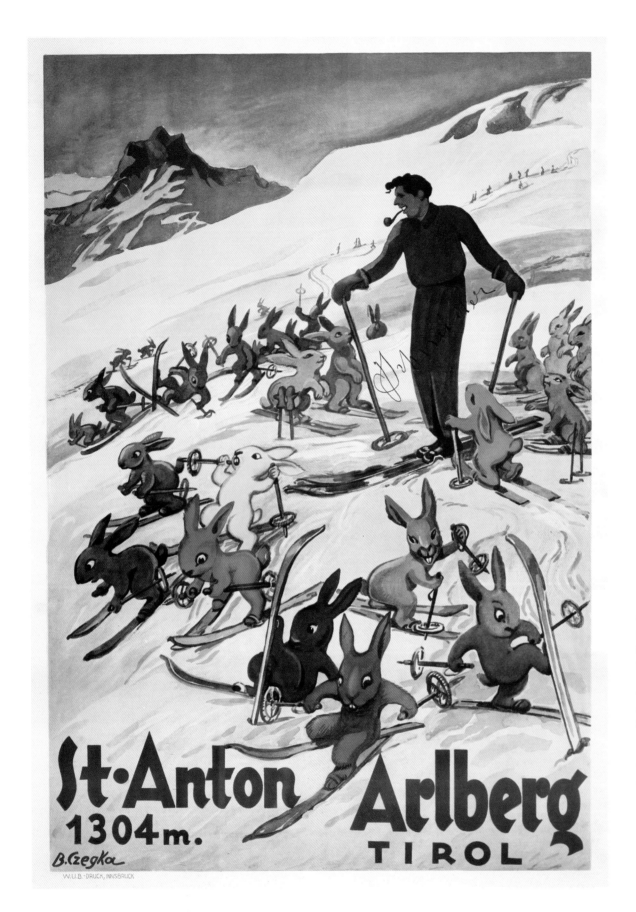

← ARLBERG SKI SCHOOL
This humorous poster by
Berta Czegka shows Hannes
Schneider instructing a
beginner's class of colorful
and mischievous rabbits,
whose attempts at skiing
are way off the mark. The
signature is Schneider's.

→ TYROL
The wooden mountain hut
at a high-altitude crossroads
is typical of the picturesque
Tyrol—with snow hanging
thickly over the eaves. Ski-
touring was a popular pastime,
and people would stay at these
huts rather than descending to
the valleys below.

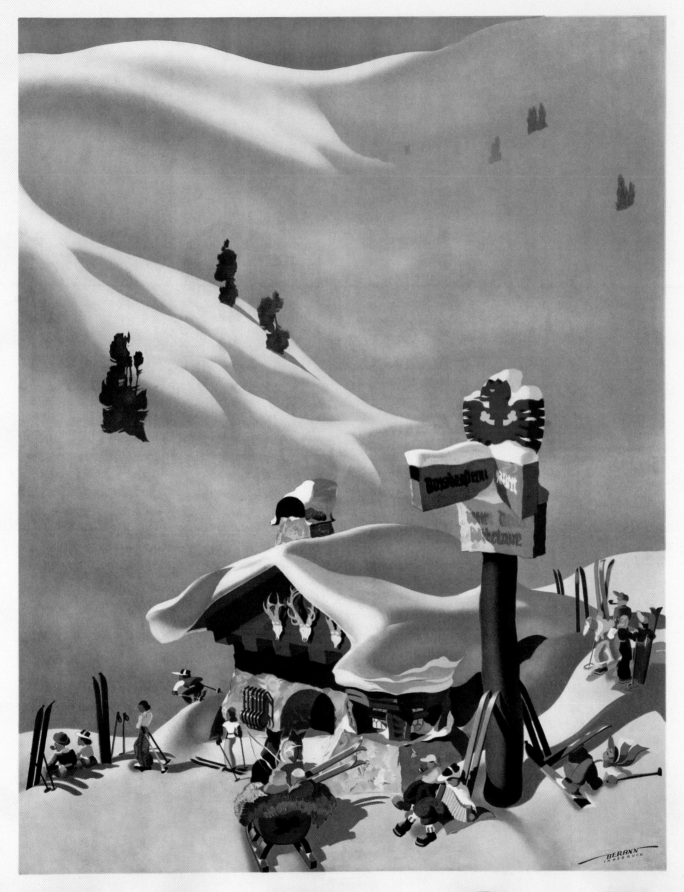

TIROL

WINTERSPORT
IGLS
B.INNSBRUCK

GRAND HOTEL IGLERHOF

HOTEL IGLERHO
WINTER u. SOMM

STATION

IGLS

A woman uses the classic helpless-female ploy of having her bindings adjusted for her by the stronger man. Directly above Innsbruck, Igls remains a small resort today, with limited runs.

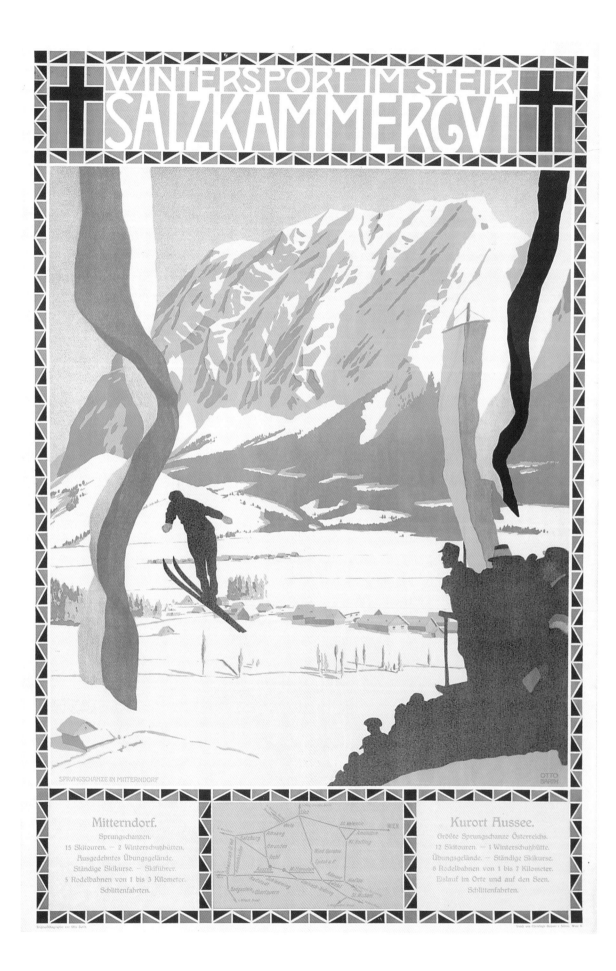

SALZKAMMERGUT

An early Austrian poster by Otto Barth shows ski-jumping near Mitterndorf, in the Steir region just south of Salzburg. Man has always wanted to fly, and ski-jumping is the closest he can get, short of parachuting. The jumper here adopts the correct position of leaning forwards along the skis. In the Olympics, marks are given for "flying with style."

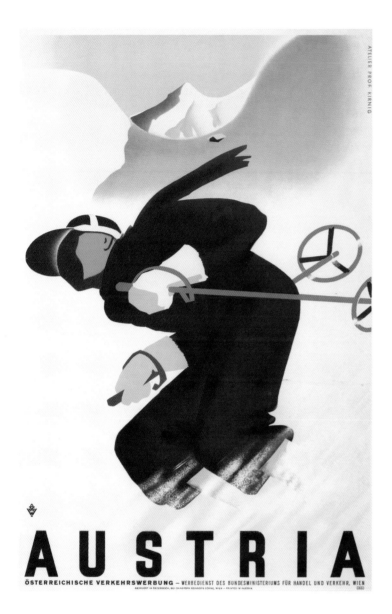

DOWNHILL IN AUSTRIA

The Austrian Tourist Board in Vienna used this 1930s design by the Kirnig studio to convey the exhilarating speed and energy of skiing downhill–below the knees, lost in a mist of powder snow.

SUNSHINE ON THE AUSTRIAN SLOPES

A French-language version of an Austrian Tourist Board poster from the 1930s, designed by Joseph Binder, with strong angular lines, and blocked use of shadow accentuating the image of ultra-bright sunlight.

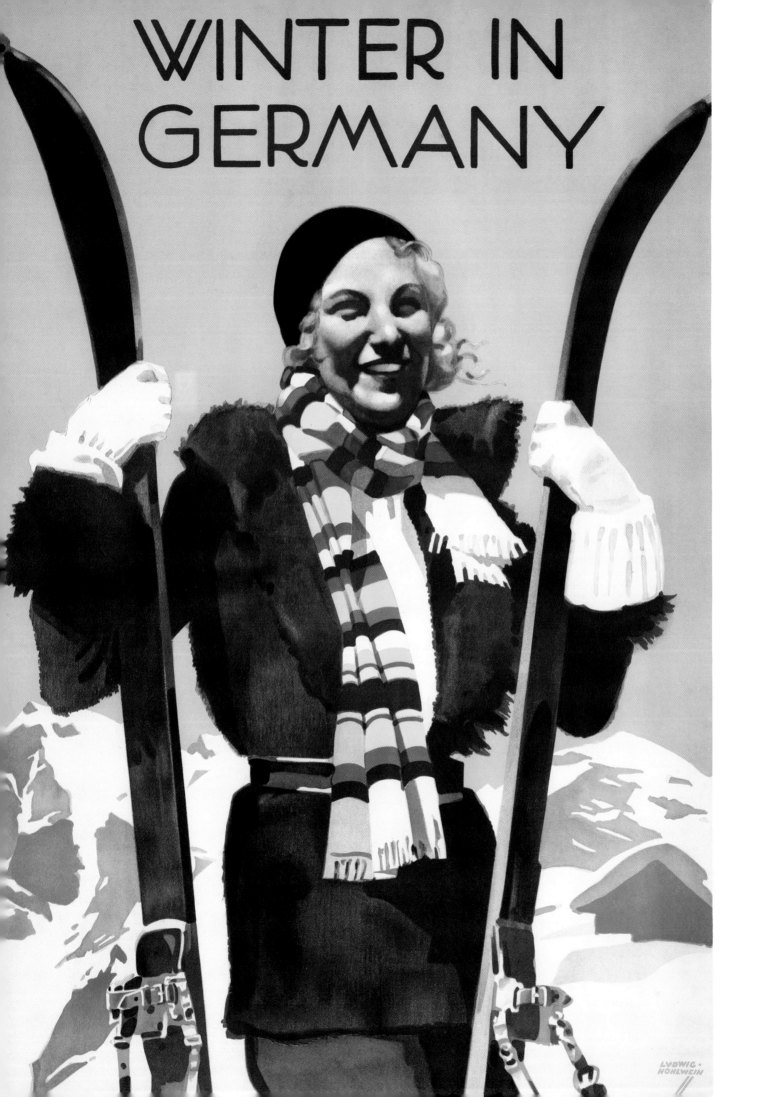

For two successive centuries, Germany was a key influence in the development of poster art. The invention of lithography in Munich by Aloys Senefelder, in the late eighteenth century, was further developed in France. Munich also saw the founding, in 1896, of an arts journal called *Die Jugend* ("The Youth"), which gave its name to Jugendstil, the German version of Art Nouveau. That same year, the magazine *Simplicissimus* was launched, containing posters designed by political cartoonists that conveyed their messages with a brutal simplification that would affect future graphic styles.

Movements to end old bourgeois snobberies separating crafts—industrial or applied arts—from "fine" arts were gaining momentum across Europe. Domestic arts and smaller commercial arts, including mass-produced posters, were gaining new status. Germany's strongest influence on twentieth-century international design was the Bauhaus, the most famous school of design, craftsmanship, and architecture, founded in 1919 at Weimar by architect Walter Gropius. Later moved to Dessau and then to Berlin, it was closed in 1933 by the Nazis, but its ideals took root in other countries. Layout and graphic design were increasingly influenced by this school, with its appreciation of the use of blank space.

The centers of German poster art were Berlin and Munich. The latter's proximity to the developing ski slopes of Bavaria ensured high-quality production and design in advertisements for the emerging resorts and for ski clothing, equipment, and transportation.

The most instantly recognizable and best-known of German poster artists was Ludwig Hohlwein. Born in Wiesbaden in 1874, he studied in Munich and began poster work in 1906. His style of sharp contrasts and simple, geometric letters was used for advertisements for tailors in Munich, for Audi automobiles, and for the German Prisoners' Fund and other World War I posters. His iconic, graphic posters for the Munich Zoo continued graphic trends concurrent in London and Paris. In addition, he designed posters and logos for Munich's popular beers; but it is perhaps for his later zealous contributions to the Nazi propaganda machine that he is best known.

Angular images of fascist Germany reflect that era, as can be seen in Hohlwein's poster for the controversial 1936 Winter Olympics at Garmisch-Partenkirchen. It is unclear whether the heroic skier shown is raising his hand in victory or in the Nazi salute. Hitler attended these fourth Winter Olympic Games—the veneration of physical heroics was part of Nazi ideology. The use of sport for political ends raised objections from foreign observers, including the British skiing authority Arnold Lunn, who pointed out that "there are still people who ski for fun."

The best skiing in Germany is found in the craggy Bavarian Alps, bordering Austria, in picture-postcard scenes of traditional balconied wooden chalets, some with gaudily painted façades. It was here, at Berchtesgaden (subsequently famous as the site of Hitler's mountain retreat, the Berghof) that skiing was first attempted in Germany, in 1898. The skier, Georg Weiss, used Norwegian skis and one *stock*, or pole. Today Berchtesgaden hosts international FIS skiing and snowboarding competitions as part of the competitive World Cup circuit.

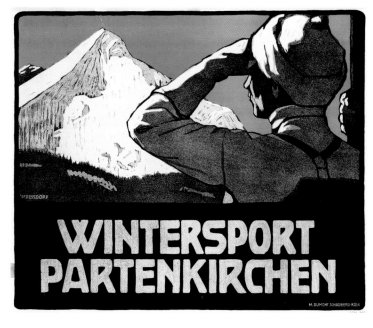

WINTERSPORT PARTENKIRCHEN

Above: Strong typography almost dominates the simple graphics of this 1906 poster by Reisdorf, advertising Partenkirchen. This was later linked with Garmisch to make one resort.

Left: Ludwig Hohlwein, Germany's best-known poster artist, depicts a typical blonde *fräulein*, in this 1935 poster with English typography. Despite increasingly troubled times, even within Germany, skiers still played on the Bavarian slopes.

GERMANY

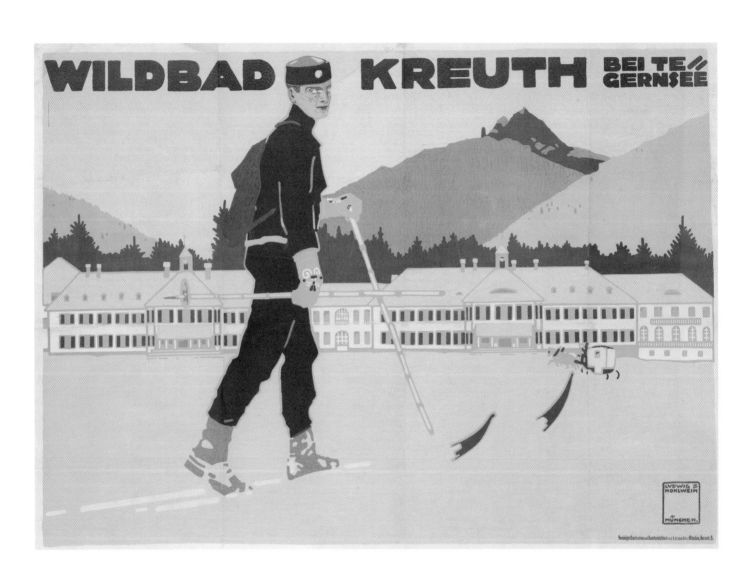

WILDBAD KREUTH

This small Bavarian resort on lake Tegernsee was known for cross-country skiing, or *langlauf*. It has now become a major conference center for top-level scientific and political gatherings.

⊕ LODEN

Loden Frey, a fashion brand in Munich, used this 1914 poster designed by Edwin Henel to advertise the suitability for skiing of the waterproof woolen fabric *loden*, used in so many Austrian and German clothes.

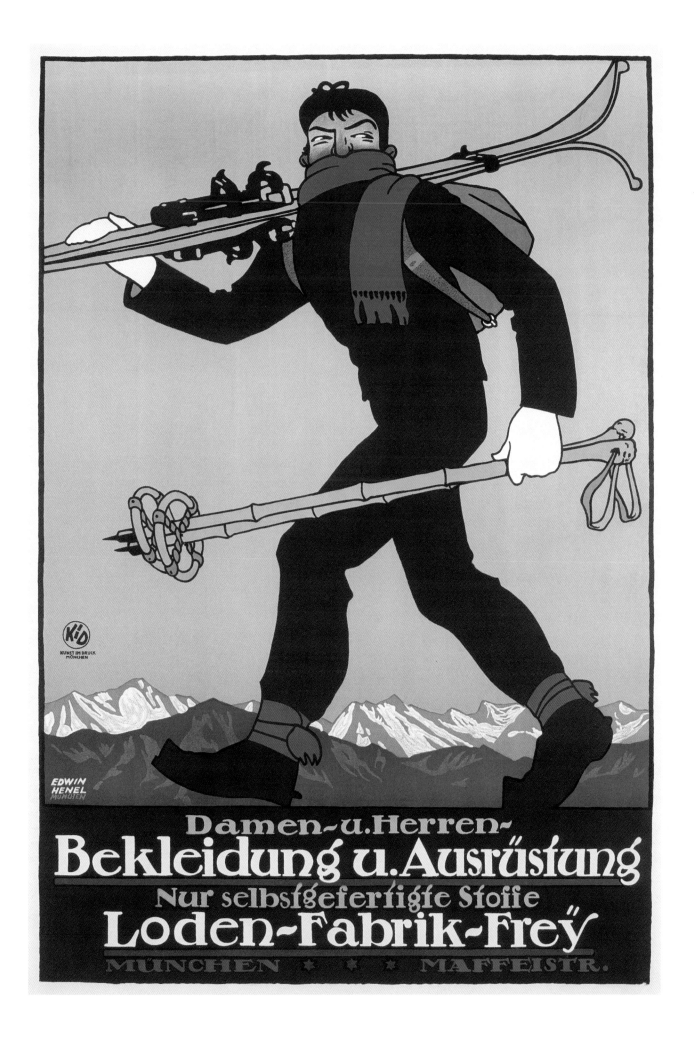

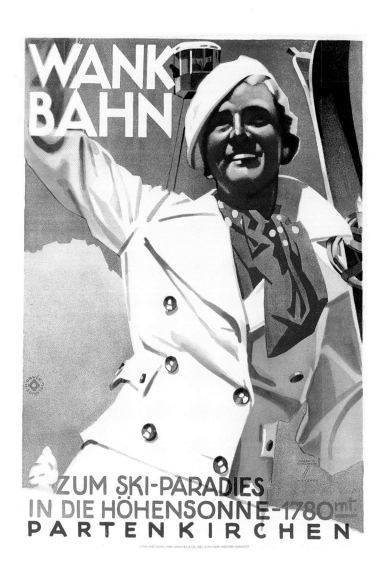

WANK BAHN

ZUM SKI-PARADIES IN DIE HÖHENSONNE 1780mf
PARTENKIRCHEN

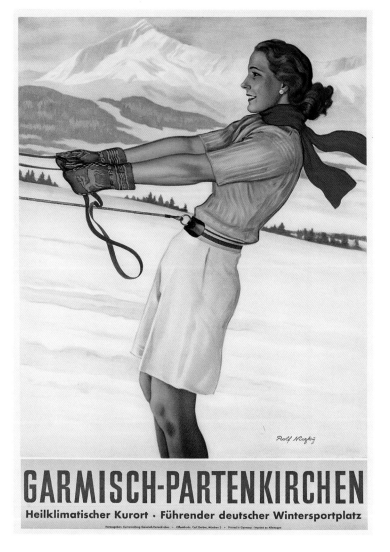

GARMISCH-PARTENKIRCHEN
Heilklimatischer Kurort · Führender deutscher Wintersportplatz

↑ SKI PARADISE
Another of Hohlwein's idealized blonde young women promotes the cable car to the top of one of Garmisch's highest mountains, the Wank (pronounced with a V).

⊕ GOLD MEDALLIST
Christl Cranz took the gold medal for Germany in the Women's Alpine combined at the 1936 Winter Olympics.

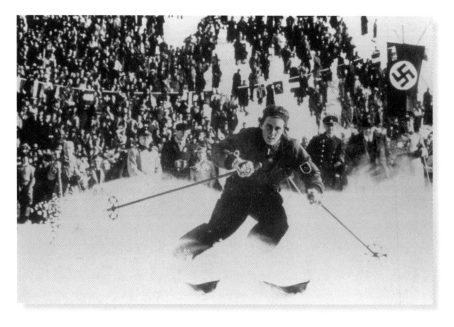

↑ GARMISCH-PARTENKIRCHEN
We can only guess if a horse or car is pulling this fine example of healthy youth in Niczky's 1938 poster. Note the Norwegian reindeer gloves.

⊕ 1936 WINTER OLYMPICS
Hohlwein's poster for the 1936 Winter Olympics. Willy Bogner, who later designed skiwear in the USA, pronounced the oath at the opening ceremony. During this, the British team were briefed to make the Olympic salute (arm to the side) rather than the Nazi salute (arm to the front) as they came before Hitler.

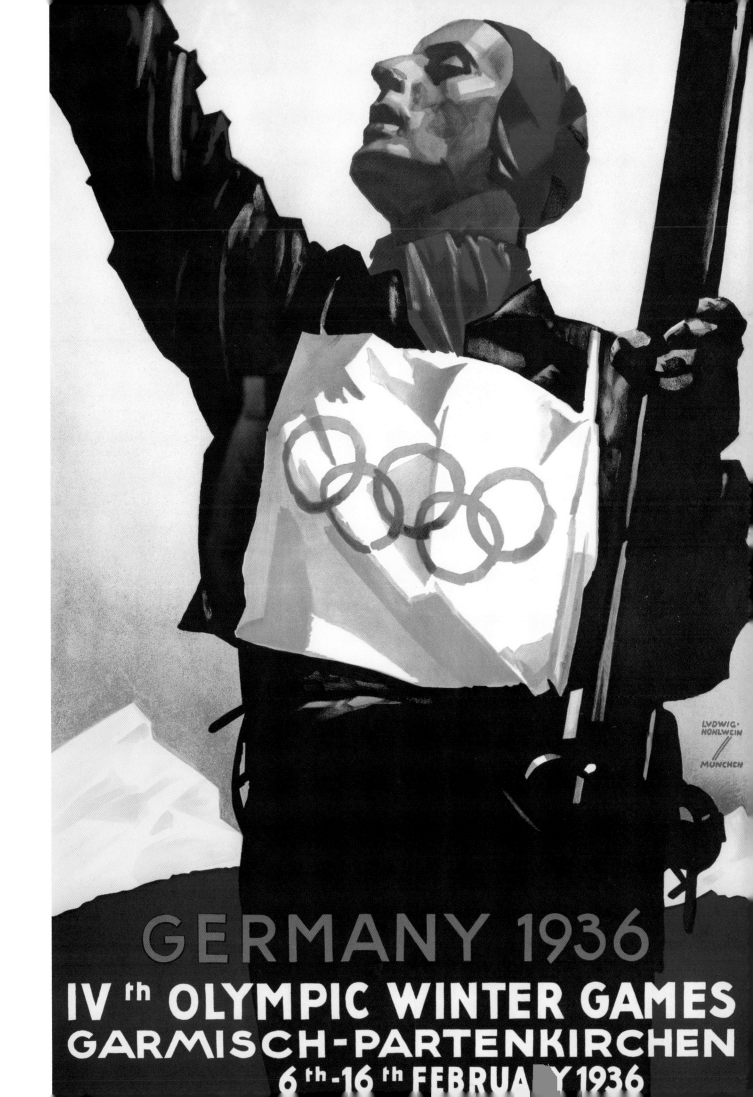

GERMANY 1936
IVth OLYMPIC WINTER GAMES
GARMISCH-PARTENKIRCHEN
6th-16th FEBRUARY 1936

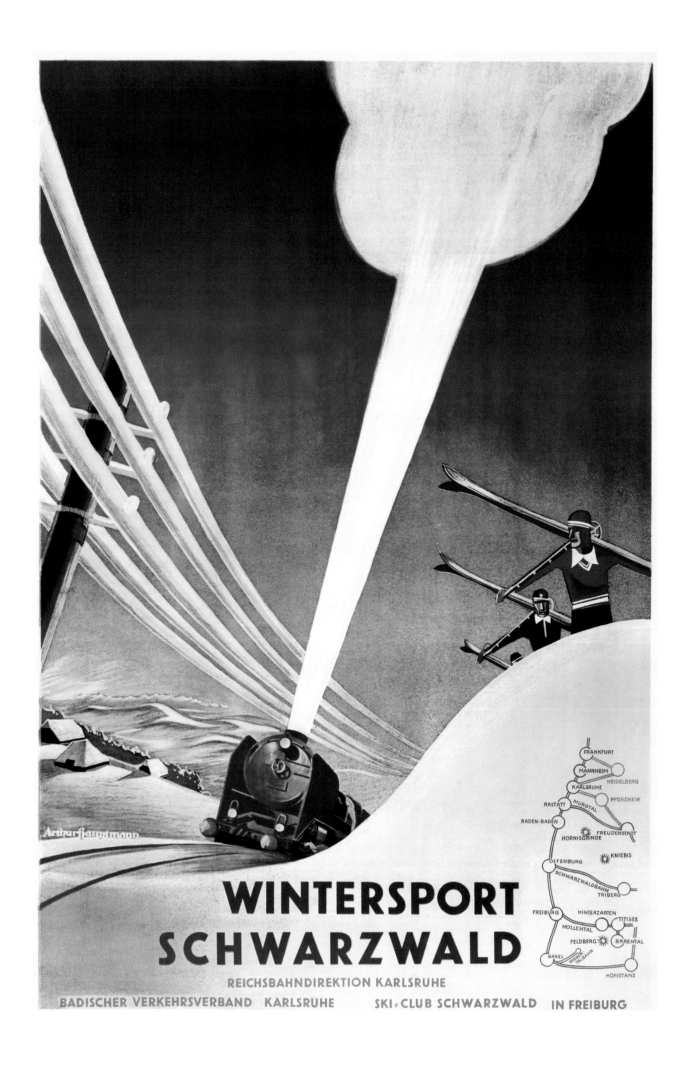

44

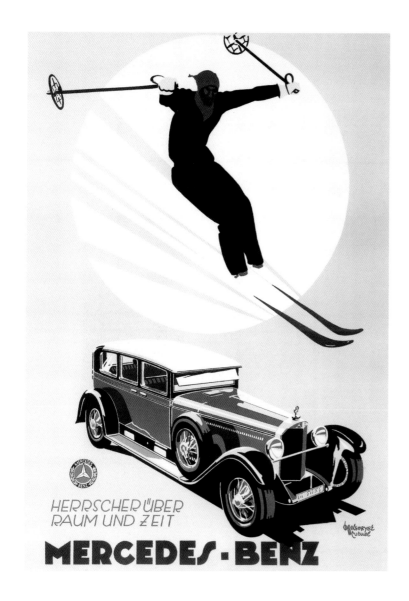

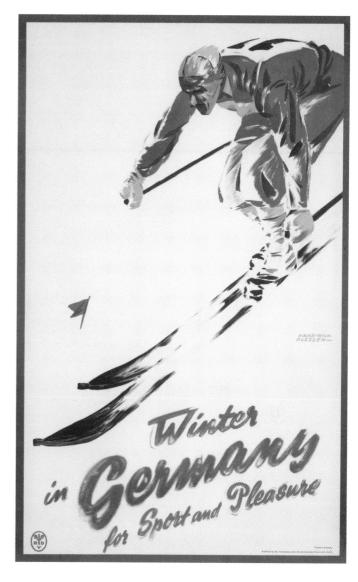

⊖ BLACK FOREST

The Schwarzwald, or Black
Forest, includes some of
Germany's most scenic skiing
country. It was easily reached
from the city of Munich via the
national rail network, which
commissioned this dramatic
poster by Arthur Hauptmann.

⊕ MERCEDES-BENZ

One of Germany's most
important icons, Mercedes,
used skiing to give added
glamor—as if any were
needed—to one of their
vintage models.

WINTER IN GERMANY

Hans-Wilhelm Plessen created
this 1935 image of a racer
in downhill attacking form,
which was used in many
different languages to
promote German tourism.

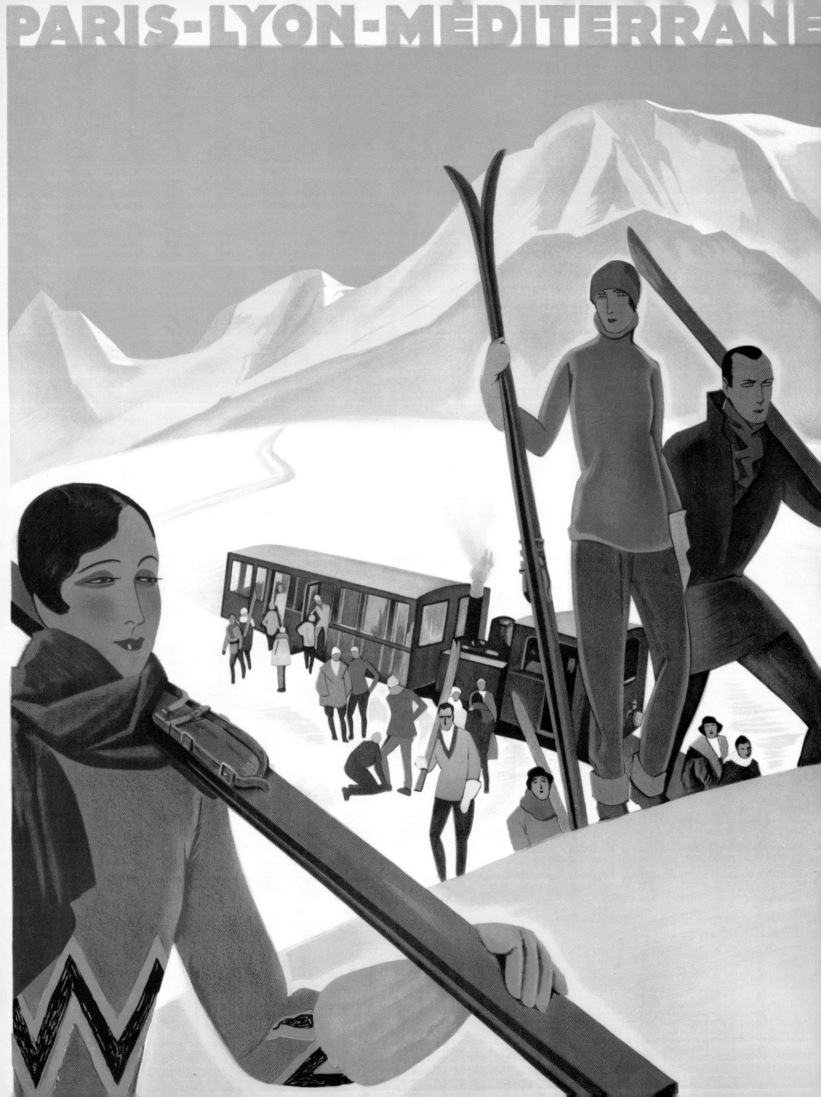

In late nineteenth- and early twentieth-century France, the development of winter sports ran parallel to several major developments in the visual arts. One of these was the growing popularity of poster art. The other, closely allied to the first, was the growing taste for Japanese woodblock printing.

Until the 1850s, Japanese art had been largely unknown in the West, but in 1858 the United States was granted full trading rights with Japan, and that began to change. Porcelain imported into the U.S. and Europe often arrived packed in Japanese prints. Interest in such prints began to grow, and in 1862, a shop on the rue de Rivoli, in Paris, began to sell fine examples. Among its early famous customers were Manet, Tissot, and Whistler. Both Manet and Monet had exceptionally fine collections of Japanese art, but its influence on the Impressionists' own style remained superficial. It was only later—in the work of Post-Impressionists such as Gauguin, Van Gogh, and, above all, Toulouse Lautrec—that this influence began to spread.

The trend for sacrificing naturalism in favor of non-representational color and outline, and for posing figures in silhouette against a neutral background—both characteristics of late nineteenth-century poster art—can be traced back to Western variations on the work of Hokusai, Hiroshige and Utamaro. The strong Eastern graphic influence, together with technical elements of woodblock printing and the development of color lithography, led

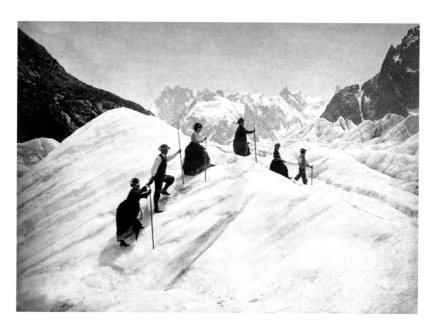

to new experiments and was a determining influence on French poster art. The visual imagery of the late nineteenth century owes much to Toulouse Lautrec's interpretations of Montmartre low life and to Jules Cheret's colorful advertisements for entertainments and products such as Dubonnet and Saxolene lamp oil. The carnival spirit of Cheret's designs lives on in the early French sporting posters, clearly influenced by his style. Cheret was awarded the Légion d'honneur in 1889 for "creating a new branch of art, by applying art to commercial and industrial printing."

Another important development in poster art was the more abstract work of "Cassandre" (Adolphe Jean-Marie Mouron). Born in the Ukraine of French parents, he produced, in the 1920s, unsentimental, ruthlessly graphic designs for railways and shipping lines. The high quality of his work attracted the best form of flattery: imitation. The travel companies were keen to promote their services for vacation as well as business travel to a wider public—services hitherto available only to an elite. Suitable images had to be found to lure an urban population to mountain, seaside, or spa, and Cassandre and his imitators supplied them.

This new style of design, later called Art Deco, after the international decorative arts exhibition held in Paris in 1925, where it was first showcased, dominated style throughout the interwar

Above: Learning to do kick-turns in ski-school at Megève in 1924 looks somewhat unwieldy by today's standards. Notice the length of the skis and the primitive bindings—still at early development stages prior to the 1935 invention of cable bindings.

Left: Roger Broders was one of the finest designers of Art Deco French travel posters, specializing in an exuberant graphic style. Many were for the PLM railway company, including this 1930 image of *Sports d'hiver* attracting people to the Chamonix valley, on the Mont Blanc railway.

Above right: An 1860s photograph shows a typical early tourist outing on the vast glacier, the Mer de Glace, on Mont Blanc. Chamonix grew from a mountaineering center to become the most-visited natural site in Europe.

FRANCE

years. Art Deco illustrations in magazines, books, and posters gave a perfect insight into a world epitomized by the "bright young things" of the 1920s. The inventive elegance of the period bore witness to carefree days, selling a myth of dreams and wish fulfillment that few, in reality, could afford. The work of Roger Broders encapsulates this time. A graduate of the École des Arts Décoratifs, Broders worked as an illustrator, and between 1922 and 1932 he produced memorable graphic images for railway advertising, for PLM (Paris-Lyon-Méditerranée). In these, he depicted the holiday playgrounds of the Riviera and the Alps, then enjoying a heyday before economic and political problems stopped play. His approach was descriptive yet geometrically stylized, making good use of spatial elements and light, whether conveying sunshine or mountain cold.

Mont Blanc, the highest mountain in Europe and part of the frontier between France and Italy, was a natural subject for French poster art. The challenge of conquering its summit had appealed to climbers as early as the seventeenth century. When, in 1901, a railway station opened at the nearby town of Chamonix, it brought a decisive upturn in the town's fortunes. Thousands arrived, attracted by the various newly discovered winter sports.

Skis had first been seen in France at the 1878 Exposition Universelle, where a Grenoblois mountaineer Henri Duhamel, bought them out of curiosity and later used them to explore the slopes around Chamrousse. In Chamonix, a local doctor named Payot first used skis in 1897 to visit his patients in the neighboring countryside. In the winter of 1898–99, an English party, led by travel organizer Henry Lunn, brought with them to Chamonix six pairs of skis and a Swiss guide, to try the new

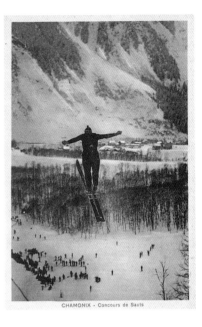

CHAMONIX · Concours de Sauts

sport. Lunn brought his son Arnold, then ten years old, on the trip. Later, looking back on the trip, Arnold Lunn commented, "The few visitors who bothered to ski in Chamonix were regarded as reckless faddists . . . I voted skiing a poor sport. You fell about so." The "poor sport" nonetheless prospered, not least because of his family's part in developing tourism and competitive skiing.

Chamonix expanded with ever-larger hotels and new facilities, including, from 1905, an ice rink, where skating and ice hockey opened the 1906–07 season. The choice of Chamonix for the first Winter Olympic Games in 1924, in which 300 competitors from 16 nations participated, ensured its role as a winter resort. Today it remains one of the 11 "Best of the Alps."

The advent of the railway gave skiers from Lyon, Geneva, Grenoble, and Dijon access to the valleys of Savoie; La Clusaz, Combloux, Morzine, and St. Gervais expanded to receive the new visitors. Other mountainous regions also welcomed skiers—the lower-altitude Vosges, Jura, and Pyrenees.

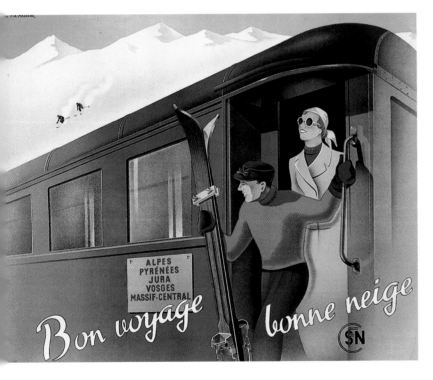

Above: The poster by Pierre Fix-Masseau—"Bon Voyage, bonne Neige"—for an idealized snow train, shows all the mountain ski destinations reached by French Railways: the Alps, Pyrenees, Jura, Vosges, and Massif Central.

Above right: Chamonix was the chosen setting for the first Winter Olympic Games in 1924. A period postcard from Chamonix in the 1920s shows a jumper in full flight, using the Olympic jump.

Skiing became fashionable.

In 1916, during World War I, Baroness Maurice de Rothschild, seeking mountain rest on medical orders, went off to St. Moritz, in neutral Switzerland. The possible presence of German visitors inflamed her patriotic spirit. Returning to Paris, she resolved to establish a French Alpine resort to rival St. Moritz. With the help of her ski instructor, she chose the little Savoie village of Megève and proceeded to transform it into a luxurious retreat for the rich. In 1921 she opened the Hotel Mont d'Arbois. Soon Megève was France's most fashionable ski resort, offering not only rustic charm and pretty scenery but also sophisticated restaurants and nightlife. In subsequent years it welcomed a clientele from stage and screen, including Rita Hayworth (and her husband, the Aga Khan), Roger Vadim, Brigitte Bardot, and Jean-Paul Belmondo. Today there are still fur coats and poodles at Megève; the traditional cachet and fairytale scenic magic live on.

The fashion for a suntan, an innovation of the 1920s, was observed here, too—although it did not need to be acquired on the pistes; reclining on a deck chair in the mountain sun was perfectly acceptable. Nevertheless, a taste for active sport was growing steadily, and skiing, in particular, was winning new enthusiasts. A poetic description of the sensation of skiing was penned in the 1920s by the French writer Colette: "Then onto our feet we strapped once more our wings, and set forth upon our flight down the valleys."

In 1933, the Fédération Française de Ski, the French ski school, was founded. Emile Allais, from Megève, became France's champion skier and played a major part in spreading French techniques, replacing the Austrian Arlberg style. The international success of the charismatic racer Jean-Claude Killy in the 1960s reinforced this supremacy. From the late 1940s to the present day, newly adapted and purpose-built resorts and efficient uphill transportation and safety procedures have altered the Alpine map of France, providing excellent facilities for all ages alongside the essential pleasures to complete a French holiday—superb food and wines.

Above: This poster from 1930 by Jean Raoul Naurac, showing a ski-jumper wearing baggy trousers catching the wind, was an image used with differing typography for several different resorts and competitions. This version was before the lettering was introduced.

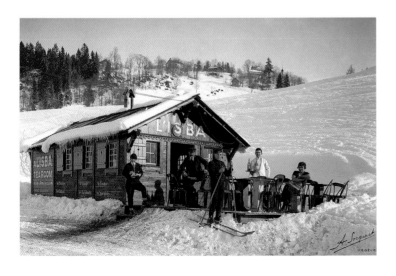

Left: Megève in 1928, arriving on skis at the Isba "buvette"—a small snack bar that was a welcome pit-stop during a day's skiing.

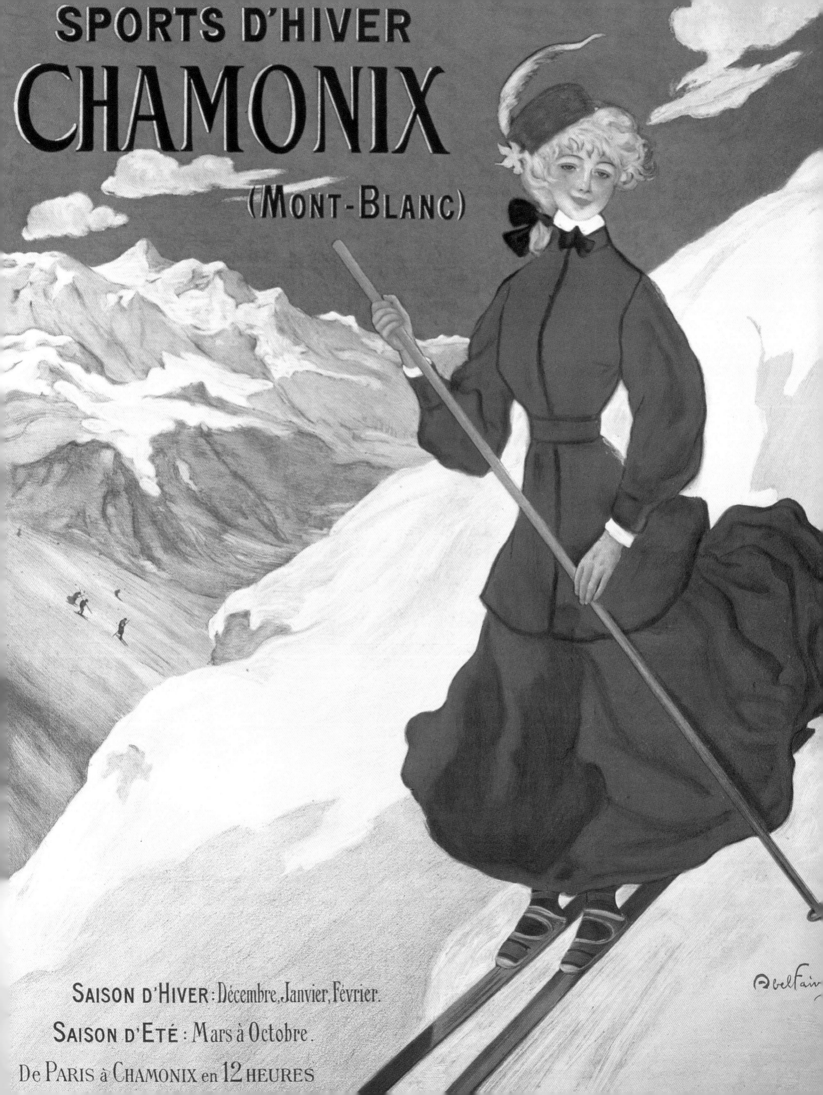

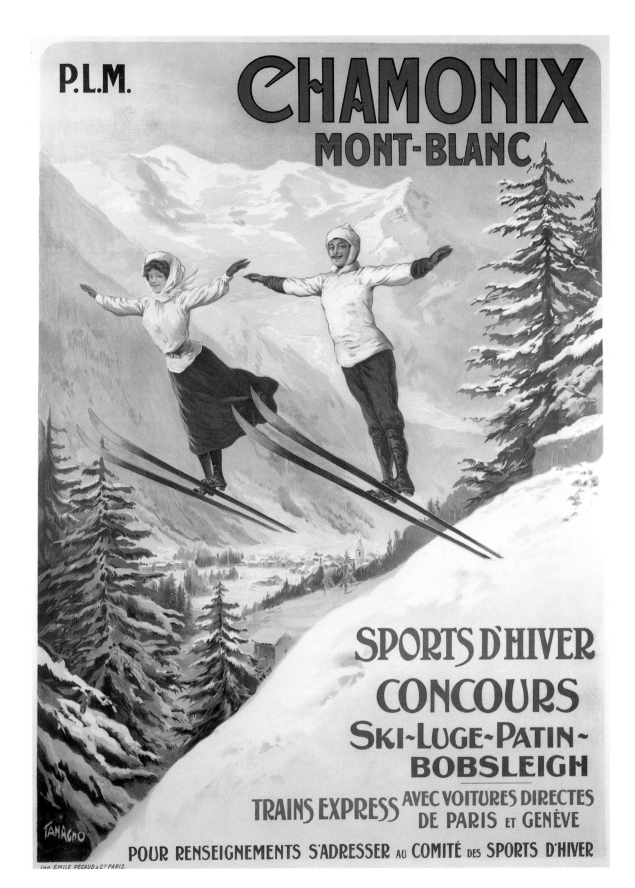

⬅ CHAMONIX

Abel Faivre's 1905 design is a popular reproduction today, used for promotional publicity. An original poster would cost five figures in dollars, sterling, or euros. Note the journey times of 12 hours from Paris, four from Geneva.

➡ FLIGHTS OF FANCY

Francisco Tamagno's improbably romanticized concept shows ski-jumpers jumping in an unlikely fashion. White jerseys, often hooded, were highly fashionable in the early 1900s, when this poster for PLM was published.

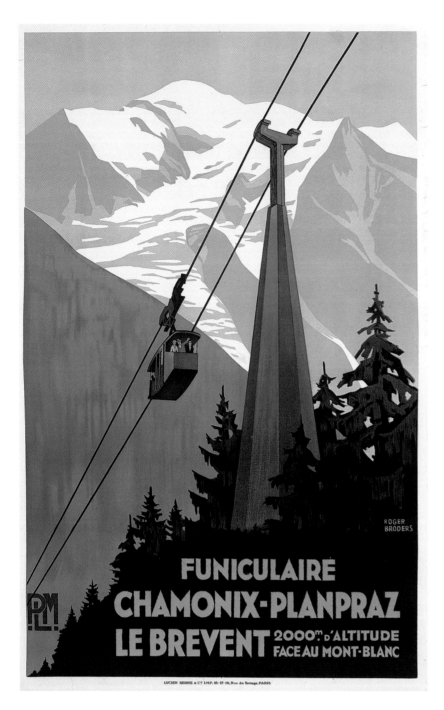

⬅ LE BREVENT CABLE CAR

Roger Broders used dramatic diagonal lines to convey the uphill movement of the cable car to Le Brévent, installed in 1930. It faces the Alps' highest summit, Mont Blanc, which looms majestically in the background.

➡ MONT BLANC

The Mont Blanc Railway over the Col de Voza gives spectacular views of Mont Blanc—at 15,772 feet (4,807 metres), Europe's highest peak. The stark, geometrically graphic style of Georges Dorival's 1928 poster is reminiscent of Cassandre's linear style.

➡ MONT BLANC TRAMWAY

The Mont Blanc Tramway runs in winter from St. Gervais to Bellevue, giving access to the skiing area of Les Houches in the Chamonix valley. In summer, it continues to the Nid d'Aigle (Eagle's Nest), giving superb views over the Bionnassay glacier.

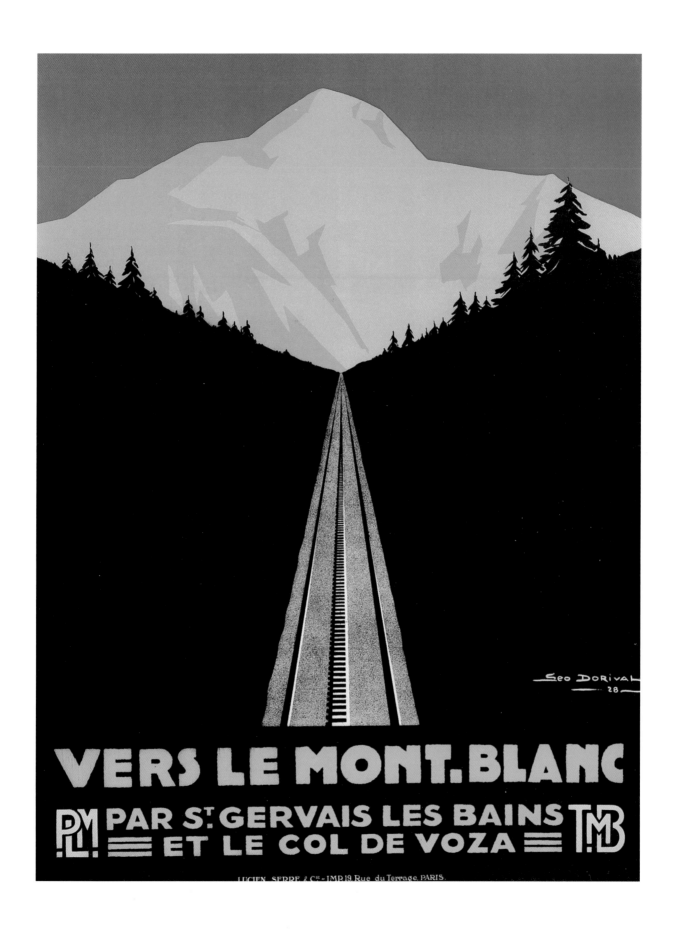

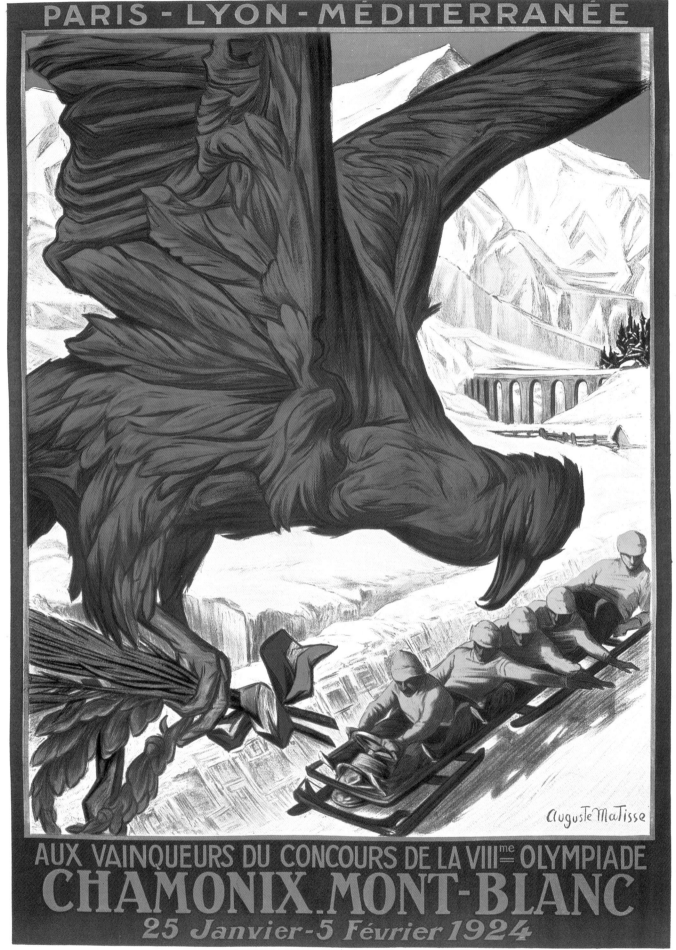

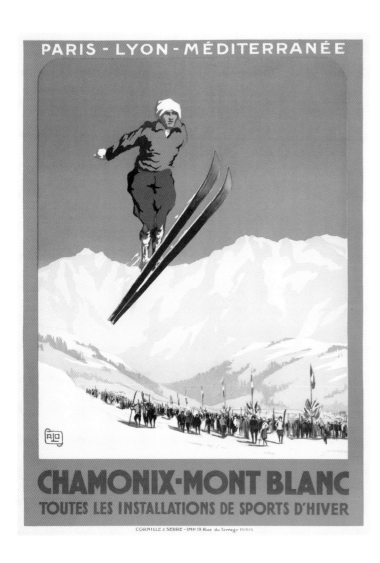

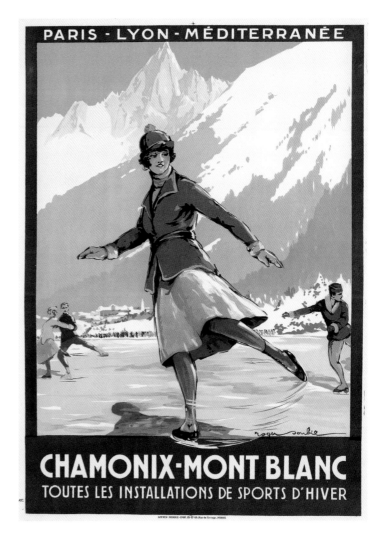

⬋ 1924 Winter Olympics

The first-ever Winter Olympic Games were held in Chamonix in 1924. The PLM Railway advertised the event in a series of posters showing the various Olympic sports by different artists. Auguste Matisse depicted the bob-sled.

⬆ Ski-jumping

One of the PLM Olympic posters shows ski-jumping– hugely popular with spectators. The Norwegians won 11 of the 12 medals for skiing. In the special jumping, Anders Haugen, a Norwegian émigré to the USA, jumped further but lost marks for style. Fifty years later it was found that his score had been incorrectly calculated, and he was awarded a bronze medal, aged 86.

Ice-Skating

Another of the PLM Olympic posters with altered wording, advertising all the best facilities for winter sports, no doubt especially improved for the Olympics. An ice rink was first built in Chamonix in 1905.

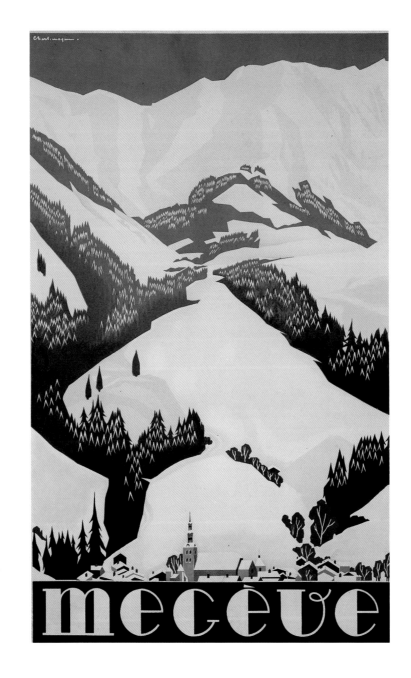

← MEGÈVE

This view of Megève by Charlemagne is too distant to show the medieval center's carefully preserved architecture and picturesque church, outside which horse-drawn painted sleighs await passengers. The rustic chic resort nestles amid panoramic surroundings.

↓ CITROEN

A specially adapted caterpillar Citroen on supersize skis makes a test drive in the snows of the Mont d'Arbois side of Megève in 1928. Baroness Rothschild opened a hotel there in 1921.

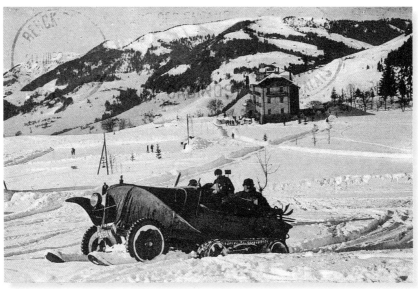

St Gervais-les-Bains

Thermal waters are indicated by the wording "les Bains." St. Gervais capitalized on its healing waters as yesteryear's large hotels bear witness. The newly nationalized railway SNCF owned a cable car linking St. Gervais to Mont d'Arbois, above Megève, depicted in this 1930s poster by Roger Broders.

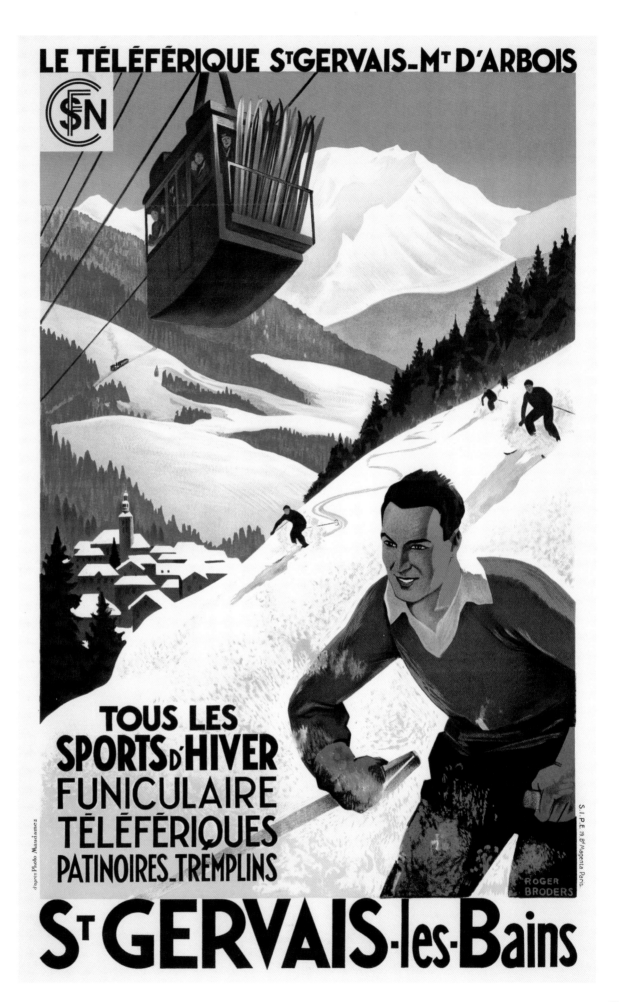

CHEMINS DE FER DE L'EST

LES VOSGES

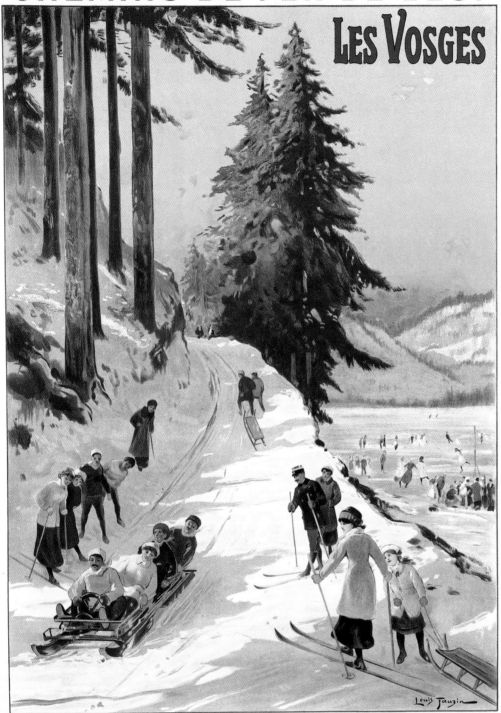

IMP F CHAMPENOIS - PARIS

Louis Tauzin

⬅ LES VOSGES
The PLM railway company was not alone in commissioning artists to attract visitors to their region. The Chemins de Fer de l'Est—the Eastern Railway—was advertising mountain holidays in the Vosges as early as 1913, in this busy scene by Louis Tauzin.

➡ SPECTATOR SPORT
Around 1930, the railway for Alsace-Lorraine (bordering Germany) commissioned Roger Broders to design a poster showing the winter fun to be had once the snows came—even if the slopes here are lower than the Alps.

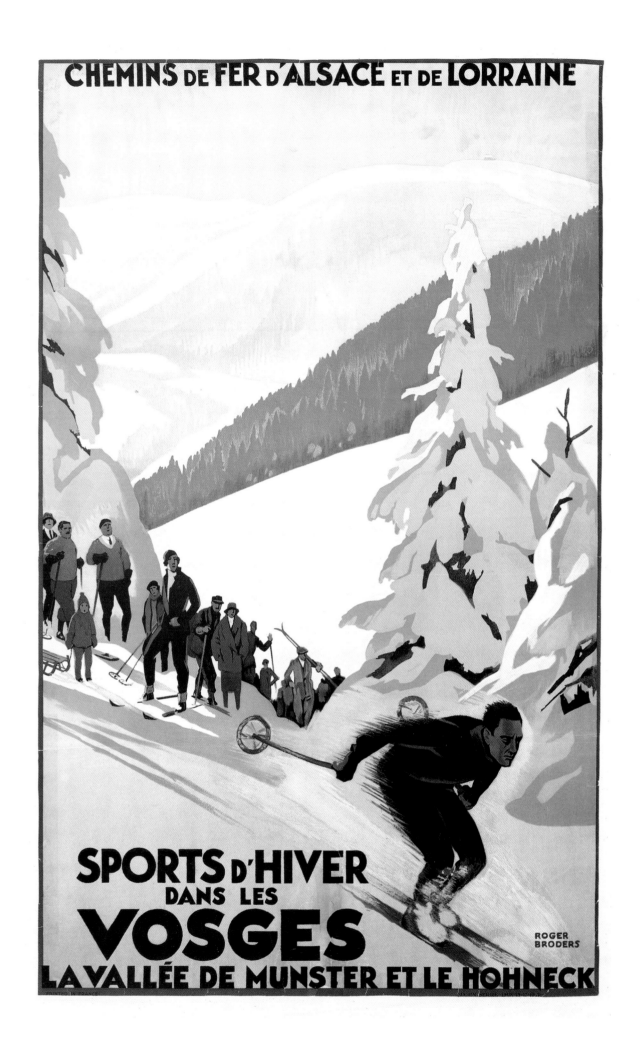

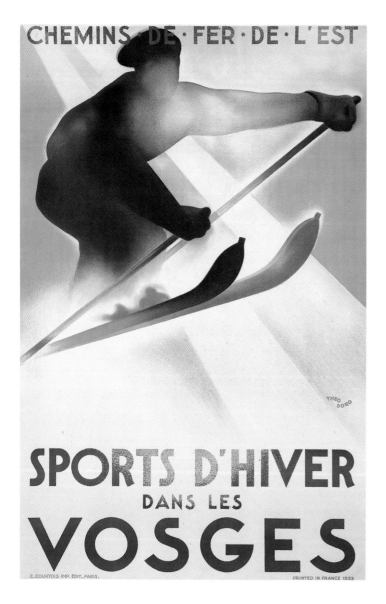

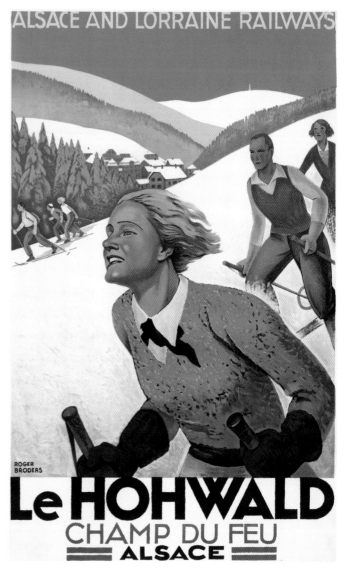

ACTION SHOT
Almost photographic in its immediacy, this 1933 Eastern Railway poster by Theo Doro gives us close-up drama, heightened by the restricted use of color to monochrome.

ALSACE
Le Hohwald is a ski station in Alsace Lorraine, surrounded by mountains and forests. It is good for cross-country skiing, as shown in this 1930s poster by Roger Broders. The model for the foreground figure was his wife.

⊕ JURA
Eric de Coulon's strong graphic design using dramatic purple shadows, from 1935, promotes the pleasures of open-air exercise to be found in the mountainous Alps and Jura regions of France.

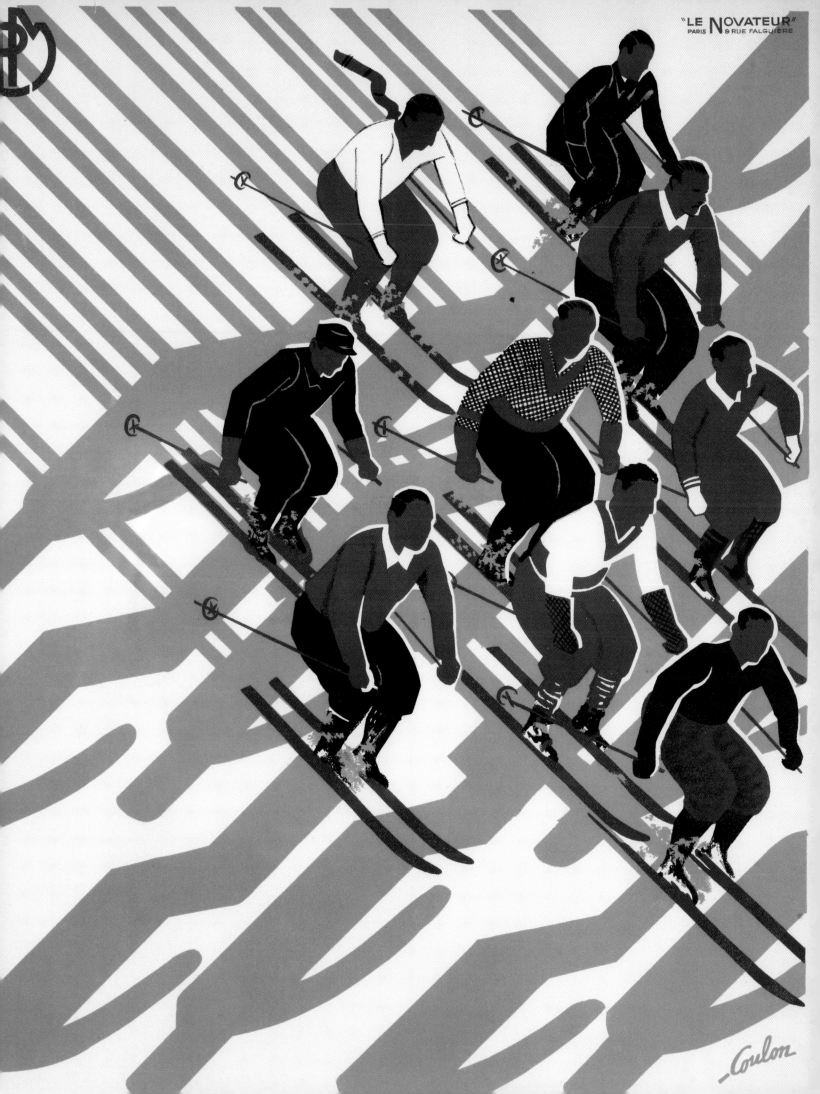

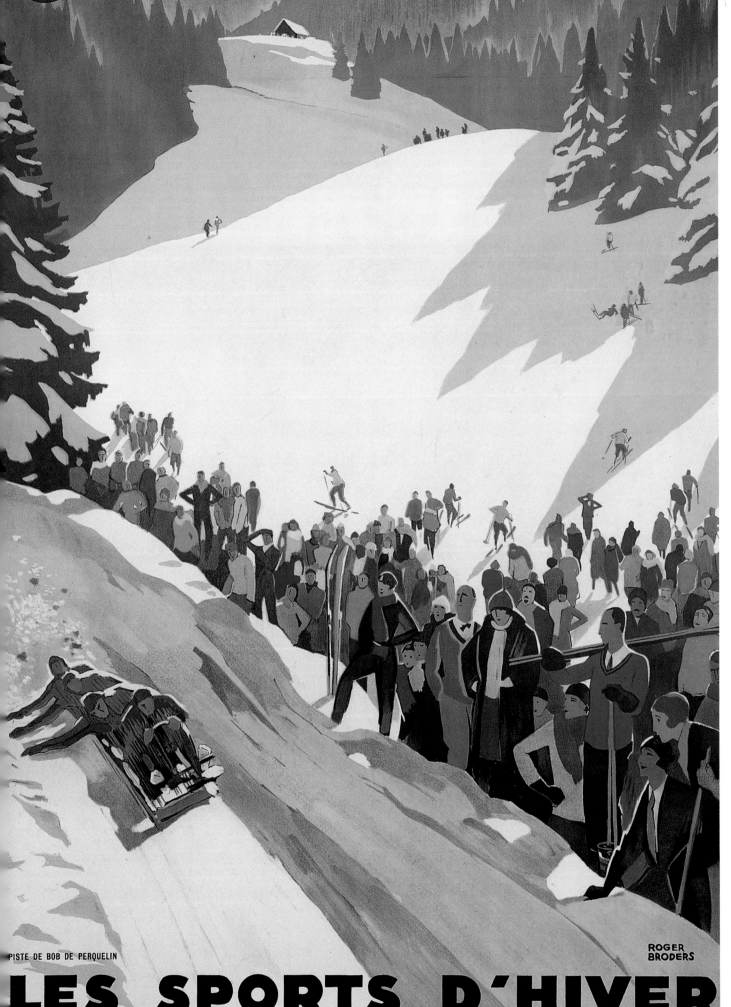

PISTE DE BOB DE PERQUELIN

ROGER BRODERS

LES SPORTS D'HIVER
St PIERRE DE CHARTREUSE

← St Pierre de Chartreuse

Roger Broders used simplified graphic lines and strong colors to convey lively atmospheric scenes, as in this 1930 poster of crowds watching the four-man bobsled at St. Pierre de Chartreuse, near Grenoble.

↓ Val d'Isère

"Val" only really took off in the 1960s, thanks to the associations with Jean-Claude Killy—one of skiing's superstars. The terrain is *formidable*, to be translated in English or French, depending on your level of skiing, as both are true.

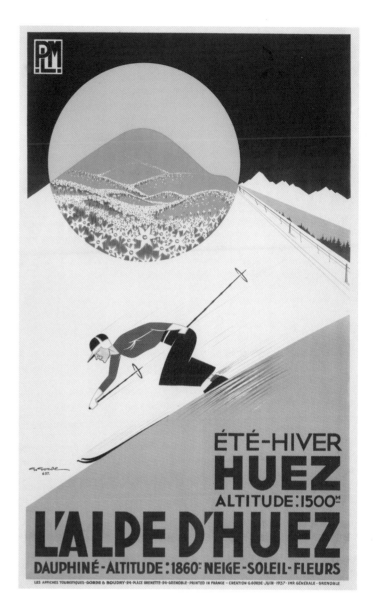

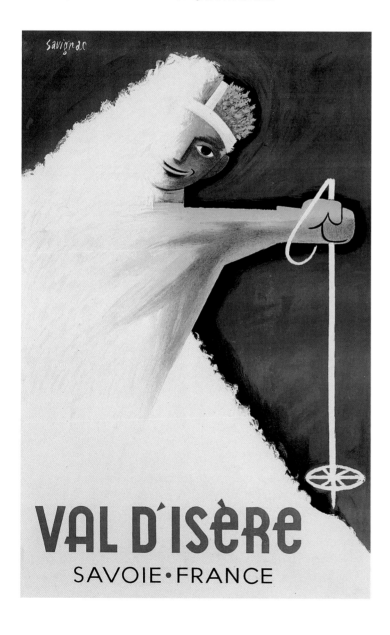

Alpe d'Huez

Gaston Gorde's 1937 design employed a clever decorative device so the poster could be used in summer as well as winter, advertising snow, sun, and flowers. In 1936, Jean Pomagalski invented the drag-lift here and put his name to it—the Poma.

As skiers today reach almost superhuman speeds, it is surprising to realize that Italy's first ski club was founded only a little over a hundred years ago, in Turin in 1901. Skis had arrived in Italy around 1896, as ski-mountaineering was introduced by a Swiss engineer and chemist living in Turin—Adolfo Kind had purchased two pairs of Norwegian skis with wicker attachments and a six-foot pole. The first skiing courses were held in the winter of 1901 under the guidance of Scandinavian instructors, and gradually better equipment appeared.

Although Italy has produced fine—and fast—racers, such as Zeno Colo in the 1950s, skiing is a very sociable sport in a country known for *la dolce vita*. The appealing Italian poster designs all convey this attitude.

Regional differences remain strong in Italy (which was unified only in the mid-nineteenth century) and foster a competitive spirit. From the early days of skiing, local tourist boards exploited this in their promotional advertising. Aosta, Piedmont, the Dolomites, Tirolo's two provinces of Trentino and Alto Adige were the main skiing areas. One of the key historic routes into Switzerland, over the Great St. Bernard Pass, has now been superseded by a tunnel beneath it; more recently, a tunnel beneath Mont Blanc provides easy access to France. The accessibility of the Aosta Valley and its proximity to Turin and Milan has encouraged the development of many small resorts in this area, for cross-country as well as downhill skiing. Monte Bianco (Mont Blanc), Monte Rosa, and Gran Paradiso form majestic backdrops to the region.

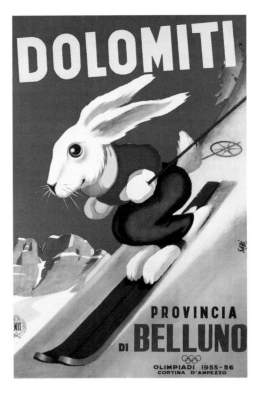

Perhaps the most charming of the Aosta Valley resorts is Courmayeur, an old traditional mountaineering village. It is still relatively unspoiled, retaining old buildings and a period feel. Another Aosta resort, Breuil-Cervinia, boasts Italy's most reliable snow. It was developed in the 1930s and lies directly across the mountains from the Swiss resort of Zermatt, sharing the Matterhorn and offering a reverse view of this classic emblem of the Alps. In the nineteenth century, the village of Breuil was the base camp for climbing attempts on the Italian side of the Matterhorn. Today, with more sophisticated ski lifts, the mountain has lost some of its fearsomeness. Zermatt skiers can now cross the frontier for lunch and a high-speed "motorway" descent to an Italian meal in the sunshine, or share the high glacier runs with Italians crossing over in the reverse direction.

Italy's most famous ski resort, Cortina d'Ampezzo, lies farther east, in the Dolomites. Situated in the Ampezzo Valley, Cortina is outstandingly beautiful. Its fame began early in the twentieth century, with a ski club founded in 1903. Centered around a bell tower, its buildings convey an air of historic grandeur, appropriate to the roll call of famous names who have stayed here. The Hotel Cristallo was the closest to St. Moritz's Palace Hotel, with a similar clientele of industrial magnates and international aristocracy.

In 1935, the vertiginous Faloria cable car, linking Cortina with the Faloria pistes, was built—a triumphant feat of engineering. Extensively developed for the 1956 Olympics, Cortina was then

Above: The White Rabbit from *Alice in Wonderland* was always late: this cheeky racing rabbit has skis to get there faster. The Dolomites' majestic rose-red rocks rise behind, beautiful in their cragginess.

Below: An early equivalent of a motorized people-carrier, with caterpillar tracks, has reached the area of the high Falzarego pass, near Cortina, to give the lone skier the thrill of carving unique tracks on untouched snow.

Right: Speed itself is the focus of the abstracted movement in this poster designed by Franz Lenhart for the German market (it was also published in French). Cortina is one of the 11 Best of the Alps resorts today.

ITALY

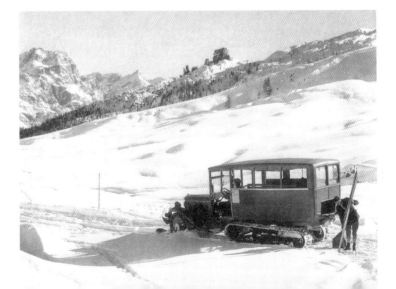

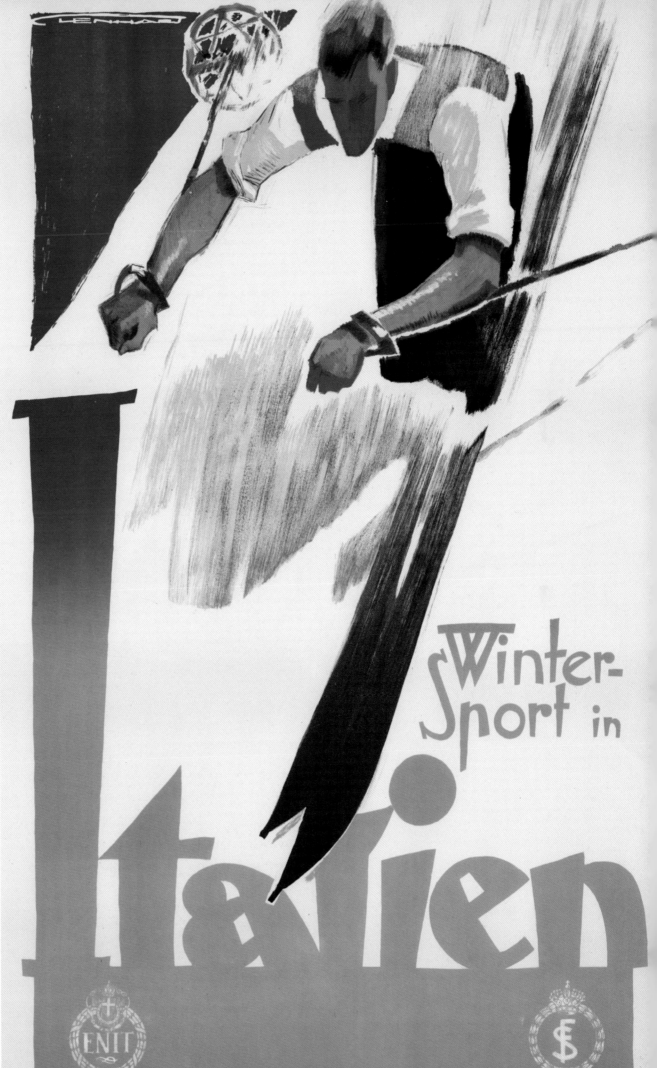

ahead of its time with facilities. These are now somewhat fragmented, although the resort still hosts events on the World Cup circuit, including the Women's Downhill.

Breathtaking views of the pink-tinged vertical rock faces of Monte Cristallo are everywhere. These attractions, plus the additional lure of the region's sumptuous gastronomy, stylish shops, and allusions to the town's colorful history, continue to attract as many as 70,000 visitors *a day* in high season. Skiing seems only part of the experience; inhaling the pure mountain air, people-watching, and reveling in the luxurious atmosphere figure highly on the agenda, evidenced by the number of fur coats—more to be seen than in any other resort except perhaps St. Moritz.

Returning to where it all began, Piedmont is where eyes were focused in 2006, the year of the Turin Winter Olympics. The resort village of Sestriere at 6,670 feet (2,033 metres), was developed from 1935. It was initially created by one of Italy's leading industrialists, the legendary Giovanni Agnelli—of Fiat fame—and his son Edoardo. It set the pattern for future resort development: the rich stayed in expensive suites at the Principi di Piemonte or Duchi d'Aosta hotels, while its proximity to Turin brought middle and working classes to enjoy the modern facilities. Today, Sestriere links in with a ski circuit known as the Milky Way, offering some

248 miles (400 kilometres) of slopes, joining runs from Sauze d'Oulx and Montgenèvre in neighboring France. The altitude, ensuring good snow, made it the perfect center for many of the 2006 Olympic events.

For advertising the Olympics, electronic media have largely supplanted the poster. Back in the nineteenth century, Italian poster art was dominated by the Milan publishing firm of Ricordi. Founded in 1808, Ricordi made use of the latest printing presses and techniques of lithography, brought from Germany, as well as methods of photoengraving learned in Paris. Well known as music publishers, they produced posters to advertise opera performances, using designs as dramatic as the productions they represented. Pictorial posters made an impression on a public used only to letterpress, conveying, in the words of one critic, "an unexpected artistic gaiety."

An Italian artistic trend that lent itself well to depictions of sport was Futurism. The Futurist movement began in 1909 with Filippo Tommaso Marinetti's article praising the automobile. The subsequent Manifesto of Futurist Painting and Technical Manifesto, in 1910, aimed to show machines or figures actually in motion. Signatories to the manifestos were Umberto Boccioni, Carlo Carrà, Luigi Russolo, Giacomo Balla, and Gino Severini. The Futurist Exhibition in 1912 in Paris caused a furore, which continued in Berlin, London, and across the rest of Europe. As an aesthetic force, Futurism was cut short by World War I, but the graphic influence lived on long afterward. While Futurism strove to capture movement, the effect of speed was also well suited to the style. These graphic influences, along with the sheer fun of winter sports, are clearly visible in the following posters.

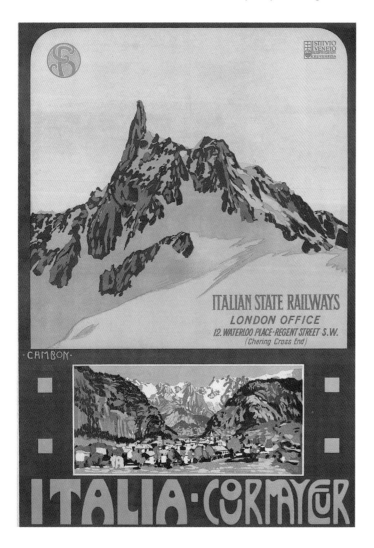

Above: A single-poled skier looks faintly unsteady near Cortina, whose church tower is visible in the background. Note the protective leggings.

Left: This Italian State Railways poster is one of the oldest Italian posters, dating from approximately 1906. It shows both winter and summer scenes in Courmayeur by Cambon. The most attractive of the Aosta resorts, it has stunning views of the Mont Blanc massif.

Right: ENIT (Ente Nazionale per il Turismo) and the state railways, FS (Ferrovie dello Stato) commissioned travel posters in the 1930s with wording in different languages. This French version, designed by Michahelles in 1935, attracts attention for some curious fashion details.

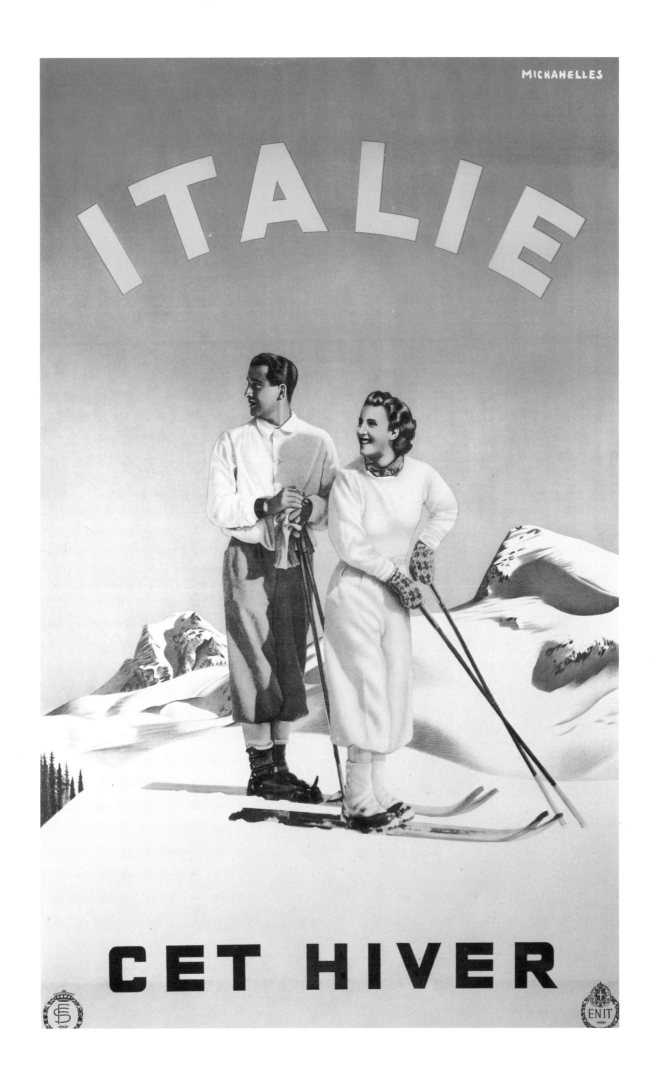

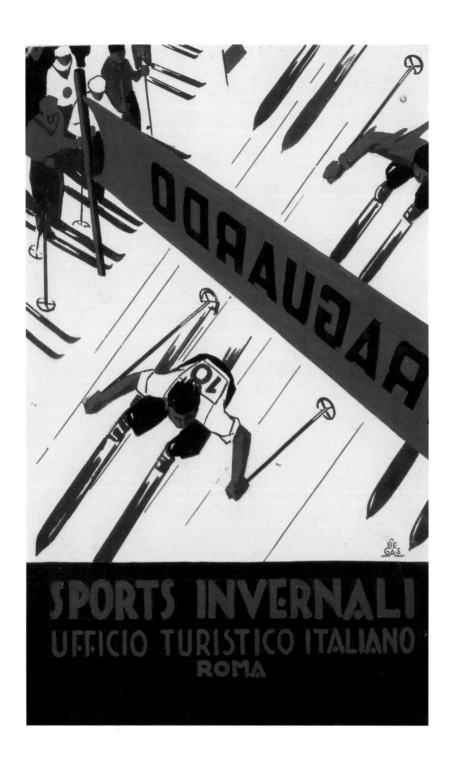

SPORTS INVERNALI
UFFICIO TURISTICO ITALIANO
ROMA

← WINTER SPORTS

A clever bird's-eye view of the finish of a race was used to generally advertise winter sports in a poster for the Italian Tourist Office in Rome.

→ CORTINA

Although a center for international competitive skiing on the world circuit, Cortina was also a busy hub of social life for Italians and foreigners, including royalty. Franz Lenhart skilfully captured the fragmented effects of light experienced at speed.

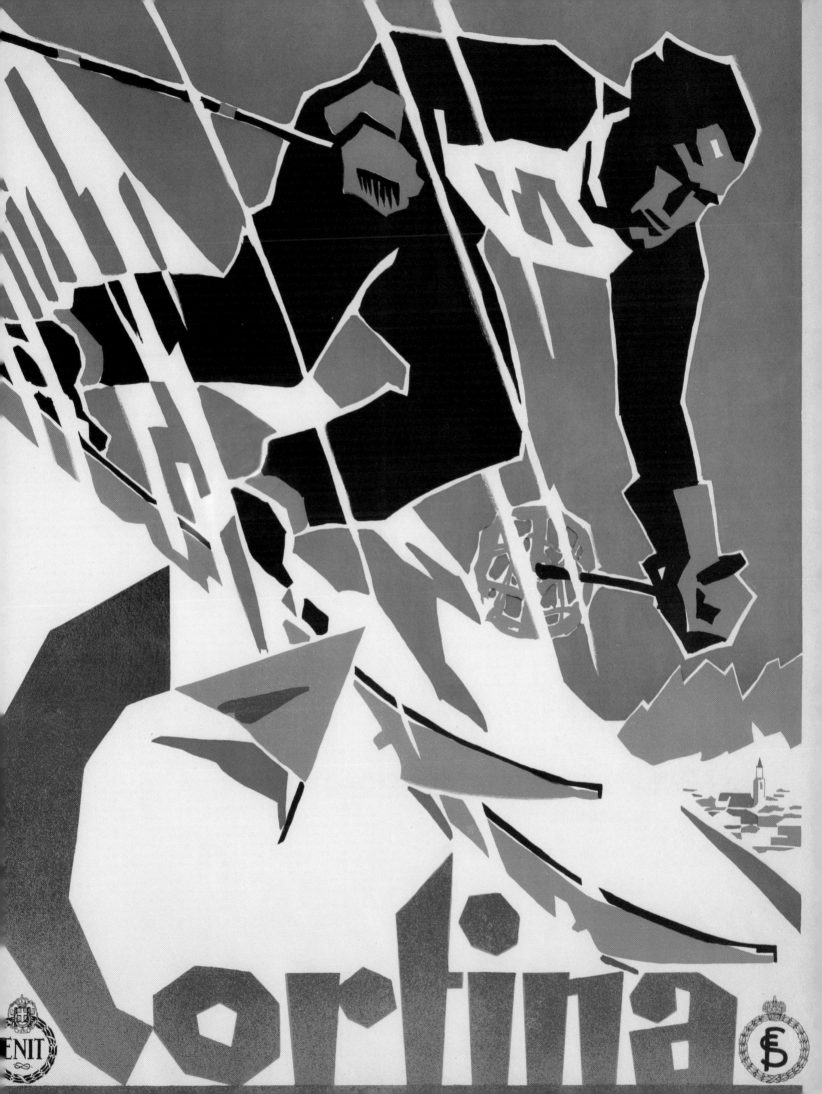

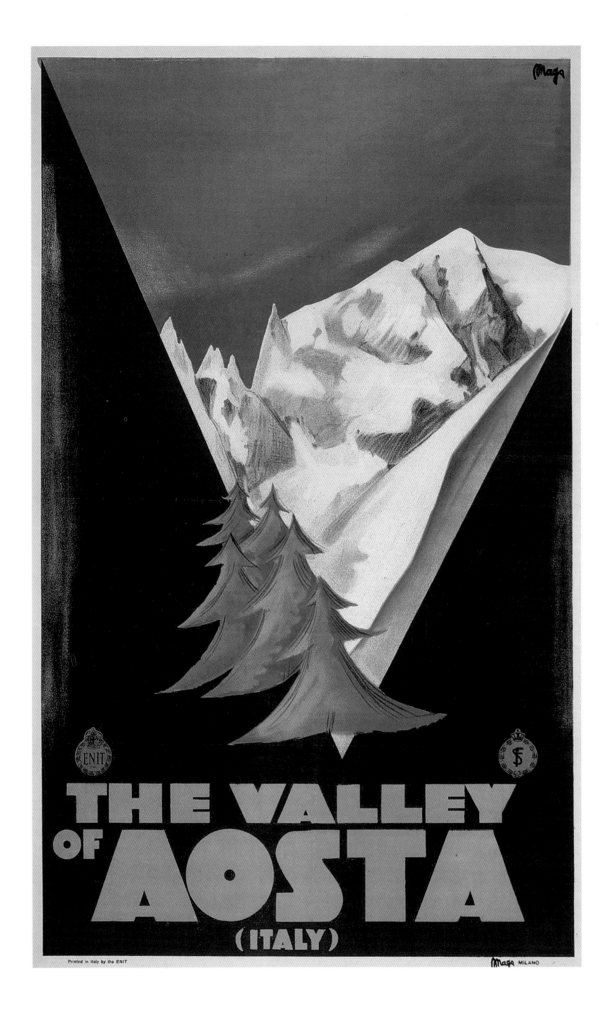

VAL D'AOSTA

Within reasonable reach of Turin, the Aosta valley is the main route from Italy through to Switzerland. Branching off this are many resorts, with varied levels of skiing, in areas of outstanding natural beauty—as shown by this Maga poster.

CONCA DI PILA

The novelty value of these seemingly smiling "bubbles" in 1954 obviously delighted the Italians, whose sense of color and design is second to none. Conca di Pila lies just above the town of Aosta.

CONCA DI PILA – mt.1814
VALLE D'AOSTA

DA AOSTA A PILA IN TELECABINA • DA PILA A CHAMOLÉ IN SEGGIOVIA E SKILIFTS

ESENTE DA BOLLO (art. 19 all. B
del D. P. R. 24/6/54 N. 342)

ASSESSORATO REGIONALE PER IL TURISMO

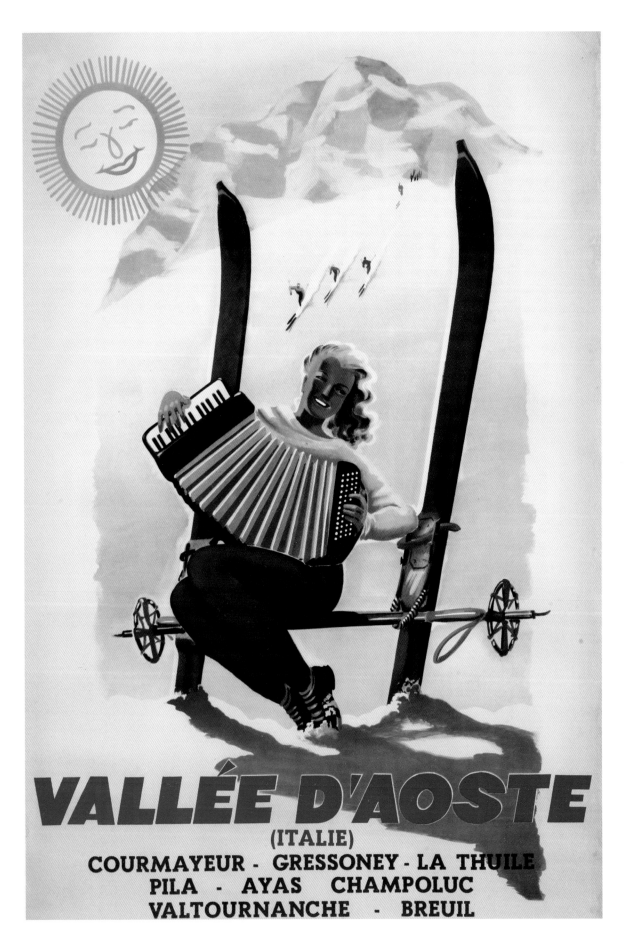

VALLÉE D'AOSTE

(ITALIE)

COURMAYEUR - GRESSONEY - LA THUILE
PILA - AYAS CHAMPOLUC
VALTOURNANCHE - BREUIL

AOSTA RESORTS
A French poster for the Aosta valley, listing the popular resorts of the time. Sunshine plays an important part in any skiing holiday, as does music and song.

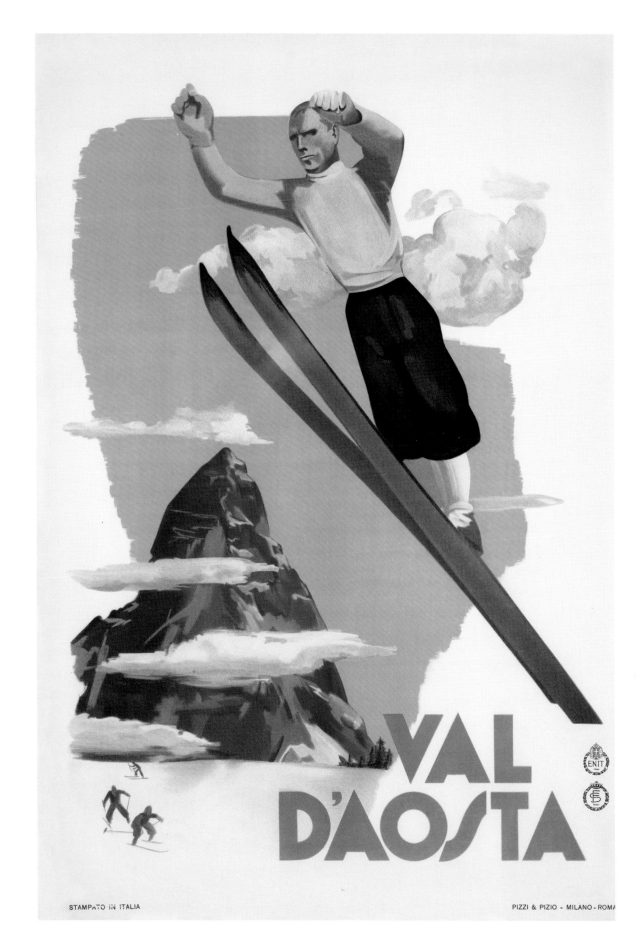

MONTE CERVINO

The Matterhorn or Monte Cervino, seen from the Italian side forms the backdrop for this dramatic ski-jumping poster, which bears ENIT and FS emblems. Today you also can ski downhill, cross-country, carve, tour, snowboard, or heliski.

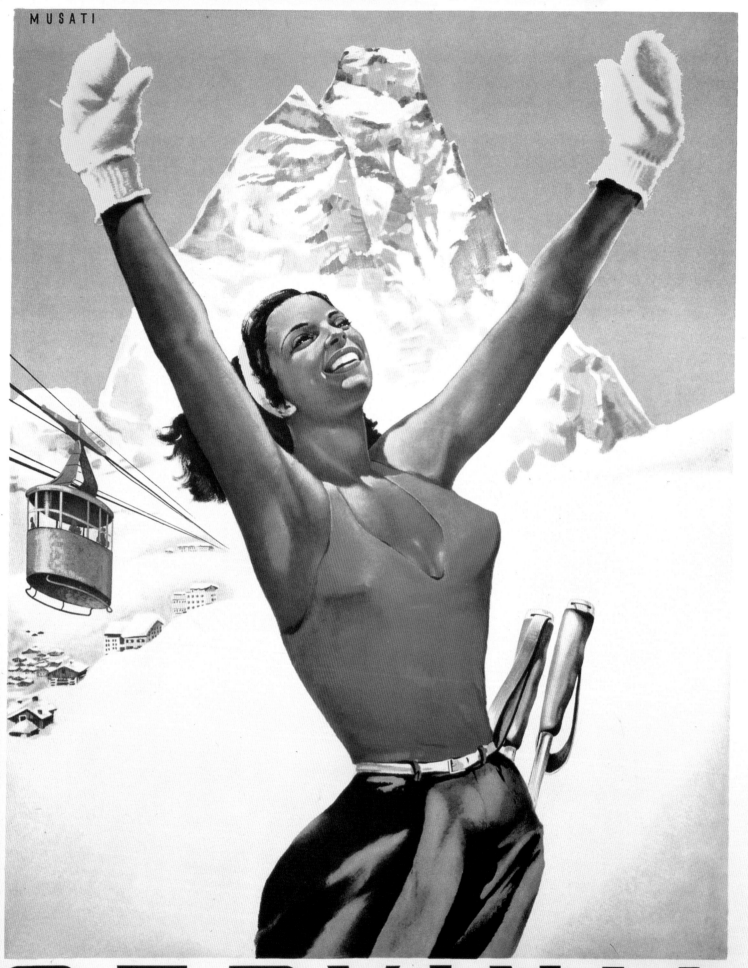

CERVINIA

Cervinia lies off the main Aosta valley in Valtournenche, bordering Switzerland. The Matterhorn's extraordinary natural pyramid shape dominates all views. Musati's poster from 1953 has one clear message–sun and fun.

O SOLE MIO

Musati was commissioned by Aosta's regional tourist board to celebrate the joys of blue skies and sunshine that could be enjoyed at the various valley resorts. The model and colors used are not dissimilar to his Cervinia poster.

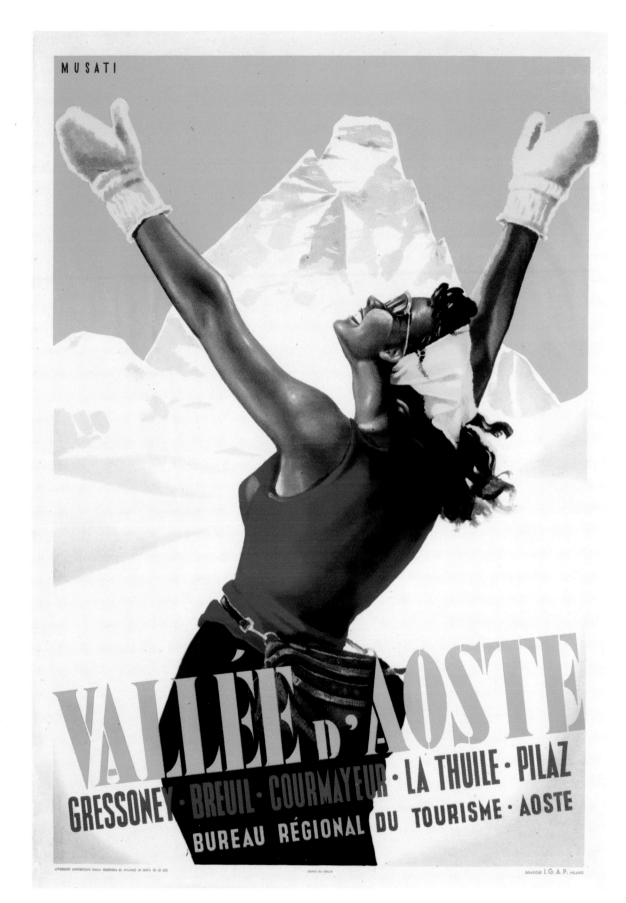

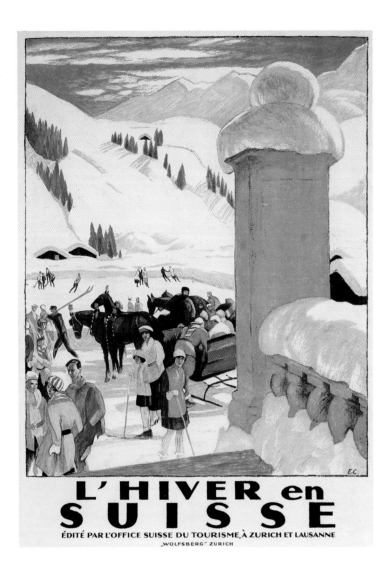

L'HIVER en SUISSE

ÉDITÉ PAR L'OFFICE SUISSE DU TOURISME, À ZURICH ET LAUSANNE
"WOLFSBERG" ZURICH

Above: Emil Cardinaux was the finest of the Swiss early poster designers. This rare image, created in 1921 for the Swiss Tourist Office, fetched nearly £11,000 at Christie's London auction in 2006. Skiing, skating, and sleigh rides are all featured.

Right: A detail of a poster for the Montreux-Oberland railway from 1934, by Edouard Elzingre. The poster was also overprinted below to promote transport to Gstaad. The Bernese Oberland resorts traded on traditional mountain charm.

On his first Alpine tour, in 1878, Mark Twain commented that "many . . . regions which were unvisited and unknown remoteness a hundred years ago, are in our days a buzzing hive of restless strangers." The buzzing has never ceased in Switzerland since the coming of the railways made the mountains accessible in winter as well as summer.

In the Valais canton, the railway came to the Rhone Valley in 1860, to Brig in 1878, and to Zermatt in 1891. Also in Zermatt, in 1898, the famous Gornergrat rack and pinion railway opened. The Simplon Tunnel was opened in 1906, the Martigny-Chamonix link established in the same year, the Crans-Montana funicular in 1911. All these developments brought tourists to appreciate the natural beauty of mountain scenery and the beneficial effects of thermal waters. The British travel writer Charles Domville-Fife acknowledged in 1926, in a book on winter travels in Switzerland, that "the history of the alpine winter resorts is the story of the mountain railway and Swiss enterprise—roused to activity by the Englishman's craze for exciting sport."

The first posters advertising Swiss tourism, by artists such as Anton Reckziegel and Emil Cardinaux, show an uncrowded alpine world, with several images of summer and winter, often with descriptive text including railway timetables. Gradually the poster emerged as more a graphic entity in its own right, with a single image. Cardinaux's image of the Matterhorn (Mont Cervin in French) against a rosy pink sky remains a timeless icon. That special romantic moment in the Alps, alpenglow, as the sun sets or rises is hard enough to photograph, but to recreate it with only four colors in lithography is indeed artistry.

The golden age of poster design in Switzerland, between 1920 and 1940, ran parallel to the ups and downs of tourism, reflecting war elsewhere in Europe and the world economic fluctuations following the Wall Street Crash of 1929. Nevertheless, the stylized, rarely abstract, designs of Carl Moos, Erich Hermès, Walter Herdeg, Martin Peikert, Hugo Laubi, Alois Carigiet, and Alex Diggelmann— inspired by contemporary art movements—captured action,

SWITZERLAND

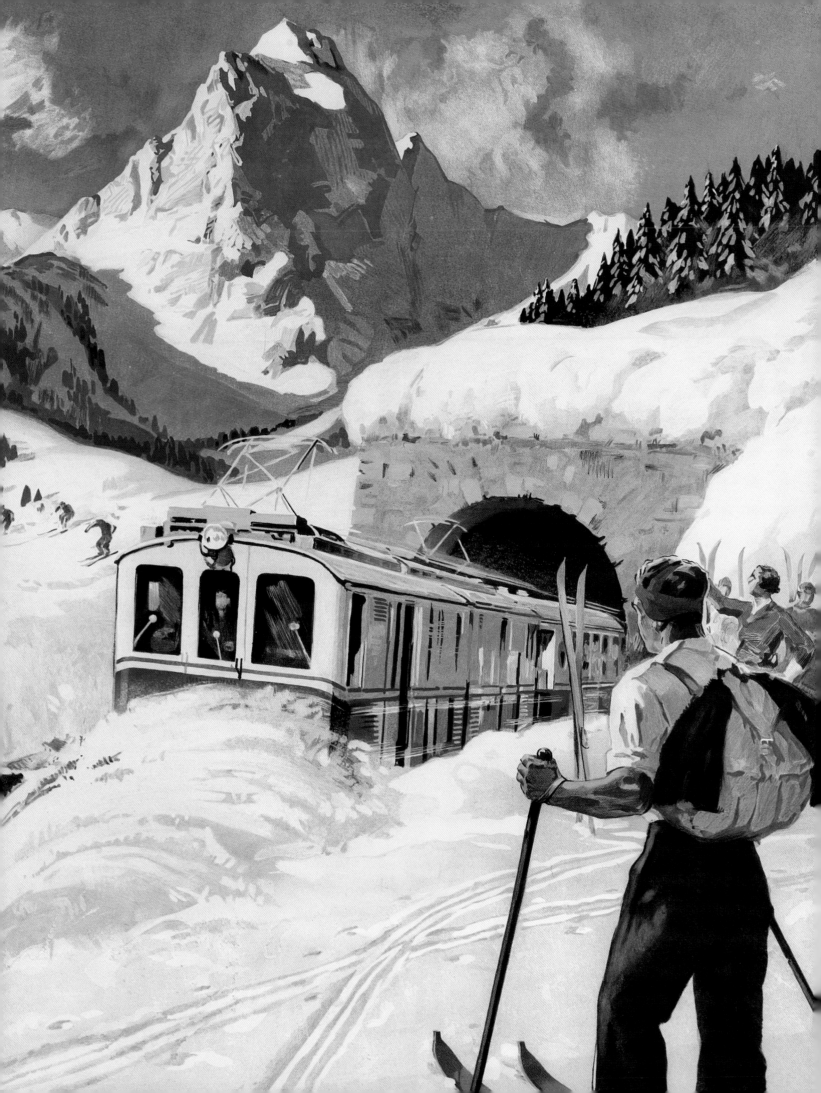

landscape, and leisure with a certain *joie de vivre*. Gradually photography infiltrated poster design, whether as photomontage or as the whole image. By the 1950s many posters were photographic. The postwar era saw a growth in resorts and facilities to reestablish tourism, with accompanying optimistic publicity, commissioned by enlightened directors of tourism for the regions, railways, and resorts. Often the winter and summer program would be entrusted to the same artist. The same image might be used with variations of text, thus reducing costs. Switzerland has always had the highest printing standards, and print workshops such as Orell Füssli and Wolfsberg in Zurich, Trüb & Cie in Aarau and Lausanne, produced some of the finest-quality posters.

Before skiing became popular, it was the curative powers of pure mountain air and water that led to the establishment of many Swiss Alpine resorts, notably St. Moritz and Davos. In Davos, the British writers John Addington Symonds and Robert Louis Stevenson, both recovering from tuberculosis, became friends. There, they discovered a new source of pleasure: the toboggan, or *schlitten*, used for practical purposes by the locals. Symonds and Stevenson pioneered the somewhat hazardous activity of tobogganing at night, when "a whole heavenful of stars reels and flashes overhead." According to Stevenson, this "adds a new excitement to the life of man upon his planet." It is exactly this

sensation, of flirting with danger, that progressed the adoption of winter sports.

In 1883, the Davos Tobogganing Club was formed, with races run on a course between Davos and Klosters. The sport of curling, native to Scotland, was also introduced to the Alps, with the first European championships held on a skating rink behind the Kulm Hotel, in St. Moritz, in 1882. Ice-skating was already a popular winter sport in parts of Europe and North America; from the 1860s, British visitors to Switzerland took their skates with them. Sledding parties, with a long line of connected *luges* behind a horse-drawn vehicle, were also popular.

Another British writer who discovered the pleasure of Alpine winter sports was Sir Arthur Conan Doyle, creator of Sherlock Holmes, who toured Switzerland in 1893. Inspired by the Norwegian Fridtjof Nansen's ski journey across Greenland, he persuaded two local brothers to obtain skis from Norway. Doyle described his not-always-successful experiments as "getting as near flying as any earth-bound man can. In that glorious air it is a delightful experience, gliding over the gentle slopes, flying down the steeper ones, taking an occasional cropper." While in Switzerland, Doyle made a 15-mile journey on skis over the Furka Pass to Arosa.

Arriving in Davos in the winter of 1901, the Richardson brothers were told the terrain was unsuitable for skiing—a fact totally

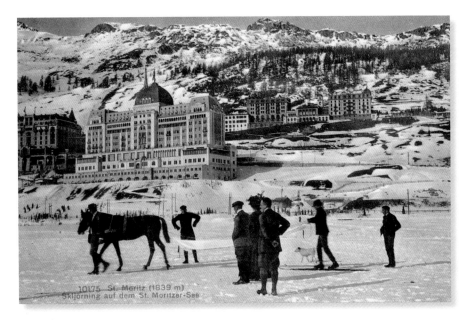

Above: Glarus was the hometown of Christopher Iselin, father of ski sport in Switzerland and pioneer of high Alpine ski-mountaineering from 1893. The first ski factory opened here at Glarus.

Left: Skijoring was dreamed up by the Lapps, who harnessed reindeer to pull sledges or skis. It was introduced to Central Europe by a Mr. Saratz from Pontresina. Reindeer were replaced by horses and the first race was held in 1906 on a road at St. Moritz, the frozen lake then deemed unsafe.

contradicted by their role in the growth of the sport. In January 1891, two cousins, Tom and Gerald Fox, brought the first skis to the Grindelwald Valley, having visited Scandinavia in 1889. At that time "Most of the visitors seemed to think them an unsafe method of locomotion."

Although Switzerland remained neutral throughout both world wars, tourism and competition skiing were halted during these periods. From 1916 onward, wounded prisoners of war returned from Germany were interned at Mürren, Chateau d'Oex, Leysin, and Meiringen. While convalescing, some were taught to ski. Restrictions on foreign travel were lifted in 1919; that winter season, St. Moritz regained its sparkle. Emil Cardinaux's famous set of posters for the resort, epitomizing this most glamorous world, continued until the early 1920s.

The Old World was now in decline, and the European aristocracy increasingly shared the winter playgrounds with wealthy Americans. There was a broadening of social classes attracted to the mountains.

The Swiss guides and hotel keepers were now basking in their good fortune, as villages of traditional charm exploited their history and installed efficient uphill lift machinery.

A key pioneering figure, in both Alpine sports and graphic arts between the wars, was Dr. Walter Amstutz. His father owned a hotel in Mürren, where the Lunns and the early British ski racing fraternity spent their winters. An excellent skier and racer, Amstutz founded the Swiss Academic Ski Club (SAS) when he was 22. In 1926 he organized the first international university ski championships at St. Moritz, with competitors from Austria, Germany, Italy, Switzerland, and Great Britain. He later became tourism director for St. Moritz, where he worked with Walter Herdeg on a series of posters, creating a special identity for the resort in the early 1930s. Under his guidance, the instantly recognizable smiling sun symbol—still in use today—was introduced in poster designs. In 1938, with threats of war looming, St. Moritz suspended its publicity plans. Ten years later, the resort's publicity got under way again for its hosting of the 1948 Winter Olympics. Amstutz & Herdeg Advertising Editions continued as a design partnership, and Herdeg later founded and edited *Graphis*, the prestigious international review of design and typography.

Postwar Switzerland saw a new influx of affluent Americans. In the 1950s many important figures in the American film and literary worlds went there to avoid the McCarthy "witch-hunts." Jet air travel brought the restless pleasure-seeking "jet set." As always, many of these rich visitors—to such fashionable resorts as Klosters—came to see and be seen; but many others came mainly because they wanted to ski.

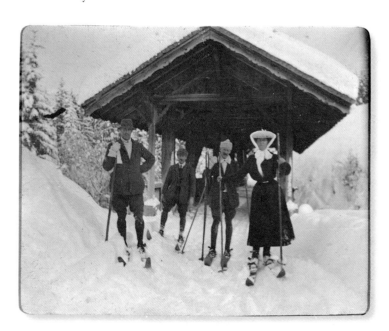

Left: The rack and pinion railway, which combined spectacle and accessibility, up Mount Rigi, above Lake Lucerne in central Switzerland, was in use as early as 1870. Anton Reckziegel's poster dates from 1907.

Above: Early skiers by a traditional roofed wooden snow bridge. These were built over rivers or streams, usually out of larch, which was waterproof because of its high density and resin content.

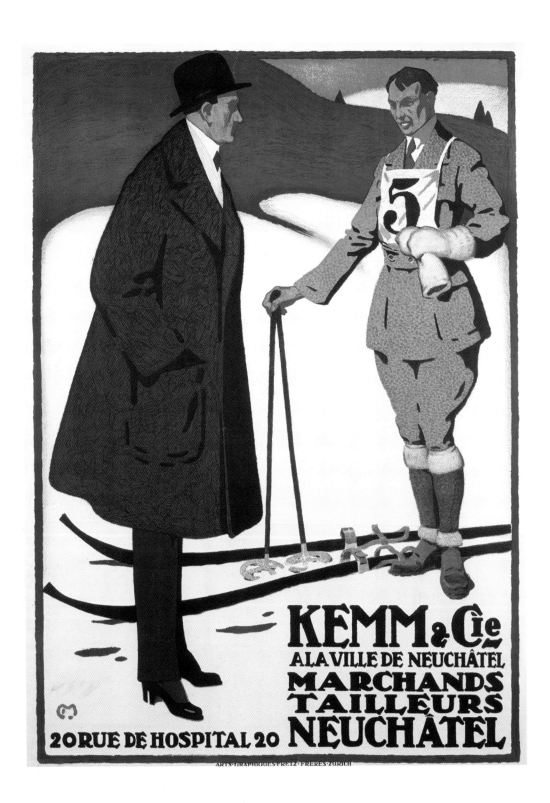

← TAILORS

An uncharacteristically static early poster by Carl Moos, before his series of memorable action images, advertised a tailors in Neuchâtel. The jodhpur-style breeches were worn by early skiers with protective leggings.

→ VILLARS

Understandably, few posters promote the obvious dangers of skiing. Nonetheless, if the proportions of this giant snowball were true, in relation to the Dents du Midi behind, these mischievous gnomes would trigger a massive avalanche. Attributed to Flemwell in 1925, there is also a 1930 version inscribed "J. E. Muller."

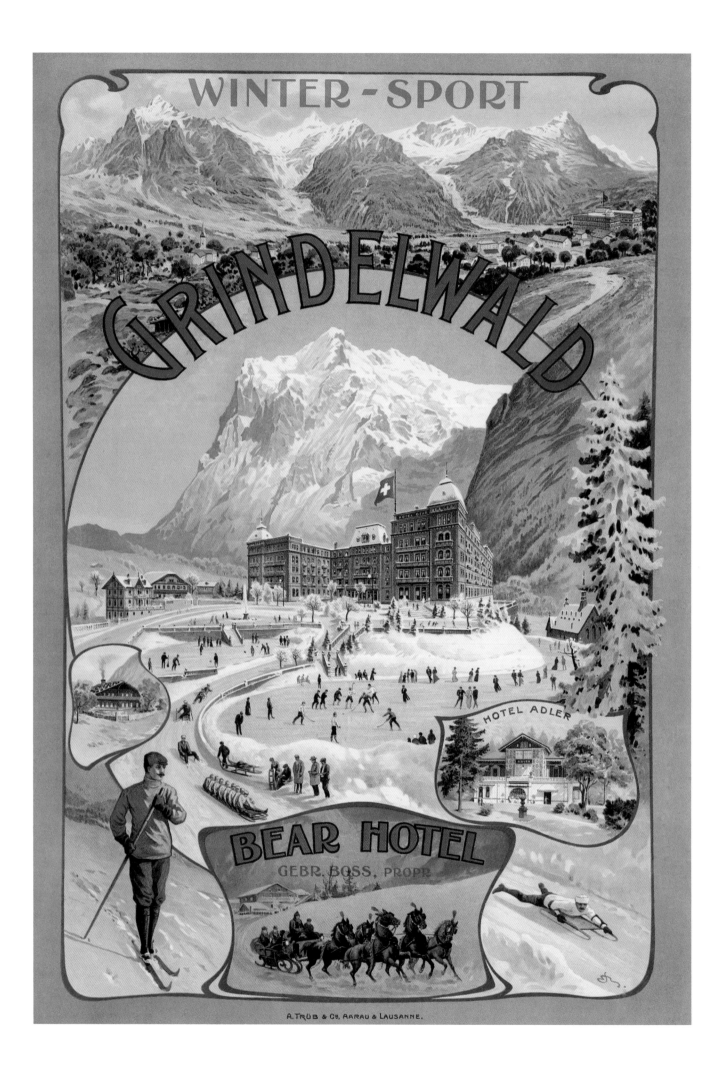

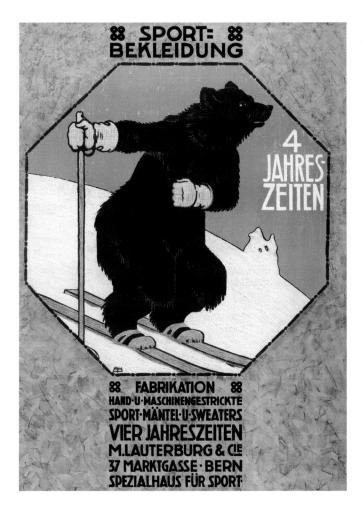

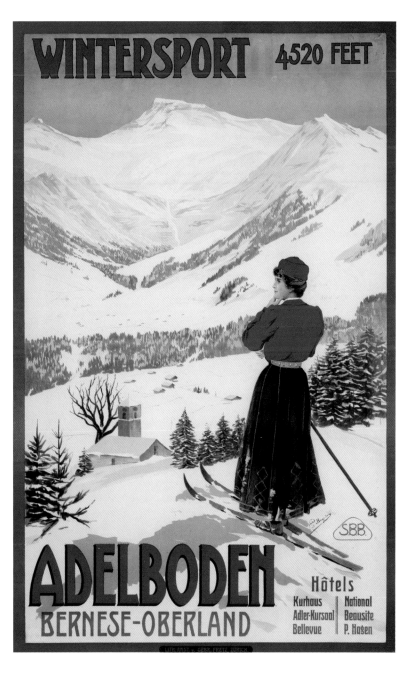

⬅ GRINDELWALD

From the 1850s, the Bear Hotel was a center for mountaineers climbing the Jungfrau and Eiger. Burnt down in 1892, it was rebuilt by 1893 on grander lines. Gerald Fox is reputed to have clattered around inside the Bear wearing the first skis in Grindelwald.

⬆ BERN

Legend has it that the founder of Bern killed a bear during a hunt, and it has remained a symbol of the town ever since. Mangold's advertisement for a tailor shows a bear looking somewhat incongruous on skis.

ADELBODEN

In the heart of the Bernese Oberland, high and sunny Adelboden was colonized by early British skiers. Poster designer Carlo Pellegrini–not to be confused with his namesake political caricaturist–also did much-reproduced charming postcards of early skiers.

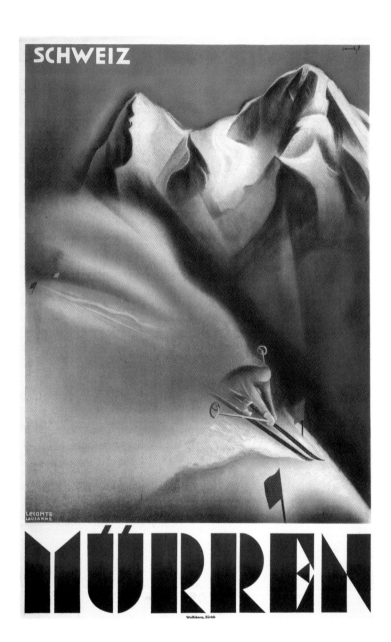

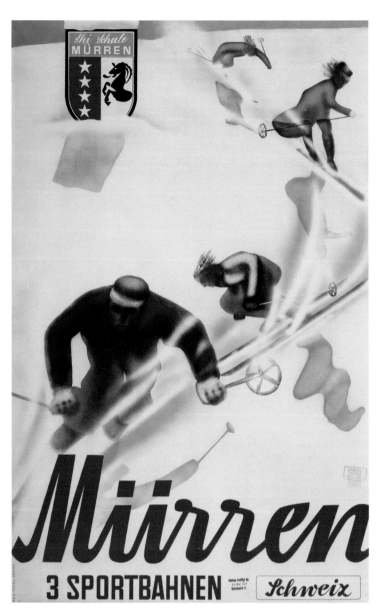

MÜRREN

Mürren, deriving its name from *murus* the Latin for "wall," perches precariously on the edge of a precipice above the Lauterbrunnen valley. Home of early racing, it is chocolate-box pretty, with dramatic views of the Eiger, Mönch, and Jungfrau.

RACES AT MÜRREN

Among the races run at Mürren is the wild Inferno, begun in 1928. It is a race without gates in a mad plunge from the summit of the Schilthorn to the valley nearly 8,000 feet (2,438 metres) below. Today there are over 1,000 competitors, testing themselves to the limit on untracked, unflagged snow.

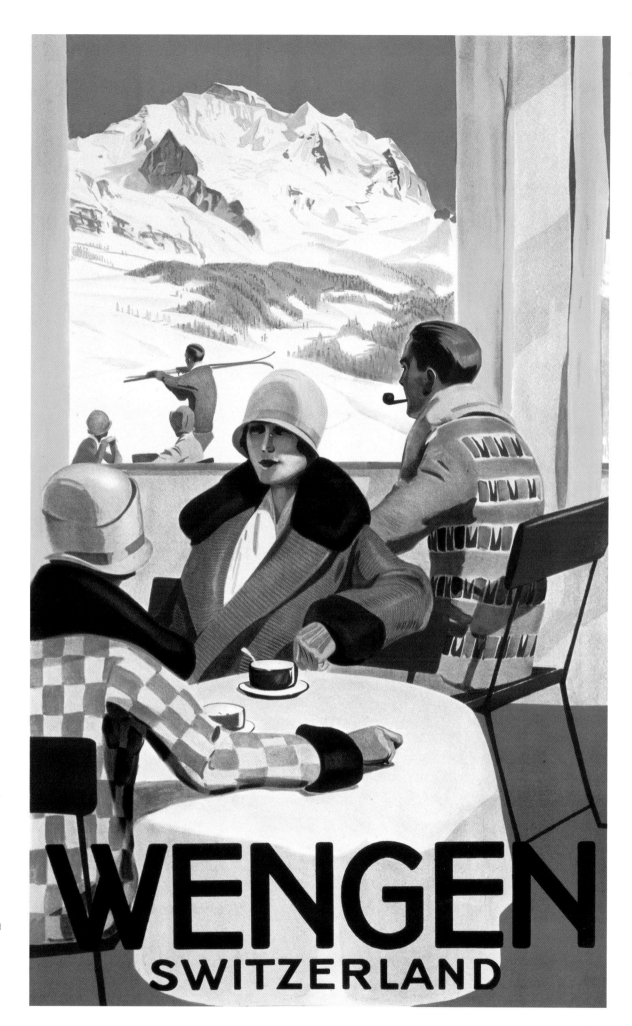

WENGEN

SWITZERLAND

WENGEN
The DHO (Downhill Only) club
was formed in Wengen in 1925
to challenge Kandahar rivals
in Mürren. Taking the train up
the mountain in order to ski
down was considered
unsporting when the general
view was "no pain, no gain."
Competition seems far from
the minds of these 1925
fashion icons, enjoying languid
off-piste pleasures.

Schweiz · Suisse · Switzerland

← Arosa
Donald Brun created some memorable posters in the 1950s. Brun and Leupin were of the "école bâloise" where resort publicity was handled from Basel—the base of most of the country's industry and commerce.

→ Summer Skiing
A 1931 poster by Alois Carigiet shows summer skiing at Arosa—one of the three earliest Graubunden resorts—for the wearing of T-shirt and shorts would otherwise be a safety hazard.

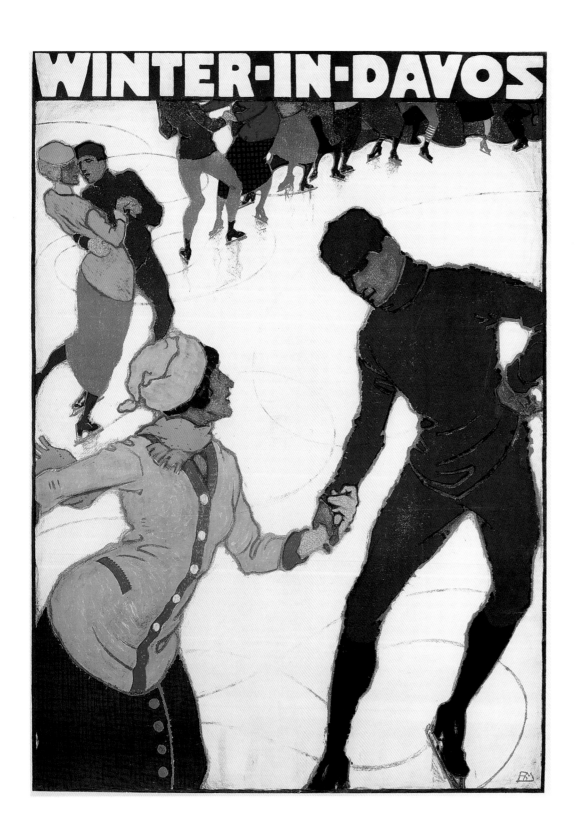

WINTER·IN·DAVOS

← **DAVOS**

The founding in 1860 of a tuberculosis clinic in Davos transformed the quiet community into a major health resort. This 1914 poster by Burkhard Mangold shows a world of continuing fun in neutral Switzerland. At first, skating was all the rage, and skiers were regarded as somewhat comic.

→ **BOBSLEDDING IN DAVOS**

Davos is still one of the top Alpine health centers, additionally hosting international gatherings of world politicians, economists, or scientists. In Cardinaux' 1918 image, the bobsled action is focal, but skiers are also in evidence. In St. Moritz, bobsled made its debut in 1890, although the famous Cresta Run was built in 1884.

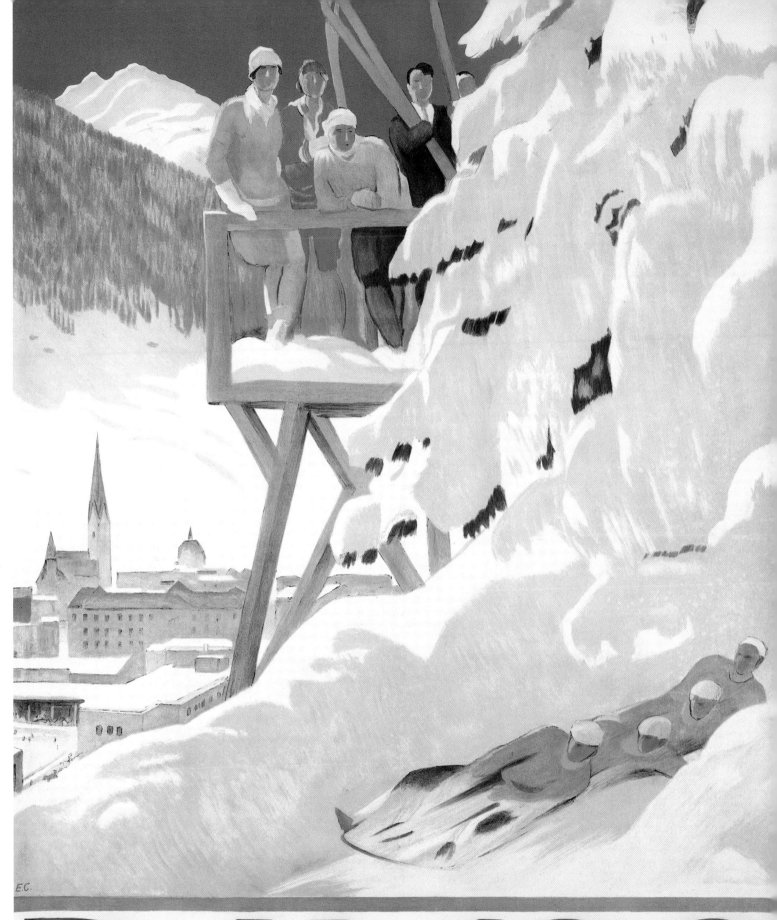

DAVOS

WOLFSBERG ZURICH

DAVOS

Five posters by Burkhard Mangold dating from 1917 are among the most highly priced and collectable winter sports posters. Showing, from left to right, sleigh rides, ice skating, winter "küren" (the resort was known as a major spa offering restorative cures), skiing, and tobogganing.

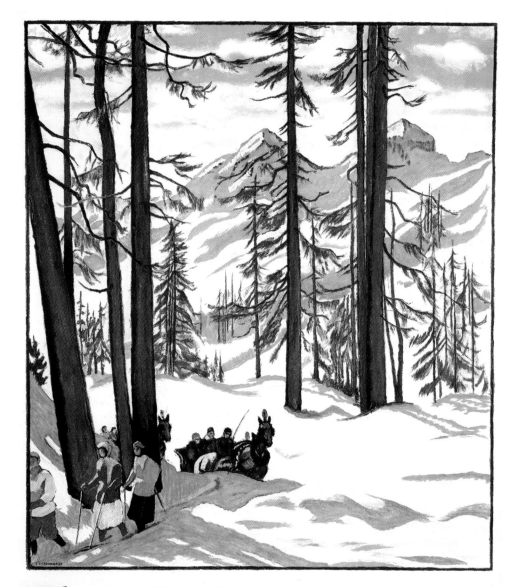

ST. MORITZ

➔ PALACE HOTEL

Emil Cardinaux produced some of the most memorably stylish posters from the early 1900s until the 1920s. Instantly recognizable for their more painterly, scenic style, rather than uniquely graphic like other poster designs. This 1920 scene at the ice rink below the Palace Hotel, St. Moritz, is one of the jewels of any poster collection.

← ST. MORITZ

An earlier Emil Cardinaux poster from 1918, publicizing St. Moritz, shows ladies in skirts skiing cross-country through the woods while horse-drawn sleighs—still in use in the resort today—take people for romantic drives through the glorious scenery.

⬇ SKIJORING

St. Moritz is superbly situated on the shores of a fir-tree-lined lake in the Engadine—Switzerland's most scenic valley. Skijoring behind galloping horses requires skill, particularly in restraining the animal, as horses tend to go faster on snow. Skijoring found its way to North America in the 1950s, and is now a highly specialized competitive sport.

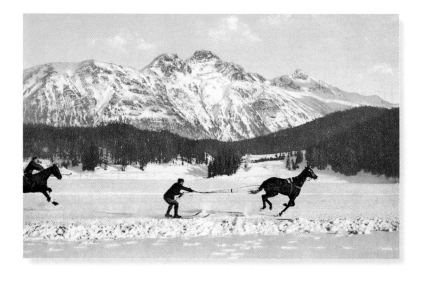

PALACE HOTEL

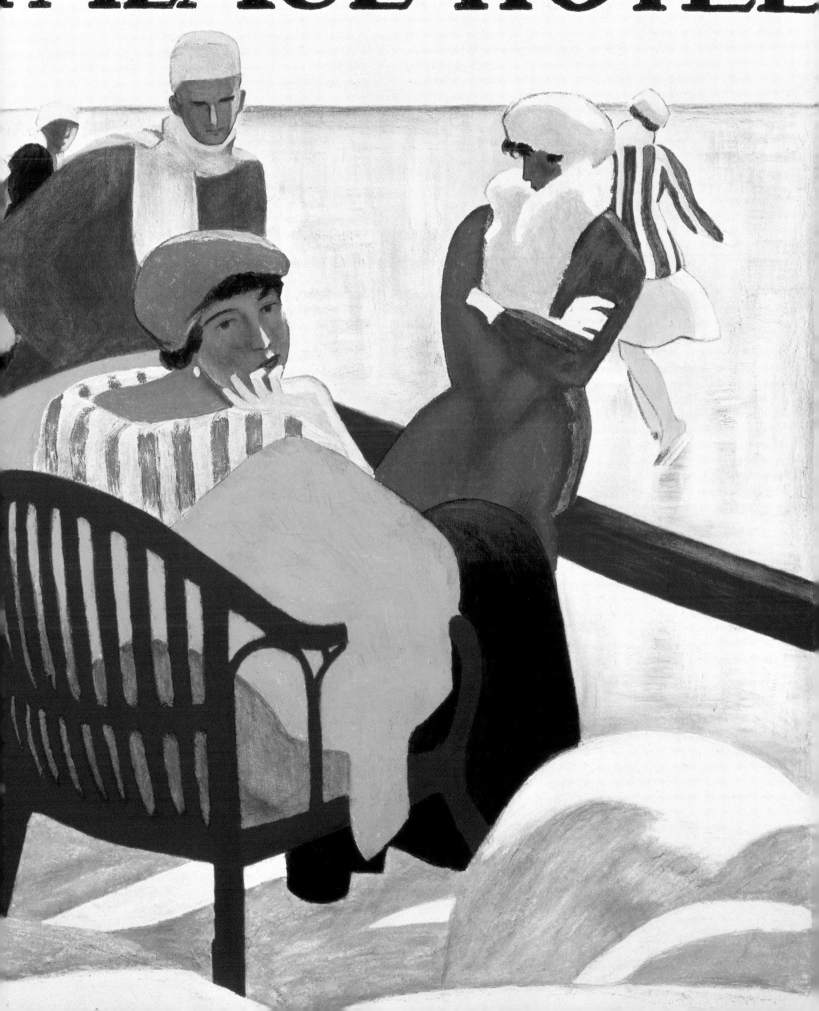

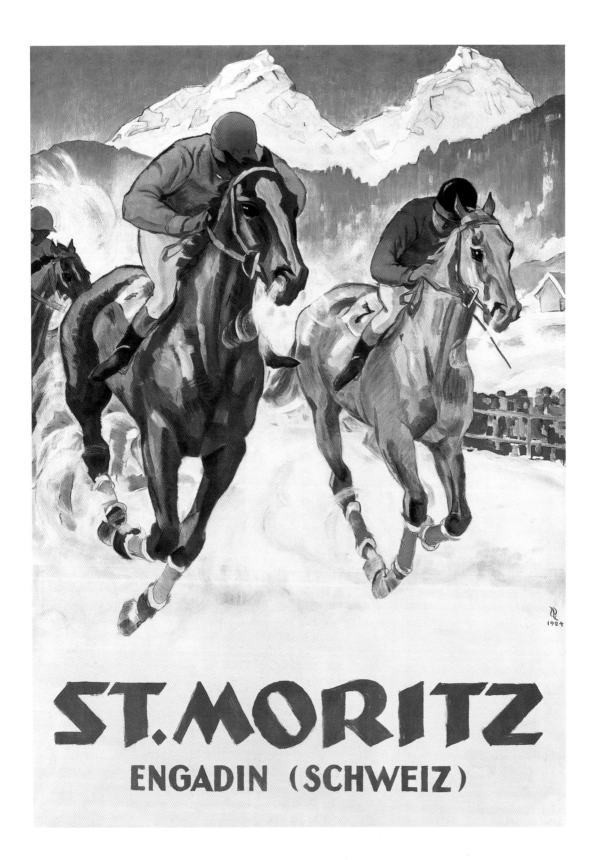

ST.MORITZ
ENGADIN (SCHWEIZ)

↑ WHITE RABBIT
One of Swiss advertising's more humorous poster designers was Alex Diggelmann, who made two versions of his white rabbit–this one in 1935 and a version on skis, dating from 1955.

← HORSE-RACING
Horse racing was first held on the frozen lake below St. Moritz in 1907. Hugo Laubi's poster from 1924 graphically offsets the action against spectacular mountain scenery.

→ SNOWBALL FIGHT
Alois Carigiet composed this sun-filled image in the 1930s, when all-in-one ski suits were fashionable. Apart from snowball fights, for non-skiers there are the distractions of extravagant shops transplanted from Bond Street, Rodeo Drive, and the Via Condotti, plus the lure of the legendary Hanselmann's–with coffee and chocolate cakes to die for.

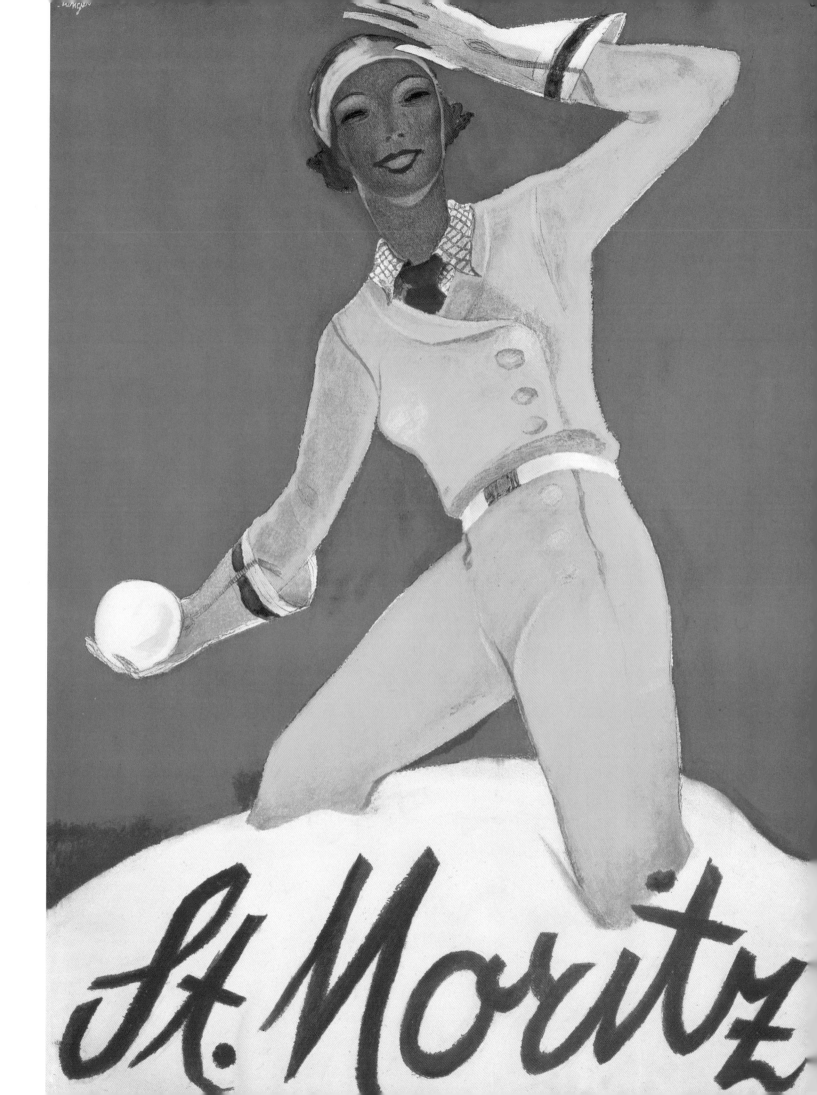

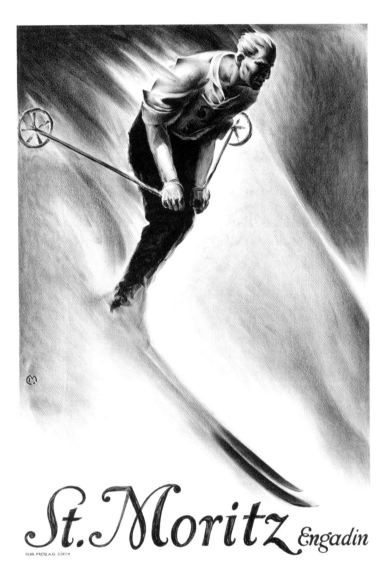

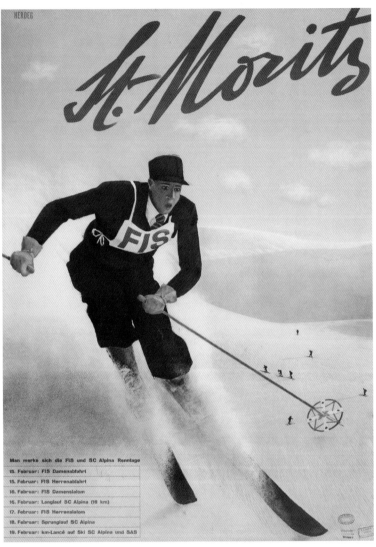

DOWNHILL IN ST. MORITZ

Carl Moos was one of the best-known Swiss poster designers in later decades; this early poster of St. Moritz, from around 1910, is almost photographic in style, the use of half-tone printing reinforcing the effect.

FIS CHAMPIONSHIPS

From the 1920s, photography was increasingly incorporated into poster design. This poster by Walter Herdeg for the 1933 FIS championships held in St. Moritz, shows concentrated determination.

➔ POWDER SKIING

By the 1950s, photography and offset printing resulted in more immediately bold posters. The creation of the instantly recognizable smiling sun symbol for the resort was introduced in a 1930 Herdeg poster, and used for all publicity from 1937. This anonymous scene of the joys of powder skiing carries the graphic wording and sun synonymous with St. Moritz advertising campaigns.

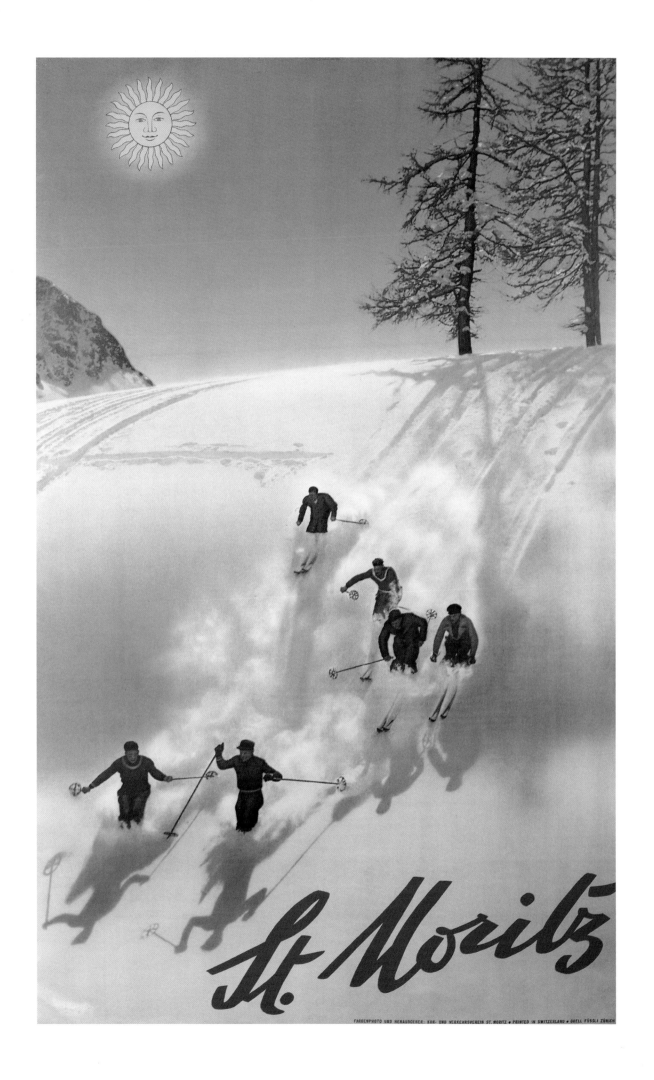

St. Moritz

FARBENPHOTO UND HERAUSGEBER: KUR- UND VERKEHRSVEREIN ST. MORITZ • PRINTED IN SWITZERLAND • ORELL FÜSSLI ZÜRICH

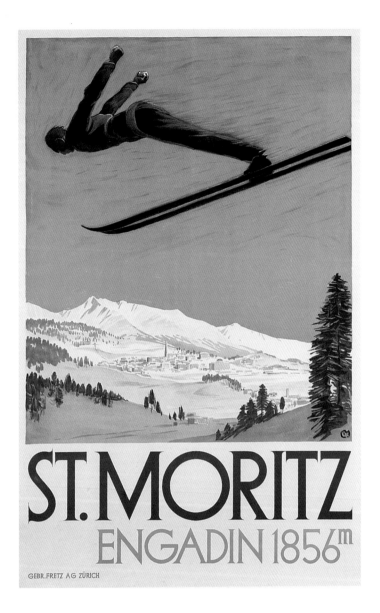

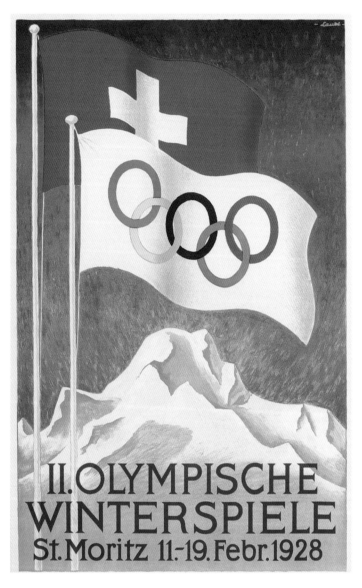

SKI-JUMPING, ST. MORITZ

St. Moritz was one of the first Swiss resorts where Nordic skiers introduced their sport. Carl Moos captures the perfect jumping position, lying along the skis while airborne. The smallness of the resort behind indicates the early date.

1928 WINTER OLYMPICS

Since 1928, the Winter Olympics have been held three times at St. Moritz. As a neutral country, Switzerland was chosen to host the first postwar Olympics in 1948. In 1928, there was still no downhill or slalom.

⊖ PONTRESINA

Further towards Italy, Pontresina is almost an extension of St. Moritz, only 4 miles (7 km) away. Diggelmann's jumper in mid-flight soars as high as a bird–flying in style.

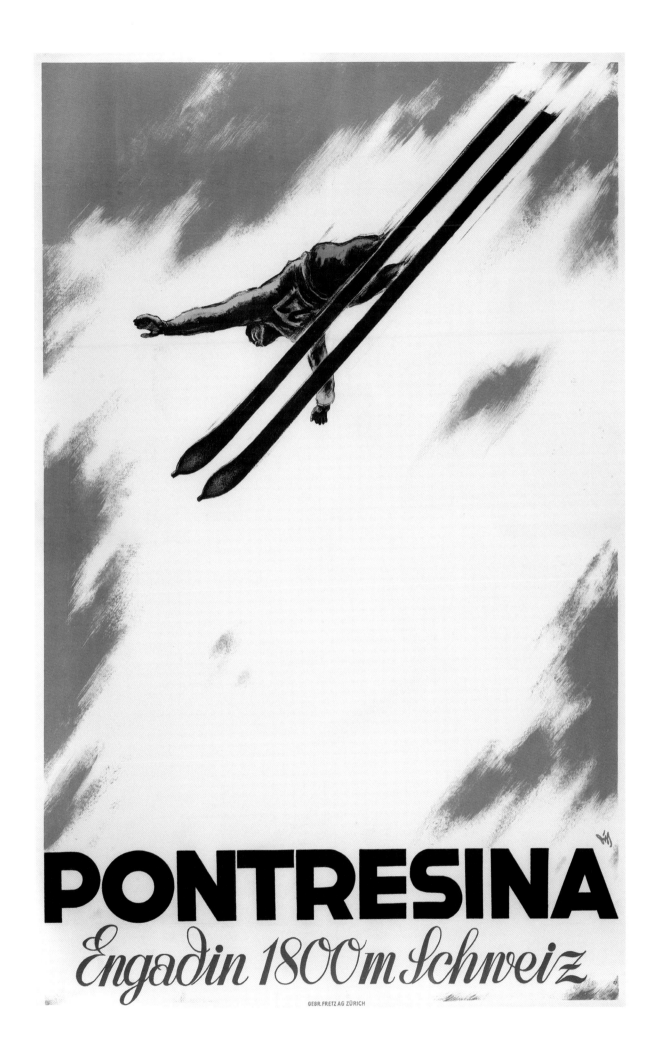

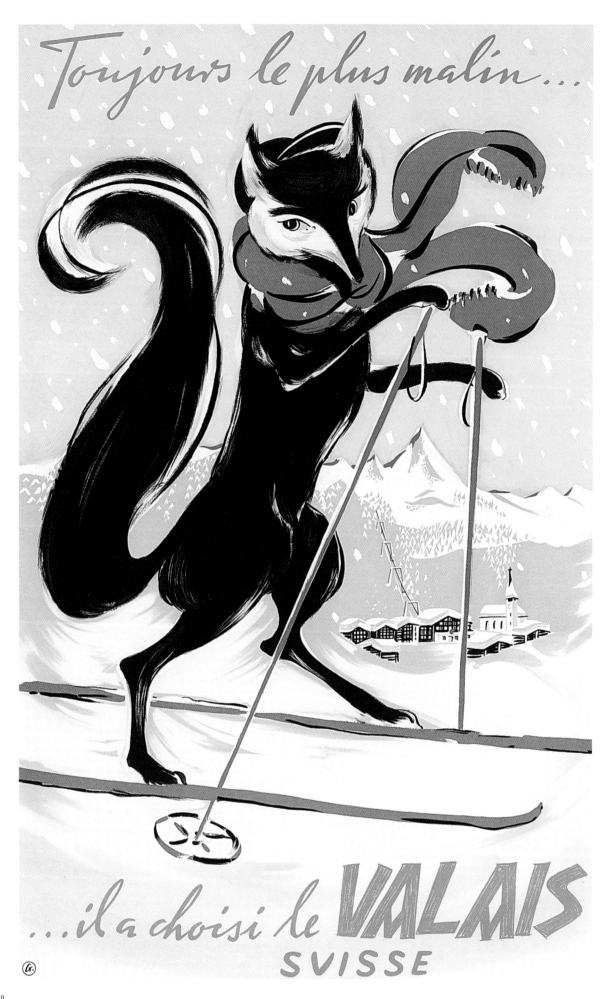

VALAIS

This 1951 poster by "G" (which stands for Gongoro) was printed in five languages for the same image—not only in French, German, and Italian for the three parts of Switzerland, but also in English and Dutch. In English the text is "Be as shrewd as he ... and choose the VALAIS." In French it is "Always the smartest ... he has chosen the VALAIS."

LAND OF SUNSHINE

Herbert Libiszewski, known as Libis, created optimistic images for the Valais region in the immediate postwar period, including this "land of sunshine," which dates from 1949. The bindings look perilously unsafe to modern eyes.

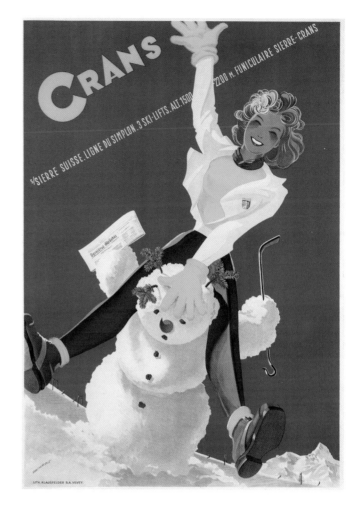

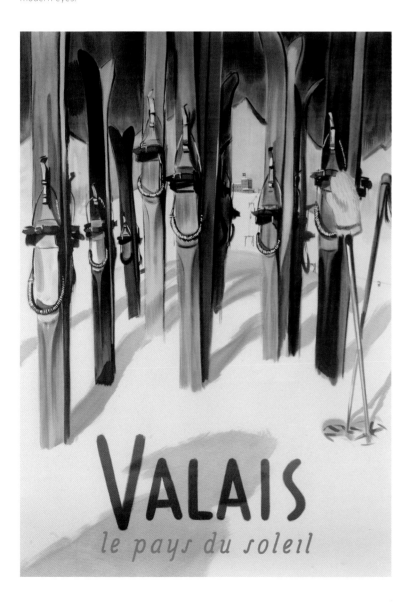

CRANS

Martin Peikert's 1946 poster shows a very upbeat bronzed image, coincidentally celebrating the freedom of Europe. Crans-sur-Sierre merged with Montana Vermala to become what is now known as Crans-Montana, on the sunny south-facing slopes of the Rhone valley.

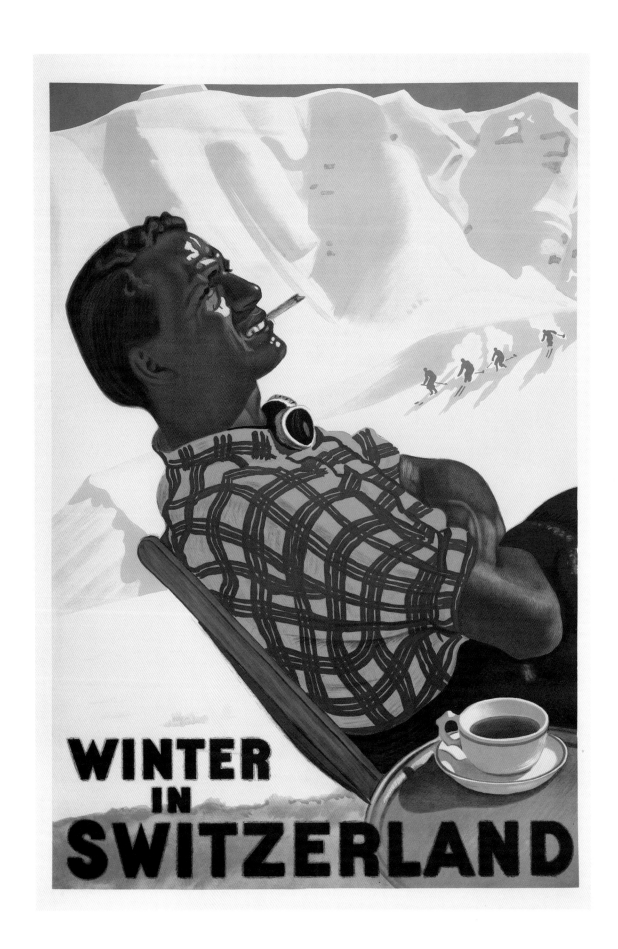

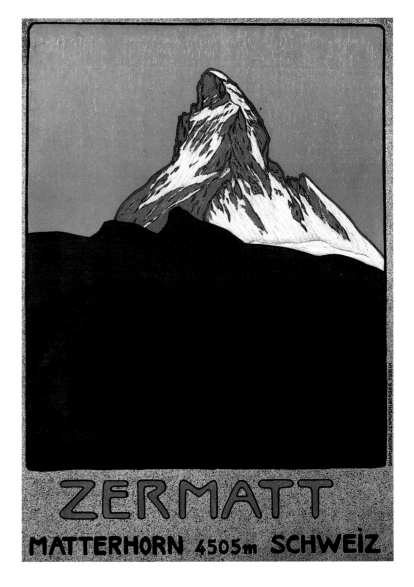

⬅ Après-Ski

Erich Hermes perfectly sums up an important part of skiing—that euphoric feeling of having pushed hard and achieved much, despite complaining muscles. Coffee never tasted so good as in the open air after completing a good run.

⬆ Zermatt

There can be fewer iconic mountains than the Matterhorn. Emil Cardinaux chose that magical moment of "alpenglow," when mountains are tinged pink by sunset, to represent Zermatt in this 1908 poster. The first winter sports season was not until 1928, when Hermann Seiler persuaded the railway to open the line from Visp to the village.

Matterhorn

With memorable views of the inescapable Matterhorn from every angle, Zermatt provides some of the most scenic ski terrain in the world. Perren-Barberini's photographic 1960s poster depicts legendary Swiss skier Simon Biner, one-time head of Zermatt's ski school and founder of popular mountain restaurant "Simi" followed by a resort hotel.

Part Two

NORTH AMERICA

"New Hampshire, Land of Glorious Winter" is the caption to this decorative poster by Dwight Shepler, a leading ski artist of the 1930s. New Hampshire includes many of the earliest eastern resorts, but don't be fooled by the sunshine—skiing in the eastern USA can be *very* cold!

DWIGHT SHEPLER 1936

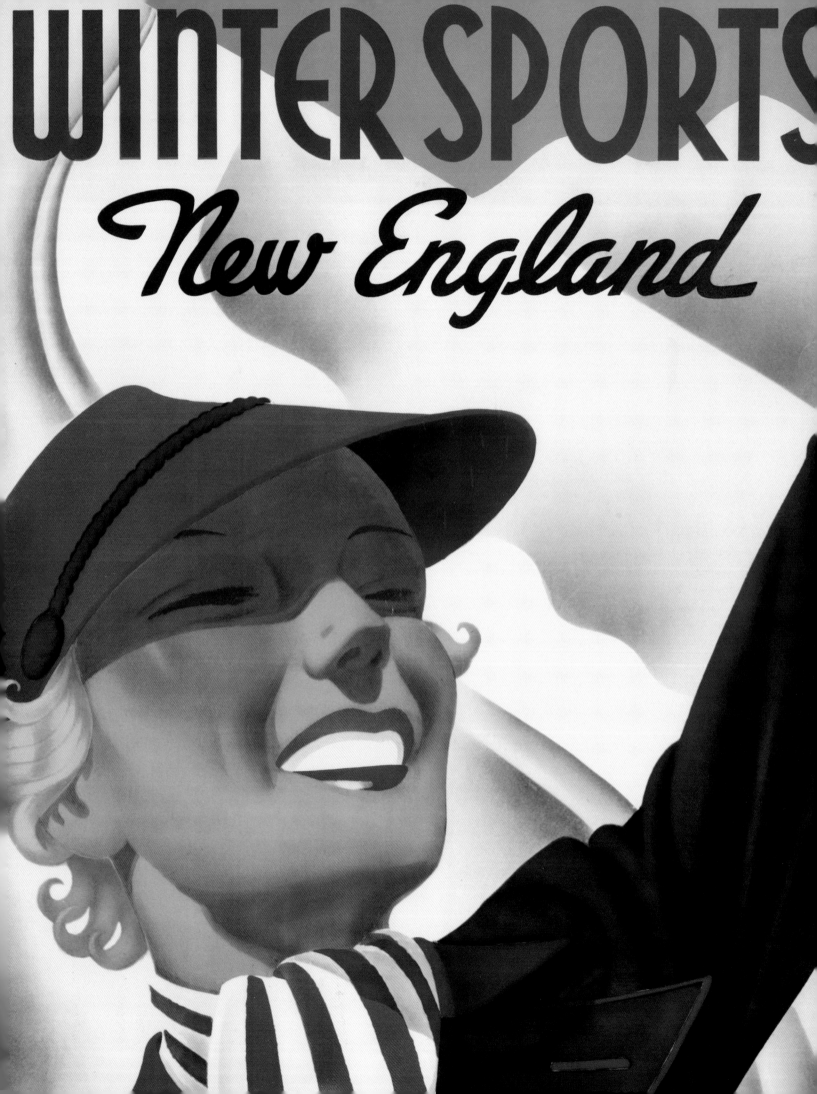

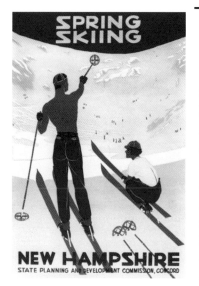

There is greater interest in skiing history in the United States than in Europe, largely thanks to the meticulous research of a handful of historians and journalists who are also keen skiers. Thus, a great deal of literature is available in numerous books and journals, notably *Skiing Heritage*, the quarterly magazine of the International Skiing History Association (ISHA). Located in Connecticut, the ISHA was founded in 1991 by the late Mason Beekley, together with eminent members including former champions, Olympic medalists, FIS members, and members of the U.S. Ski Hall of Fame.

The foundation of clubs to organize sporting competitions proliferated in the early 1900s, as the influence of Scandinavian immigrants and publications about Norwegian skiing encouraged Americans to make and experiment with their own skis. In 1905, the National Ski Association (NSA) was formed in Ishpeming, Michigan. When the FIS (Fédération Internationale de Ski), the international body regulating competition skiing, was established in Europe in 1924, the NSA represented the United States.

Ever since those early days, detailed studies of specific places, races, early competitors and champions, types of skis, including the first releasable bindings, protective clothing, and mechanized transportation have been published in the U.S. Club bulletins and annuals, journals, and now websites are filled with accounts of the minutiae essential for accurate historic records. The first comprehensive survey of American skiing, covering the years 1840 to 1940, was published by historian John B. Allen, in 1993. Titled *From Skisport to Skiing*, it skillfully interweaves elements of sporting, social, and economic history.

The American story of skiing is linked with the European in many ways. German, Austrian, and Italian experts crossed the Atlantic to teach the sport. Norwegian miners and loggers had already brought their equipment and methods farther west and north to mining territories. In Boston, in 1926, the first ski shop opened, under Norwegian ownership. Alpine skiing started to make inroads from the eastern resorts, as the Austrian style was taught in ski schools or coached at colleges.

Dartmouth College, in New Hampshire, was a leader in collegiate skiing. In 1909 the college formed the Dartmouth Outing Club to encourage interest in winter sports, including ski jumping, cross-country skiing, and snowshoeing; the club held its first winter carnival in 1911. In 1923 Dartmouth hired a Hungarian colonel, Anton Dietrich, who had fought with Austrian ski troops during World War I, as ski instructor and coach. That same year, Dartmouth held the first U.S. slalom. The first downhill race in 1927 was won by Charley Proctor, son of the physics professor who had corresponded with Arnold Lunn and organized slalom and downhill events at Dartmouth following Lunn's guidelines. Proctor was part of the 1928 U.S. Winter Olympics team at St. Moritz, and in the 1930s helped cut ski trails in New England and at Sun Valley, Idaho.

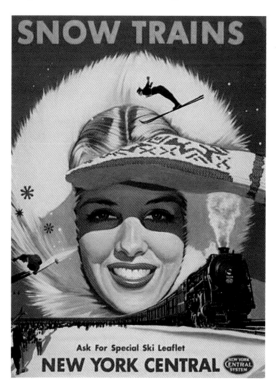

Above: During and after the Depression, state and federal governments promoted tourism. The combination of the Tuckerman headwall in the background with the idea of sunny spring skiing was used to promote New Hampshire skiing.

Left: Sascha Maurer contributed memorably colorful images for a series of posters for the New Haven Rail Road. This has all the style hallmarks—a graphic trail in the snow, energy and vigor in the foreground.

Right: Special snow trains were run from the big cities to the slopes by the New York Central. American graphics often included the train in the imagery, whereas European rail posters usually showed the end destination. Note the Norwegian ski-glove worn by this glamorous snow-queen.

In 1928, Otto Schniebs emigrated to Massachusetts from Germany and became the first instructor of the Arlberg technique in the U.S. Initially coach of the Harvard team, then from 1930 the Dartmouth College team, he finally set up a ski school at Lake Placid, New York, in 1936.

Another European skiing expert, the influential Arlberg skier Hannes Schneider, arrived in the U.S. in 1939. With help from Harvey Dow Gibson, financier and developer of a mountain resort at Mount Cranmore, New Hampshire, which already had a skiing area, Schneider was able to establish his own school.

By the mid-1930s the new sport was here to stay. The first U.S. National Downhill and Slalom championships were held in Mount Rainier, Washington, in 1935, the year of the first U.S. Winter Sports Show, in Boston. A year later, the Ski Show drew a crowd of 80,000 to New York's Madison Square Garden.

Although immigrants played a crucial role in the development of the sport, American inventions and machinery helped develop uphill transportation mechanisms. The first rope tow to be installed in Woodstock, Vermont, in 1934, was constructed on a hill leased from a farmer for the winter. Originally called the Ski-Way, it consisted of a continuous loop of rope run over a series of wheels, driven by the rear wheel of a Model A Ford. At Cranmore, Harvey Dow Gibson installed a unique form of transportation, the Skimobile, to carry skiers uphill.

New Hampshire and Vermont are still the best areas for skiing on the Eastern Seaboard. Mount Washington, in New Hampshire, at a

height of 6,288 feet (1,917 metres), is the highest peak in the northeastern United States. Nearby is the dramatic glacial cirque known as Tuckerman Ravine, site of the first U.S. giant slalom race in 1937. Skiers had to climb for two and a half hours to reach the top. From 1932, the ravine was also the course of the U.S. version of the Inferno, a top-to-bottom race based on the Swiss Inferno, held at Mürren. In 1939, Austrian Toni Matt, an instructor at Schneider's Eastern Slope Ski School at Cranmore, won by *schussing* (taking straight) the 50-degree-steep, 900-foot drop, Headwall, in a record time of 6 minutes and 29 seconds.

As in Europe, the story of skiing's popularity in America was connected to the expansion of the railways. In 1931, the first snow train, run by the Boston and Maine Railroad, began service. Special snow trains operated at weekends, taking hordes of city dwellers to the nearest slopes, responding to the new craze for winter sports and offering skiing to a new desk-bound clientele—no longer exclusively to colleges and their alumni. Posters were therefore of paramount importance in conveying the carefree mountain atmosphere.

Two of the finest artists chosen to represent this new winter world, publicized by the regional state tourism boards or the railway companies, were Dwight Shepler and Sascha Maurer. Born in 1905, Shepler exhibited and taught in Boston, working in advertising before joining the U.S. Navy, serving in the Far East and Europe during World War II. Sascha Maurer was born in Munich, Germany in 1896, where he studied under Hohlwein, becoming his protégé. He emigrated to the U.S., where his passion for skiing and close involvement with the sport led to poster commissions. His superbly visual "Ski Lake Placid" was the posters entry in Encyclopedia Britannica.

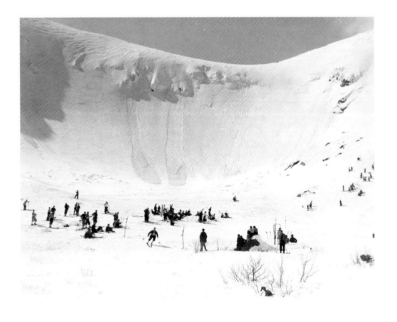

Above: The National Ski Patrol was founded after a skiing accident in March 1938 by Charles Minot Dole. It has since become the world's largest winter rescue organization. Members are recognized by a white cross on red jackets, as shown in this early poster.

Left: Harold Orne's classic photograph records the first giant slalom race in the U.S., held at Tuckerman Ravine on April 4, 1937. In 1939, Toni Matt won the Third US Inferno, modeled on the Mürren race, by *schussing* (taking it straight) down the vertical headwall.

Right: Maurer's brilliant use of ski trails combines downhill thrills with a simple graphic conceit.

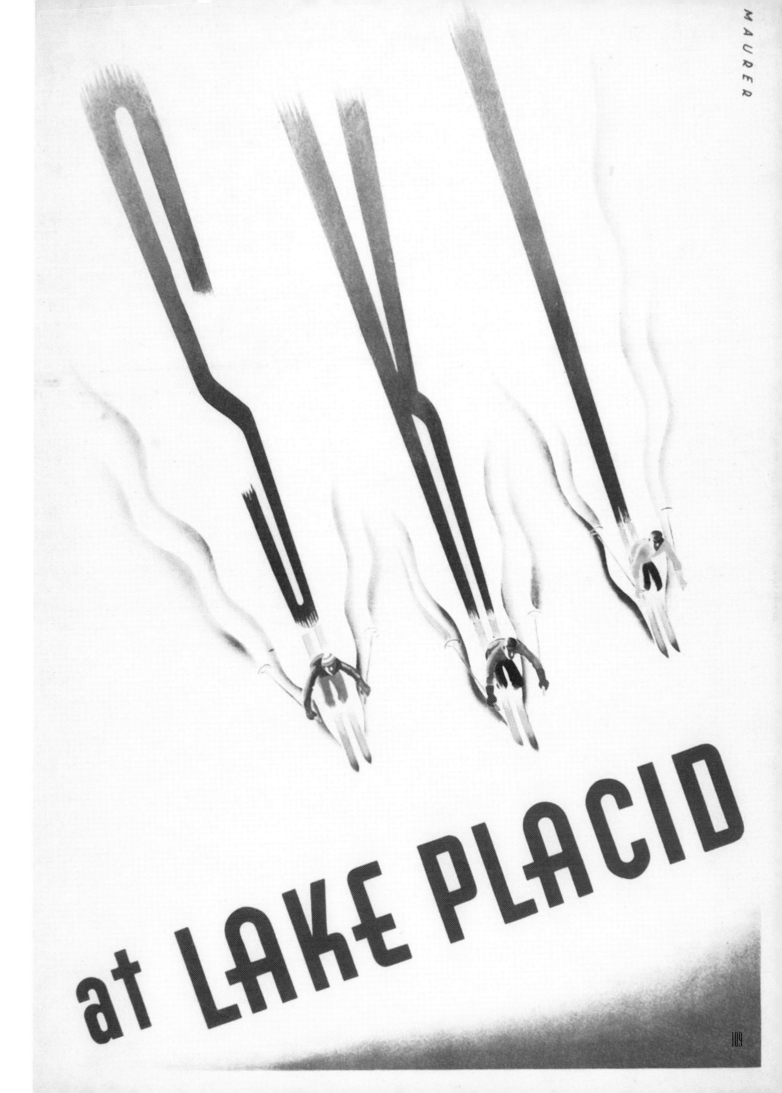

at LAKE PLACID

Take a **Kodak** with you.

American Express

← KODAK

The top makers of cameras were quick to realize the growing popularity of winter sports. They used holiday scenes to advertise their early equipment, so skiers could record their exploits for posterity, or later laughter.

↑ AMERICAN EXPRESS

Long before it was known for credit cards, American Express–founded in 1850– was known for its travelers' cheques and banking operations, and officially entered the travel business in 1915. It is unclear whether the holiday on offer is in the U.S. or Europe.

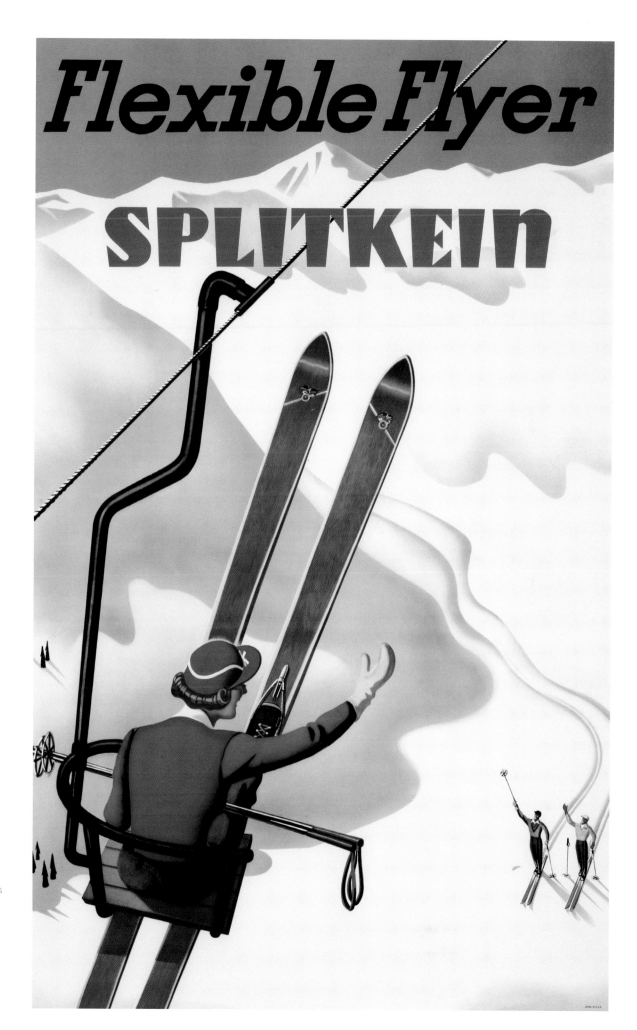

FLEXIBLE FLYER

The famous "Flexible Flyer" wooden sleds were patented in 1889 by S. L. Allen Co. in Philadelphia and continued production in the U.S. until 1999. They successfully launched a range of long wooden skis based on Norwegian designs in the 1930s and 1940s. *Splitkein* was the name given in 1936 by Austrian makers Kneissl to a new 18-layered wooden laminated ski, glued together for extra resilience. Maurer was the chosen artist to promote the "Flyer" new range.

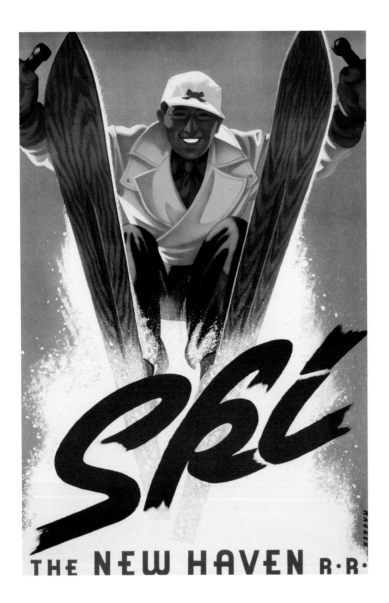

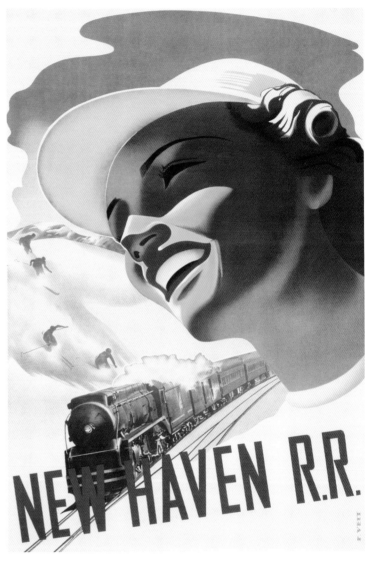

Ski Via New Haven
Sascha Maurer's exuberant action scene shows the fun to be had in a cloud of powder snow. The wearing of a formal neck-tie looks strange to our eyes today, used to more informal, layered clothing.

New Haven RR
Smiles were an essential element of the railroad's publicity message, to make believe in the pleasures of a winter playground, once the train reached its destination. Veit was the artist spreading the word in this instance.

⊙ Snow Trains
Maurer's depiction of the colorful clothes and upbeat attitude suggest a great day ahead for these 1930s skiers, if they use New Haven Rail Road's special Snow Trains, also used as ski lodges.

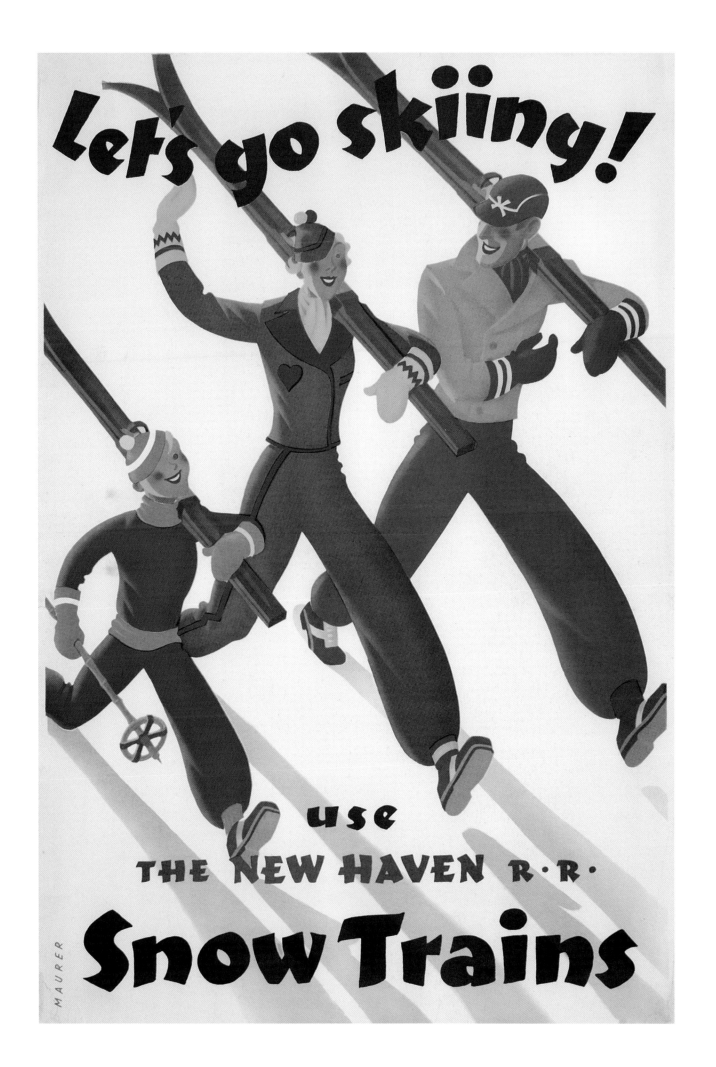

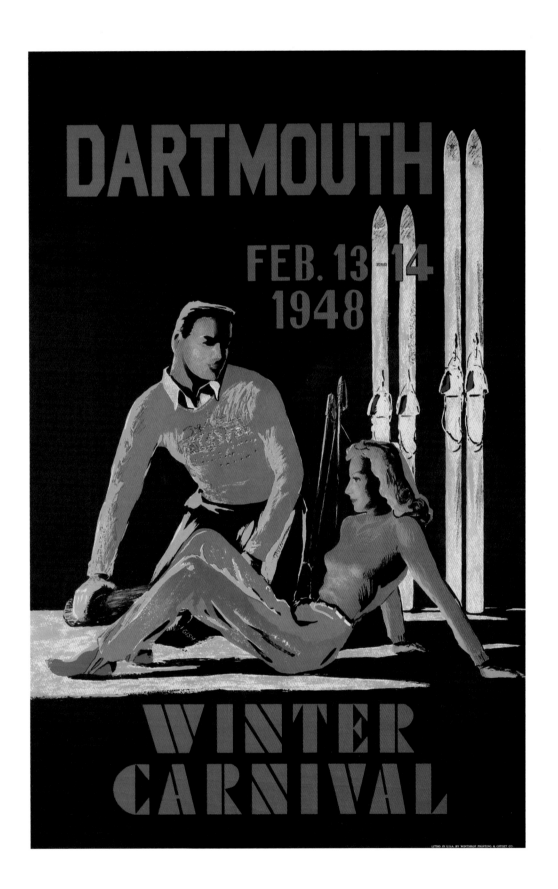

← DARTMOUTH CARNIVAL
Gish's relaxed scene, dating from 1948, shows the *après-ski* element of the famous Carnival weekend—settling down by a fire whose light is graphically reflected. Stretch trousers with heel straps were newly fashionable.

→ CARVING A TRAIL
Dartmouth College in Hanover, New Hampshire, holds a special place in U.S. ski history. The famous Winter Carnival began in 1910, when the Outing Club organized a winter weekend, centered on skiing. In Ryland Scotford Jr.'s 1940 poster, a snowflake represents Hanover as a skier carves a dramatic trail.

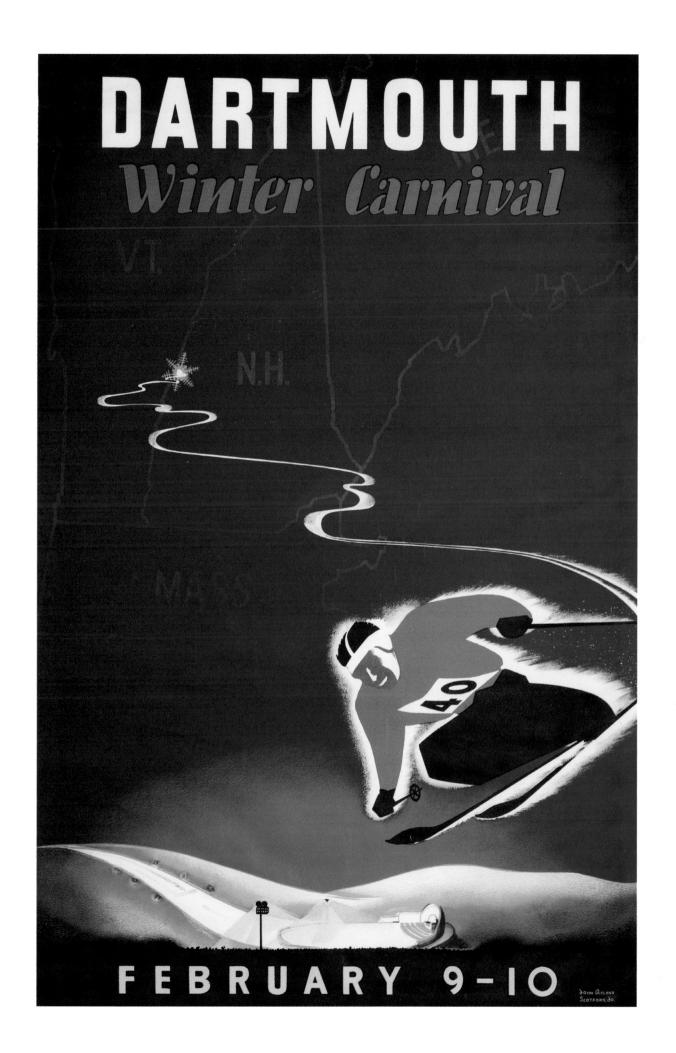

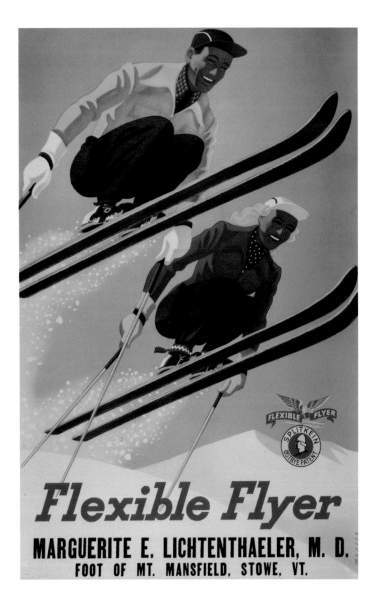

Flexible Flyer
MARGUERITE E. LICHTENTHAELER, M. D.
FOOT OF MT. MANSFIELD, STOWE, VT.

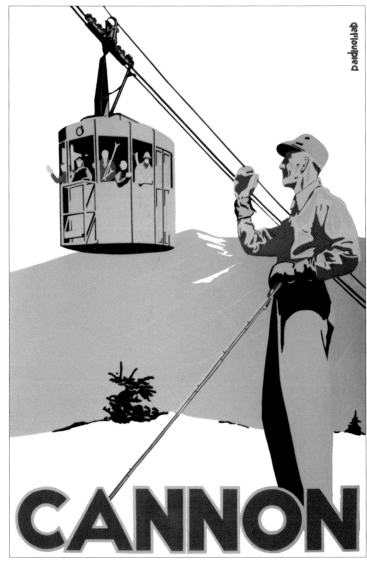

aerialpod

CANNON

FLEXIBLE FLYER

One of the "Flexible Flyer"
series by Sascha Maurer,
issued with different typography
overprinted on the lower
line. Another version was
for Cushing Academy, a private
prep school approximately an
hour west of Boston.

CANNON

The first aerial tramway in New
Hampshire opened on Cannon
Mountain, Franconia, New
Hampshire, on June 29, 1938,
serving the Taft Trail and other
newly cut ski trails. The New
England Ski Museum is situated
next to the tramway.

⊕ MAINE

With echoes of French 1950s
illustrator Raymond Peynet,
this lighthearted poster by
Hamabe makes simple use of a
minimum of colors. Sugarloaf
is Maine's key resort, with its
white "triangular jewel," where
the Snowfields have the only
above-treeline skiing for
experts in the East.

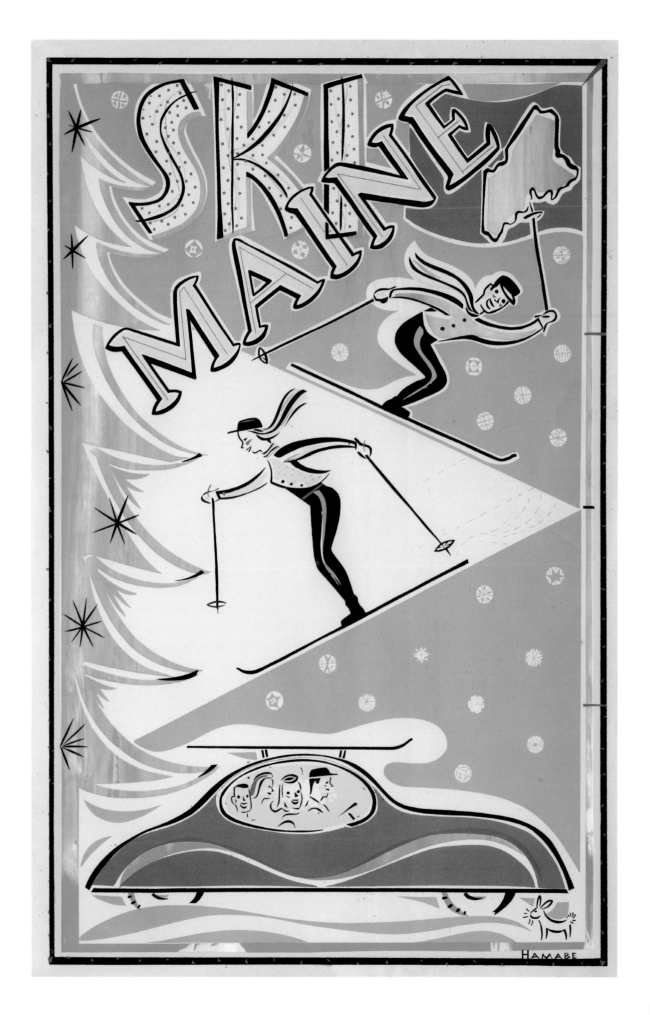

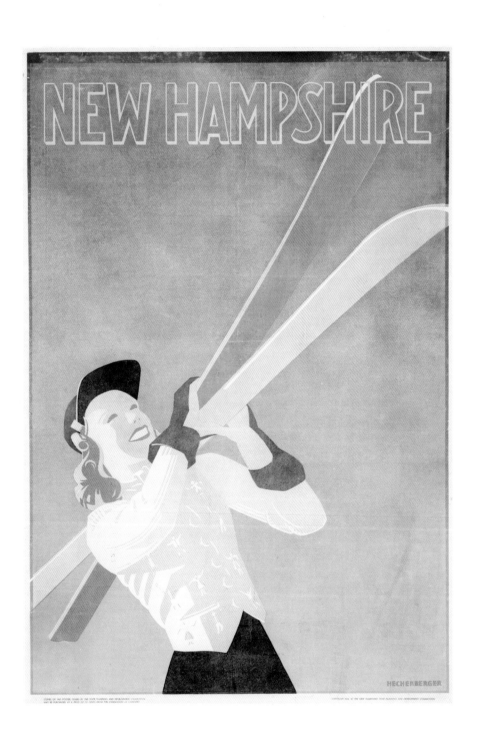

◉ NEW HAMPSHIRE
New Hampshire was the setting for many "firsts" in American skiing history—first modern downhill in 1927, first American slalom in 1928, first resort-based ski school in 1929. This Lou Hechenberger design echoes the more dramatic racer (opposite).

◉ RACER
Hechenberger's strikingly graphic racer, dating from 1939, rounds a slalom flag with a backdrop of the Tuckerman Ravine. With no lift to the top, everyone hiked up the mountain before racing down. Note the large pole baskets.

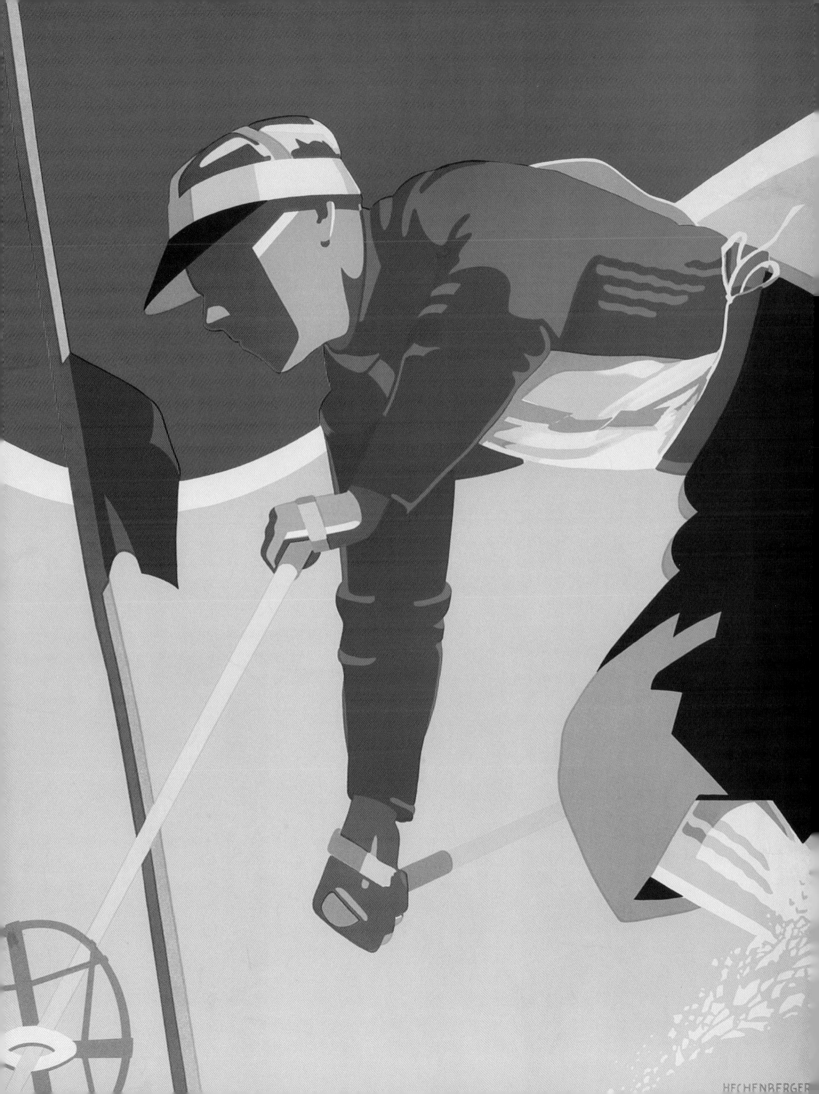

HECHENBERGER

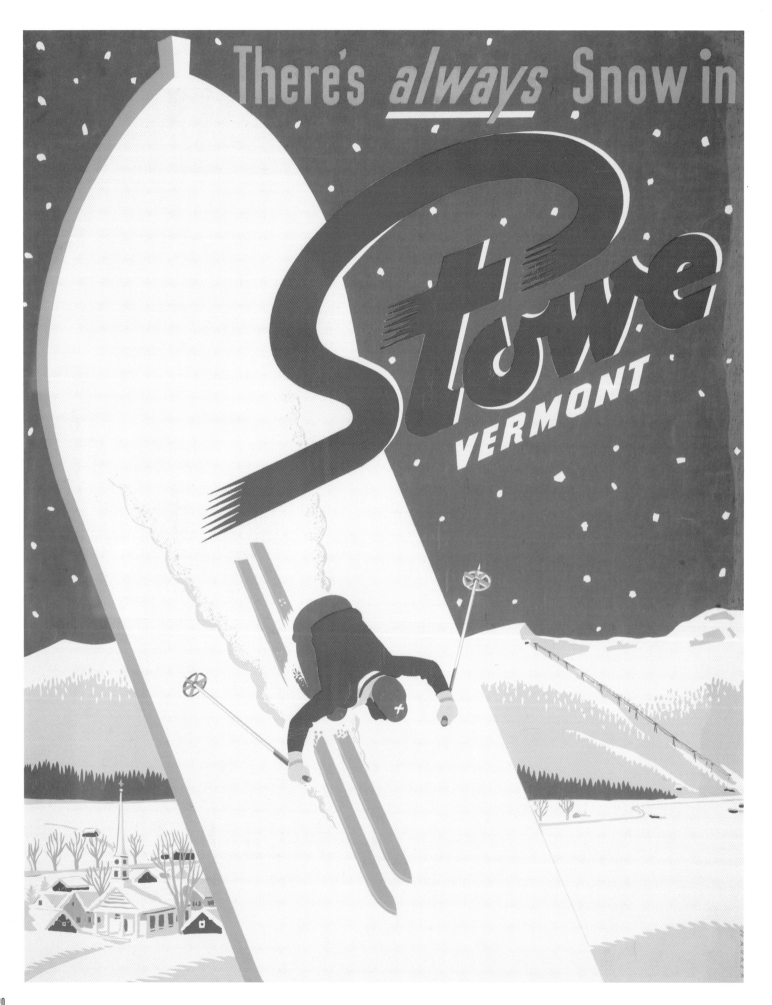

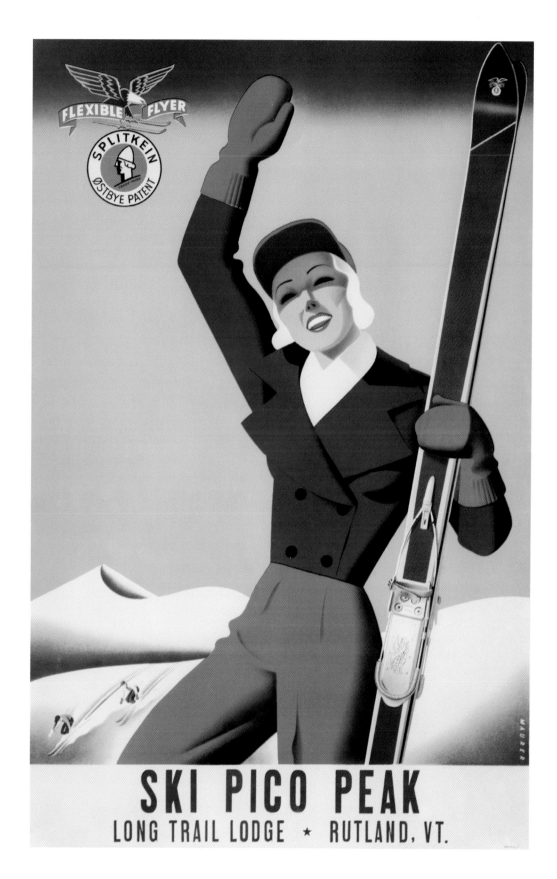

SKI PICO PEAK

LONG TRAIL LODGE ★ RUTLAND, VT.

◉ STOWE

Maurer's skills extended to direct resort promotion. Stowe is the most historic of New England resorts, encompassing two mountains–Mt. Mansfield, at 4,393 feet (1,339 metres) the highest in the state, and Spruce Peak. The first trails were cut from 1932, but descents were recorded from 1914. Maurer's Stowe logo, with the sweeping "S" in "Maurer Swash" typeface, is still in use today.

◉ PICO PEAK

Maurer's advertisement for "Flexible Flyer," with the instantly recognizable red eagle motif, is overprinted to advertise Pico Peak in central Vermont. A racing trail had been used for years from the top when in 1937, the first T-bar ski lift was installed, carrying two passengers instead of one. It became the mecca of Vermont skiing for the 1930s.

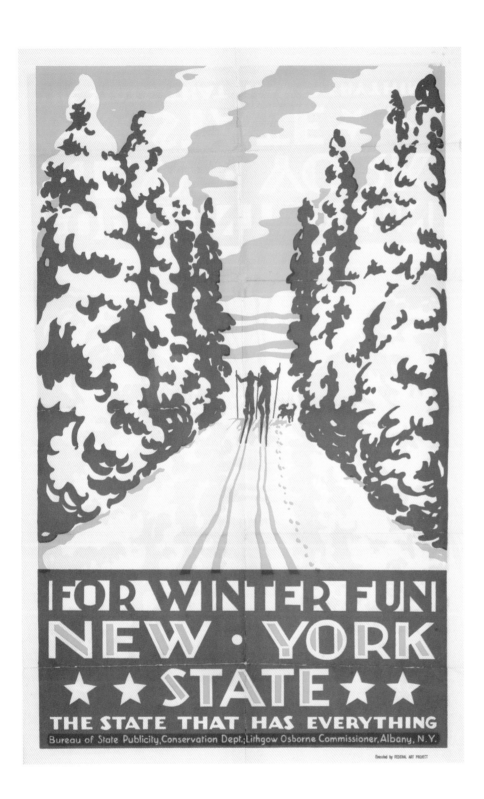

⟵ NEW YORK STATE

Inland New York State, away from the seaboard and New York City, is a landscape of lakes and mountains. The main ranges of the Catskills, Appalachians and Adirondacks all have resorts where snowfall is exploited to best advantage. Among the best-known are Hunter Mountain and Whiteface.

⟶ LAKE PLACID

Lake Placid is one of only three locations to have twice hosted the Winter Olympics–in 1932 and 1980. Surrounded by the mighty Adirondacks, closer to Montreal than New York, snow is guaranteed. Whiteface Mountain offers the greatest vertical skiing challenge east of the Rockies. Gordon Witold's official poster for the 1932 Winter Olympics held at Lake Placid, New York State, gave added impetus to the expanding American skiing industry.

III Olympic
Winter Games

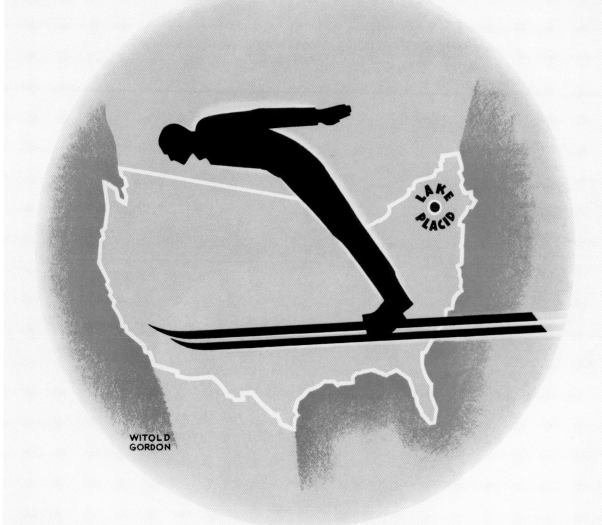

WITOLD
GORDON

LAKE
PLACID

Lake Placid, USA
February 4-13, 1932

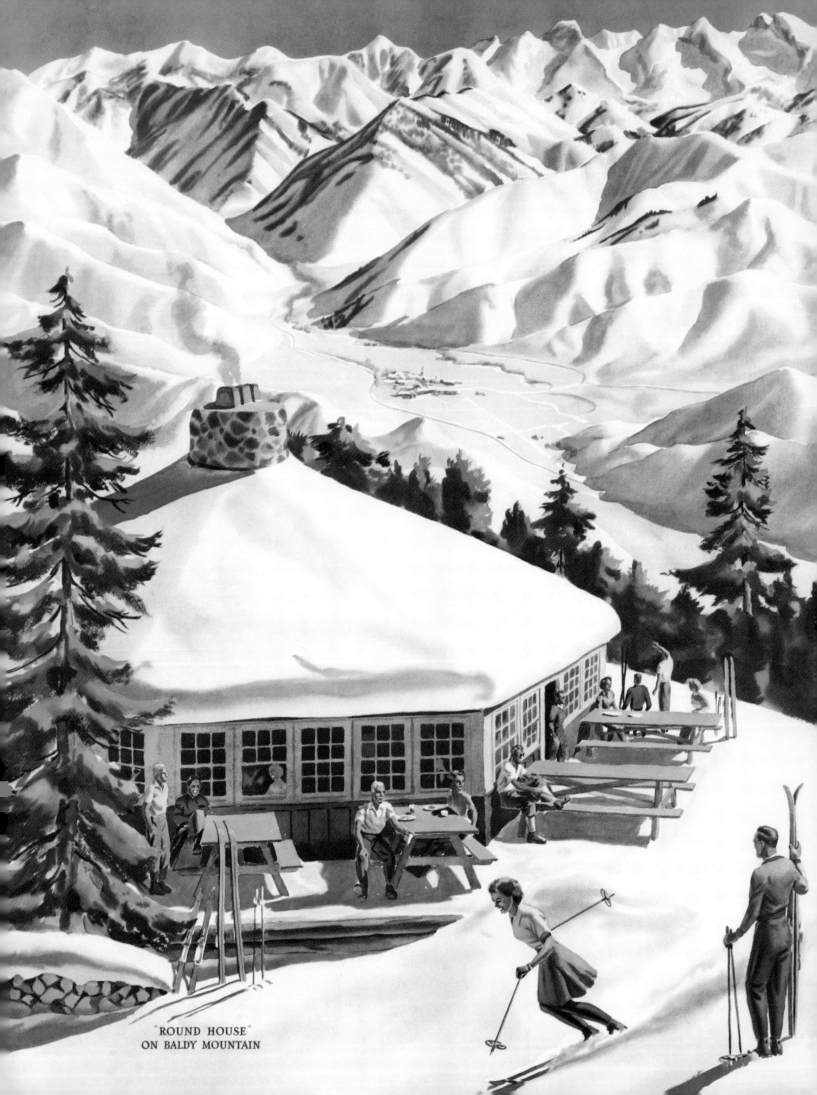

"ROUND HOUSE"
ON BALDY MOUNTAIN

The west was truly wild, the Civil War as yet unfought, when the first skis were introduced in Rocky Mountain territories. The Indian snowshoe had been used by native and settler alike on the plains, but the Scandinavian ski was far superior in the deep powder snow of the high mountains. In the 1850s, many Scandinavian gold miners emigrated to California, following the Gold Rush. Thus was skiing introduced to the United States, for with them they brought the techniques of ski jumping and cross-country skiing already popular in their native lands.

Of the Scandinavians who brought skiing to North America, one of the most famous was John "Snowshoe" Thompson. Norwegian by birth, he had moved with his family to the United States as a boy of 10. As a young man, he moved to California, where he got a job delivering mail—a job he elected to do on skis. He made his own skis (called snowshoes by the locals), from oak, calling on his memories of those seen in childhood. Between 1856 and 1876, he regularly made the 90-mile (145-kilometre) trek over the Sierra Nevada mountains, providing the miners with a much-appreciated link to the outside world.

When snow halted work in the mining camps of California and Colorado, the miners used it for recreation, donning their primitive skis for races and competitions. These events had a wild, rugged style, far removed from the elegance of European mountain spa resorts. Competitions developed for a championship belt, racing downhill on five-yard-long skis for prizes ranging from $25 to $75 (a day's wage was $3). There were no slalom courses, as the long boards were incapable of turning. Contestants invented peculiar waxes for the ski bottoms to increase speed, and the formulas for this "dope" were closely guarded secrets. Hundreds of spectators gathered to watch the sport at places like La Porte, in the Californian Sierra, site of the first American Ski Club, founded in 1861. These wilder carnival competitions remained unrecognized by the NSA (National Skiing Association) and ceased after 1911. Today's freestyle skiing has inherited carnival attributes on an even wilder scale: Crested Butte, in Colorado, hosts the annual U.S. Extreme Skiing Championships.

Most of the ski clubs formed in the early years of the twentieth century were essentially social. For many enthusiasts, skiing was a spectator sport, with ski jumping the main attraction. Norwegian Carl Howelson thrilled awestruck audiences touring the U.S. with his "ski circus" from 1911 onwards: national championships were held in Denver in 1920. In the following decades, the more adventurous began taking to the slopes themselves.

The high mountains of the Sierra Nevada, stretching 400 miles (644 km) up through California, now have more than 30 ski areas. The region around Lake Tahoe, which was easily accessible by railway, first became popular in the early twentieth century, when its fine vistas and crisp air attracted people wishing to escape the fog of San Francisco. Mining-era "snowshoes" were still in use by locals as vacationers arrived with their authentic skis and special outfits. The attraction of skiing above the treeline lured skiers from the lower slopes of the eastern states, and California soon began advertising the pleasures of a winter sports paradise, sensing

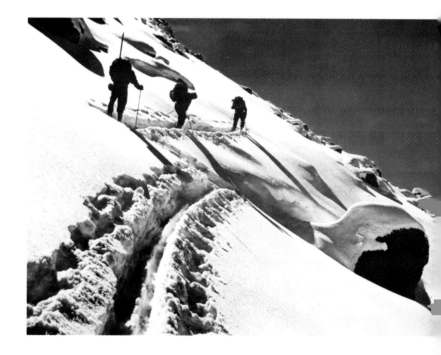

Right: The 10th Mountain Division trained at Camp Hale, Colorado, near Aspen before serving in Italy in the Appenines during World War II. On return to the U.S., several veterans became key figures in skiing's development, including Friedl Pfeifer and Pete Seibert.

Left: An enduring image of Sun Valley, of Round House mountain lodge, on Baldy Mountain, by Dwight Shepler— one of the foremost poster artists of the 1930s. The rustic-chic echoes European ski posters. Mount Baldy was opened in 1939, with wide bowls, long trails, and hair-raising runs.

USA WEST

potential future economic benefits. South of Lake Tahoe, at Yosemite National Park, a Swiss experienced in ski developments in Canada and Lake Placid, New York, was appointed director of winter sports. He built trail systems and ski huts, and hired guides as good as any in Europe. The Olympic skier Charley Proctor and eastern and European instructors ran the park's ski school on the lines of Alpine skiing. Word spread that here "one finds Europe in America."

As the century wore on, California continued to exploit its natural resources for skiers. The stunning scenery around Mammoth Mountain was explored by Dave McCoy in the 1940s; the resort that exists there today is largely his creation and vision. Squaw Valley, near Lake Tahoe, began in 1949 with a single chairlift. By 1960 it was in the full glare of world attention, hosting the Winter Olympics.

Meanwhile, other western states were developing their own skiing potential, as rope tows, T-bars, and chairlifts were installed, opening up previously inaccessible areas. In 1935, the first U.S. National Downhill and Slalom championships were held at Mount Rainier, Washington. The amateur combined category was won by skiing legend Dick Durrance, later director of the ski school at Alta, Utah, from 1940 to 1942—a position taken by Alf Engen after the 1948 Olympics.

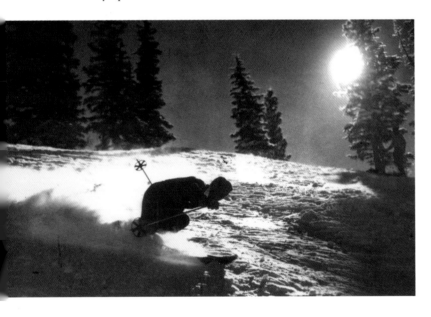

Engen had emigrated to the U.S. from Norway in 1929. Already a champion back home, he joined a team of professional ski jumpers touring the west, including Utah, where the Wasatch Mountains captivated him and his brother Sverre, later a snow safety expert. Although barred from the 1936 Olympics U.S. team for being shown in a Wheaties advertisement, he was appointed team coach in 1948. Alf was hired by the Forest Service to explore and evaluate mountain areas for future development. Thus he played a key role in the layouts of Alta and Snowbasin, in Utah, Magic Mountain, in Idaho, and Snow King, at Jackson Hole, Wyoming.

In 1936, the first purpose-built U.S. ski resort, Sun Valley, in Idaho, was created as an American St. Moritz, to boost Averill Harriman's Union Pacific Railroad. Charley Proctor was chosen to select ski runs. The world's first chairlift—modeled on a conveyor rig that loaded bananas onto fruit cargo boats in Central America—was installed on Dollar Mountain. Sun Valley became a magnet for the rich and famous, in its glory days boasting such glamorous regular visitors as Clark Gable, Errol Flynn, Claudette Colbert, Bing Crosby, and Gary Cooper. Ernest Hemingway wrote part of *For Whom the Bell Tolls* in Room 206 of the Sun Valley Lodge, although he came for hunting seasons, rather than skiing. Sun Valley was

Above: The legendary Friedl Pfeifer, a native Austrian from St. Anton and former Olympian, was first Ski School director at Aspen and instrumental in its development as a ski resort. He is shown here exhibiting his elegant style.

Top: A landmark building at Aspen— the Sardy House—with a picturesquely posed child on a cutter sleigh in foreground, in the 1950s. Recently restored, it is now a hotel.

more than a starry showcase, as its good skiing also attracted American champion skiers Don and Gretchen Fraser.

Another glamorous Rocky Mountain ski resort is Aspen, in Colorado, a state that evokes images of vast unspoiled whiteness, with superb fluffy, dry powder snow. A ski survey of the Aspen area was made in 1935 by founder members of the Roaring Fork Winter Sport Club, later the Aspen Ski Club. André Roch, a Swiss avalanche expert, commented that the slopes there were as good as anything in the Alps. He cut a racecourse on Aspen Mountain, served by a "Boat Tow": large sledges powered uphill by a gas motor, and an old mine hoist. During World War II, the 10th Mountain Division was training at nearby Camp Hale, and many of the soldiers spent their leave skiing at Aspen. One of them, Friedl Pfeifer, later teamed up with industrialist Walter Paepcke to form the Aspen Skiing Corporation in 1946. The first new ski lodges, bars, and restaurants opened shortly thereafter in the former mining town, and the world's longest ski lift opened there in 1947. Three years later, Aspen hosted the first U.S. international FIS World Championships. By the late 1950s it was the largest ski resort in the country, as well as a cultural center for music and theatre. Even larger today, it now encompasses four mountains: Aspen Mountain, Aspen Highlands, Buttermilk, and Snowmass, offering superb skiing and every luxury trimming one could desire.

Today, the skiing boom in the U.S. shows no signs of stopping. Skiers now expect all-around quality: fast lifts, groomed snow, ski patrols, good food, and comfort. Many more resorts have been opened in the past 50 years; in Colorado alone, there are some noteworthy ones. Vail (now the largest single resort, offering some of the finest open-terrain skiing), Steamboat Springs, Breckenridge, Crested Butte, and Snowmass all opened in the 1960s, with Copper Mountain, Keystone, and Telluride following in the 1970s, and Beaver Creek in the 1980s. Ironically, this newcomer to the ranks of American ski resorts chose a period-style poster to look "historic."

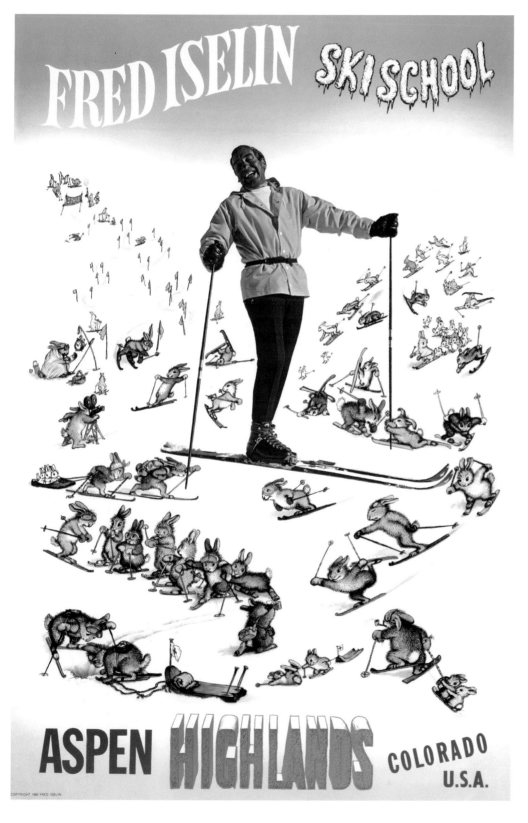

Fred Iselin was co-director (with Friedl Pfeifer) of the Aspen Ski School in the 1950s. Can Garth Williams' humorous poster be an in-joke acknowledgment to Czegka's St. Anton poster, showing Hannes Schneider similarly surrounded by a mischievous ski-school of rabbits?

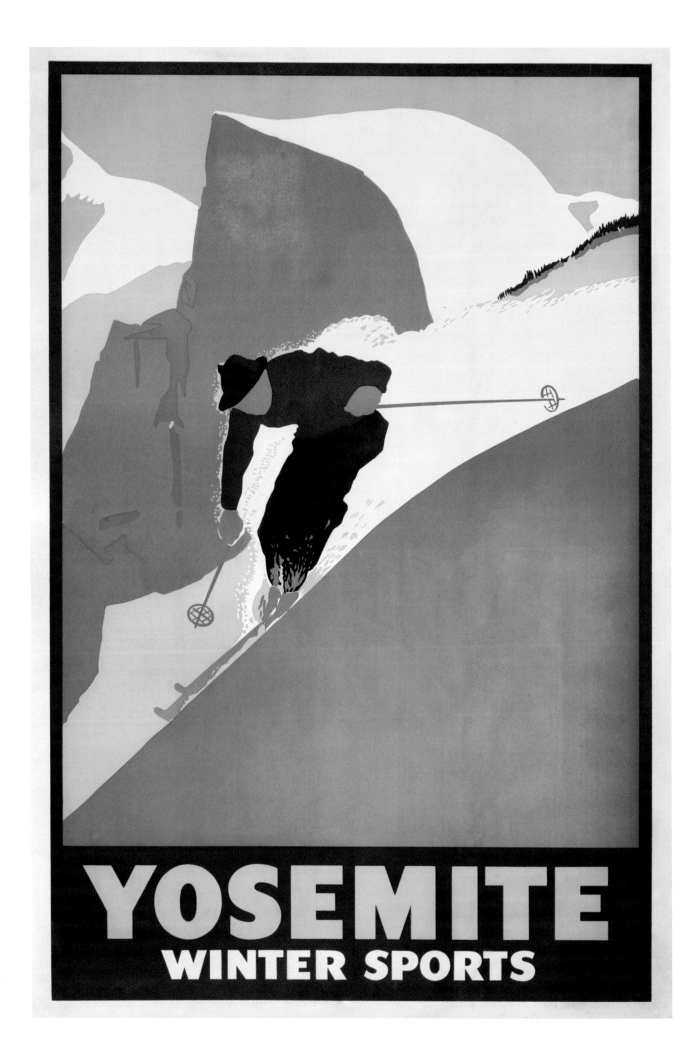

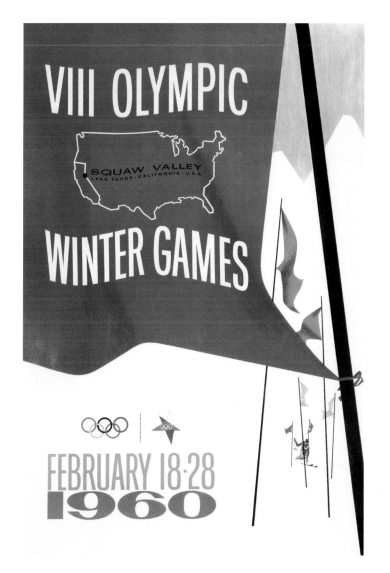

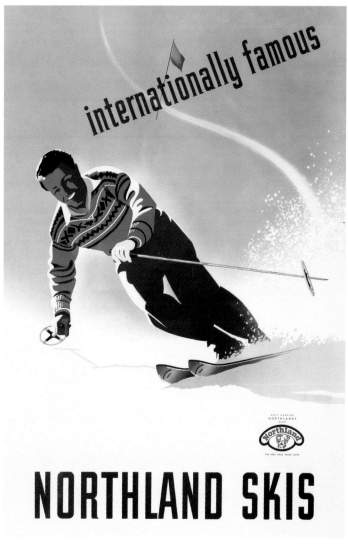

⬅ Yosemite

Molly Luce is the accredited artist for this view of the slopes of the Californian national park. "Snow Capital of California" was how Yosemite liked to consider itself and how it was promoted.

⬆ Squaw Valley

Squaw Valley hosted the Winter Olympic Games in February 1960. Chairman of the Pageantry Committee for the Opening and Closing Ceremonies was one Walt Disney, and the Games were officially opened by Vice-President Richard Nixon.

Northland Skis

Many early skiers learned on long hickory Northland skis. Founded by Norwegian Christian A. Lund in 1911, Northland manufactured skis at St. Paul, Minnesota in the Midwest, with an eastern factory at Franconia, NH. By the 1920s, they were the nations' largest producer of skis, toboggans and snowshoes, also publishing pamphlets on how to ski.

← COLORADO

Powder snow is the holy grail for skiers, and nowhere more so than Colorado. A spectacular range of high peaks, plains, and deep canyons make visually stunning scenery. Frequent, intense snowfalls ensure fluffy dry snow.

→ ROCKIES

The Rockies dominate Colorado. Local residents used skis and snowshoes long before skis were used for fun—popularized after Carl Howelson demonstrated ski-jumping at winter carnivals from 1911 onwards. Now Colorado has over 28 ski resorts.

Ski Colorado

COLORADO WINTER SPORTS COMMITTEE
State Capitol Building · Denver 2, Colorado

ASPEN

Ski Capital of the Americas

ASPEN
Aspen, originally known as Ute City, was renamed in the late 1800s after the surrounding trees on the Elk Mountains. From mining-town beginnings, it has become one of the richest and most glamorous ski resorts in the world, boasting Hollywood celebrity skiers as well as hosting world circuit competitions. Aspen is everything it's rumored to be: beautiful people, great skiing, a large city of perfectly preserved buildings, but with mountain village charm.

ASPEN HISTORY

André Roch, European avalanche expert, devized many of Aspen's trails. With Aspen Ski Club, he cut a racecourse on Aspen Mountain, using a "Boat Tow"– two large sledges pulled uphill by an old mine hoist and gas motor. He is shown here skiing in Tourtelotte Park. Aspen Snowmass now has four mountains.

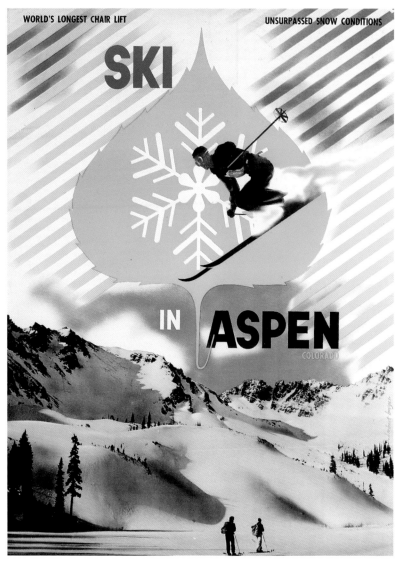

SKI IN ASPEN

Austrian émigré Herbert Bayer, a member of the Bauhaus from 1921 to 1928, heading their printing and advertising workshop, created this photomontage as one of Aspen's first posters in 1946. The leaf became the symbol for Aspen as did the sun for St. Moritz.

WINTER SPORTS
In the ROCKIES
VAIL
Colorado, USA

est. 1962 summit 11,455 ft. 4644 skiable acres

Vail

Vail is today America's largest single unlinked ski resort, with seven powdery bowls, spread over a seven-mile base. Officially opened in 1962, Vail has good skiing for all who can afford it. While Gerald Ford was president it was not uncommon to see him skiing with his secret-service "minders."

➔ Beaver Creek

Vail Resorts expanded and now own several resorts, including neighboring Beaver Creek, opened in 1980. Ten miles down the valley from Vail, it is a luxuriously elegant, quieter resort. This McMacken vintage-look poster was used to advertise the resort, as Colorado is proud of its skiing heritage.

146 GROOMED TRAILS

VILLAGE TO VILLAGE SKIING IN BEAVERCREEK COLORADO

NORTH AMERICA'S GRAND MOUNTAIN RESORT

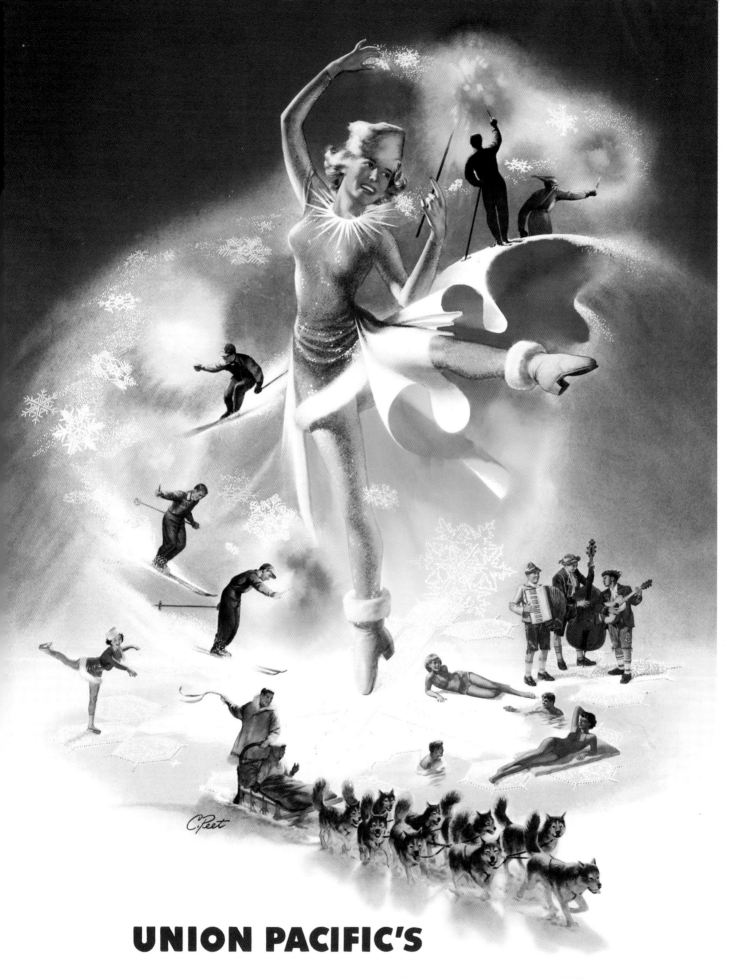

UNION PACIFIC'S

SUN VALLEY

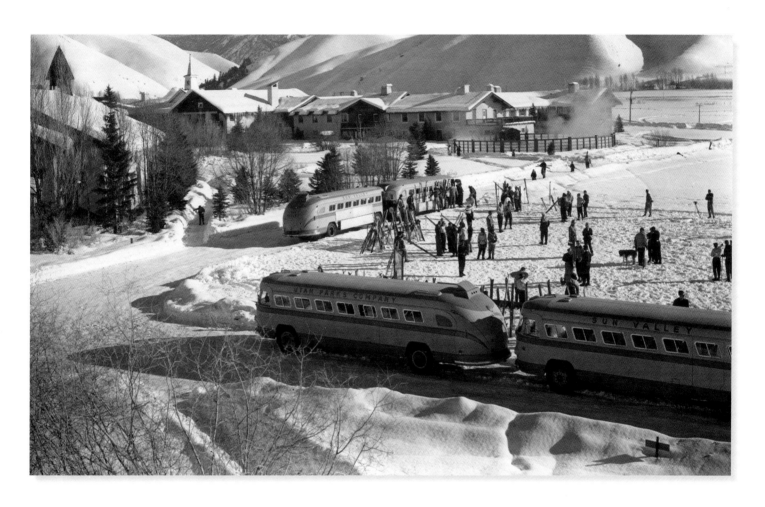

← SUN VALLEY

All that Sun Valley had to offer is shown in this montage. The "Valley" attracted legendary ice-skater Sonja Henje of Norway, winner of 10 world championships and three Olympic titles. She became a star in Hollywood, and filmed *Sun Valley Serenade* in 1941. Her ice spectaculars increased the popularity of skating.

↑ SHUTTLE BUS

The classic transport icons of the 1950s shown here shuttled skiers back and forth from the village to the slopes in Sun Valley. Initially favored by the wealthy and frequented by Hollywood movie stars, it was the first purpose-built skiing resort in the U.S.

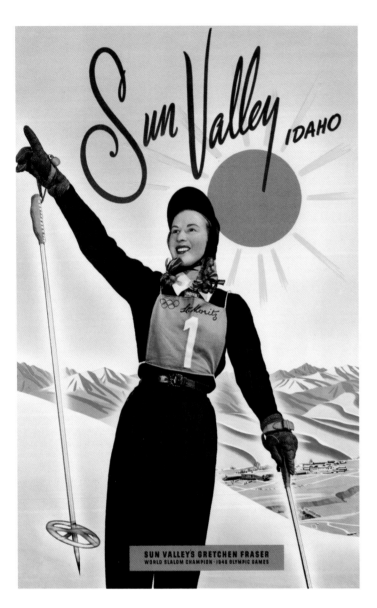

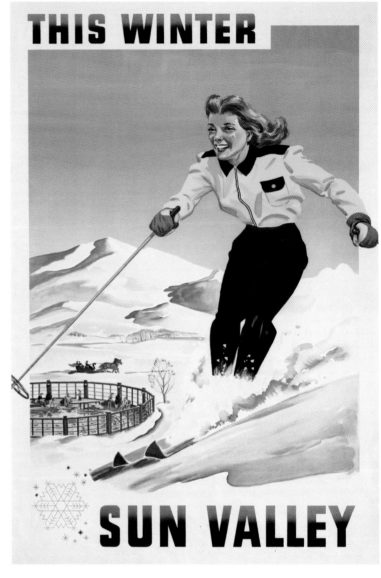

GRETCHEN FRASER

Celebrities such as Gretchen Fraser were often used to advertise Sun Valley. Fraser was the first U.S. women's Olympic gold and silver medalist, at the 1948 St. Moritz Games. She doubled for Sonja Henje in the ski scenes of the movies *Thin Ice* and *Sun Valley Serenade*.

THIS WINTER...SUN VALLEY

Sun Valley has a tradition of beauty and service, "roughing it in style," as original founder Averill Harriman called it. Images of healthy glamor were used to promote the resort, which became known as world-class for skiing, as well as superb for sunshine.

➔ SUN VALLEY RESORT

Sun Valley was built as a Union Pacific project. It opened with the world's first chairlifts, copied from banana lifts used to load fruit on to cargo ships. Harriman commissioned an Austrian expert, Count Felix Schaffgotsch, to find a suitable site for a purpose-built resort. He finally found a deserted valley north of Ketchum, Idaho reporting: "This combines more delightful features than any place I have ever seen in Switzerland, Austria, or the U.S. for a winter resort."

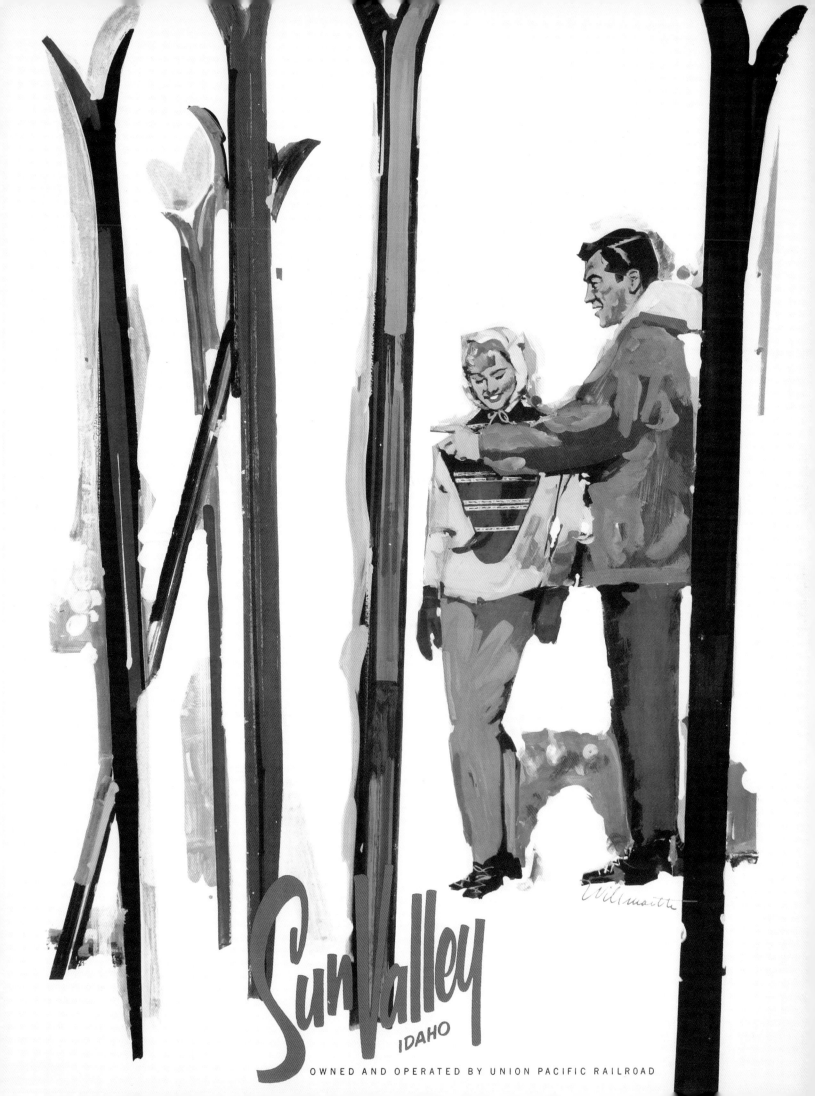

Sun Valley

IDAHO

OWNED AND OPERATED BY UNION PACIFIC RAILROAD

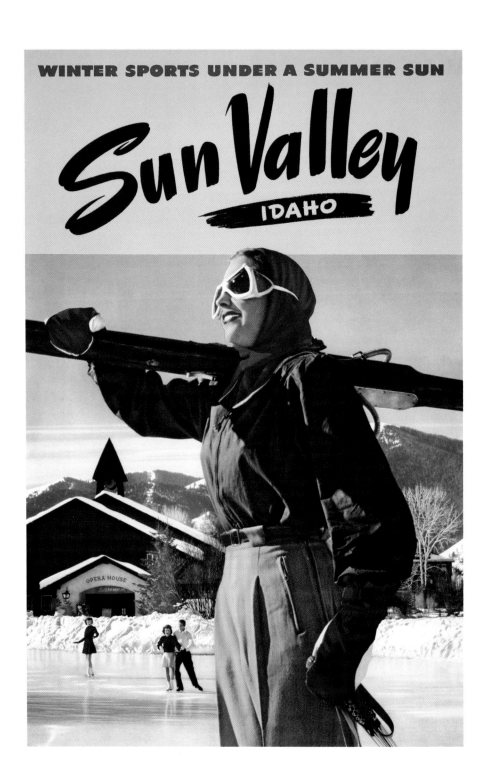

WINTER SPORTS UNDER A SUMMER SUN

Sun Valley
IDAHO

← WINTER SPORTS ...
SUMMER SUN

Schaffgotsch originally chose three mountains on which to cut trails—Dollar, Proctor, and Ruud—as Mount Baldy was considered too difficult. The last two are no longer used. Sunglasses, essential protection with the dazzling glare of sun on snow, became popular and fashionable in the late 1930s.

→ ALTA

In 1938, the second chairlift in the U.S. was installed at Alta, Utah, constructed of parts from mining hoists. In 1940, Alta Lodge was built and in 1941, Dick Durrance hired as manager and ski school director. A Dartmouth racer, at Alta he invented quick-linked powder turns, some 15 years before *wedeln* became popular. Utah is famous for its bottomless, translucent, champagne powder.

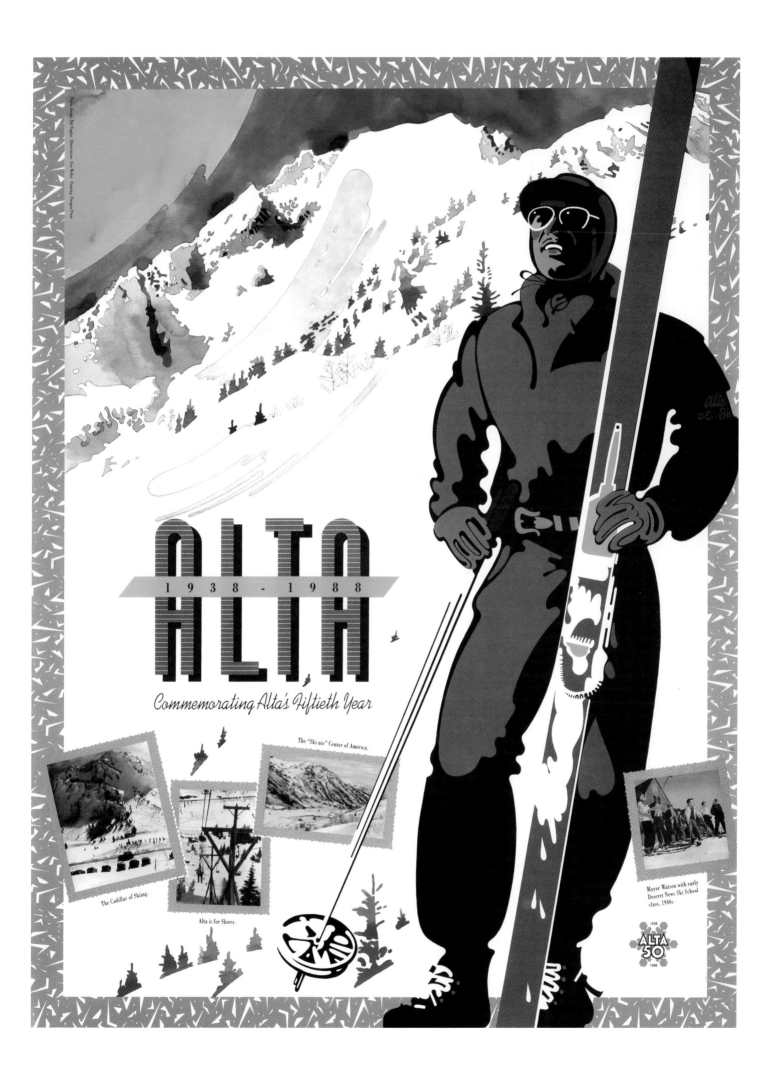

ALTA
1938 - 1988
Commemorating Alta's Fiftieth Year

The "Ski-nic" Center of America.

The Cadillac of Skiing.

Alta is for Skiers.

Mayor Watson with early
Deseret News Ski School
class, 1940s.

ALTA
50

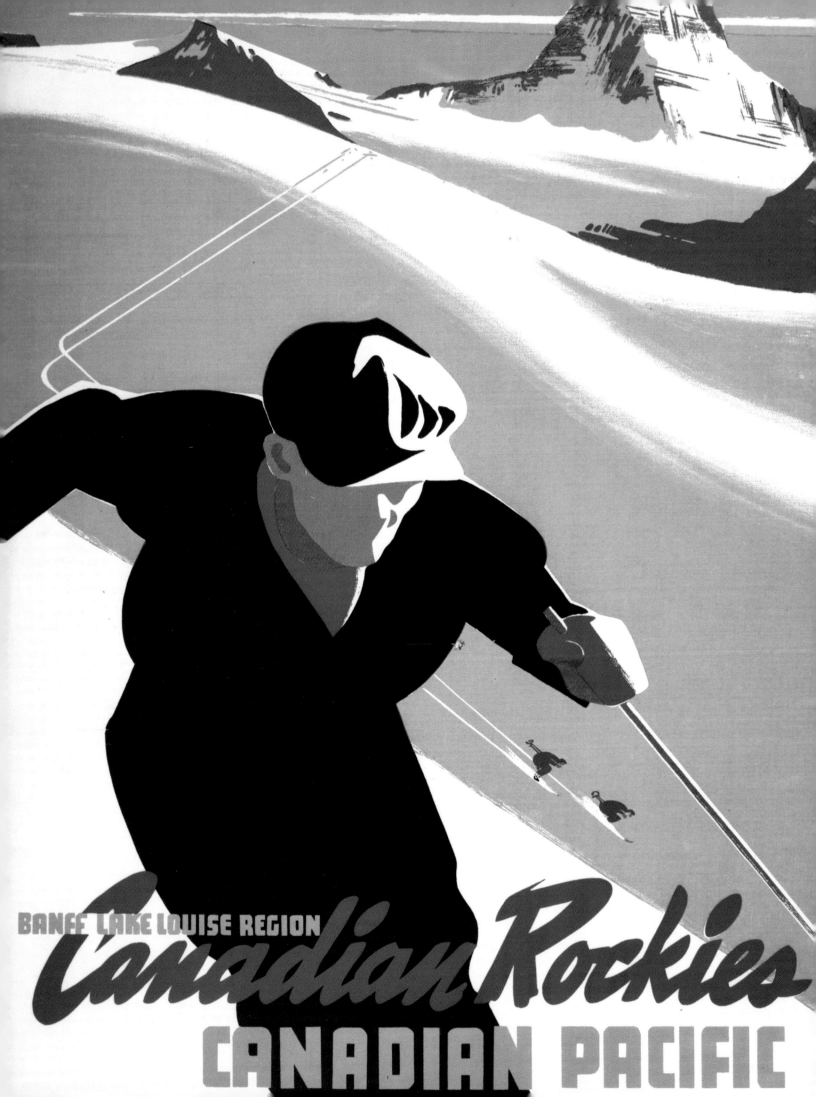

The role of Canadian Pacific (CP) was paramount in developing Canada's skiing resources. This giant travel organization, which owned not only railways but also ocean liners, airlines, and hotels, played a major role in the country's history—one of immigration, colonization, expansion, and development.

The Canadian Pacific Railway (CPR) was formed in 1881, initially to link eastern Canada to the western Pacific side. Seven years later, in the spectacular Rocky Mountain scenery of Banff National Park, the company built the magnificent neo-Gothic Banff Springs Hotel. Originally, the hotel was closed in the winter (William Van Horne, founder of the railway company, took exception to Rudyard Kipling's description of Canada as "Our Lady of the Snows" and promoted only summer sporting activities); not until the 1940s did it also open its doors to wintertime guests. King George VI of Great Britain and his wife, Queen Elizabeth (the Queen Mother), stayed there in 1939. Another famous guest was Marilyn Monroe. A dramatic glacial setting was found at nearby Lake Louise, for a second hotel, now known as the Fairmont Chateau Lake Louise.

Inevitably, the passion for skiing in the United States spread northward, and in the 1930s it became the focus of some of CP's memorably graphic sporting posters. The scenic wonders of the Rocky Mountains and the Laurentians were drawn to public attention, even though the first posters were only typographic. With the introduction of lithography to Canada came the facility to produce illustrated posters for different divisions of CP, mainly by anonymous artists. The lithographic process was overtaken by mass production of silkscreen printing, which enabled posters to be issued in alternative language versions. CP established a silkscreen-printing shop at their Windsor Station headquarters in Montreal, and a silkscreen studio, under their Exhibits Branch.

RESORTS
in the
CANADIAN PACIFIC ROCKIES
CANADIAN · PACIFIC · RAILWAY

One of the company's outstanding artists was Peter Ewart. As a young man fresh out of art school in New York, Ewart had been discouraged

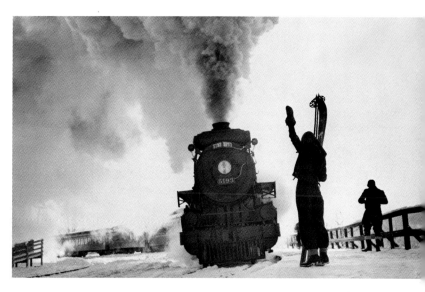

by the advertising agencies to whom he applied; then he decided to call on CPR in Montreal. This led to his first commission in 1939 and the first of 24 dramatically graphic posters he designed for CPR Railway and Airlines in the 1940s and 1950s. After the war, CP's advertising concentrated more on its airlines. However, the launch of a new scenic-domed passenger train, *The Canadian*, in 1955, brought Canada's natural splendors and skiing opportunities back to public attention.

The dramatic peaks of the Rockies are not the only part of Canada to have experienced a skiing boom. Back in the 1930s, the Laurentian Hills, in Quebec, were attracting enthusiastic skiers. In fact, the first modern rope tow in North America was built near Shawbridge, Quebec, at Foster's Hill, in 1932. It consisted of an old Dodge chassis, a continuous spliced rope roughly 1 inch in diameter, and a series of wheels and pulleys. A far cry from the advanced technology of the 2010 Winter Olympics, based around Vancouver.

Spectacular opening and closing ceremonies thanked the indigenous First Nations for allowing the Games to be held on their former lands. Harnessing the wilderness paid off, as, exceeding their wildest dreams, Canada gained the most Gold Medals, although the USA won overall.

In a country where sub-zero winter temperatures are the norm, winter sports are understandably popular, with arguably the best powder snow in the world.

Above: Canadian Pacific advertised the Rockies as early as 1924 for the glories of its natural scenery—unaware that skiing was soon to become a national sport.

Above right: In the late 1920s and 1930s, the advent of special snow trains—such as the Petit Train du Nord—from the larger cities played an essential role in the growth of skiing. This is at Val David, Quebec in 1938.

Left: Peter Ewart's 1941 poster for the Banff Lake Louise Region of the Rockies idealizes the skier's dream of getting away from it all in unspoilt wilderness.

CANADA

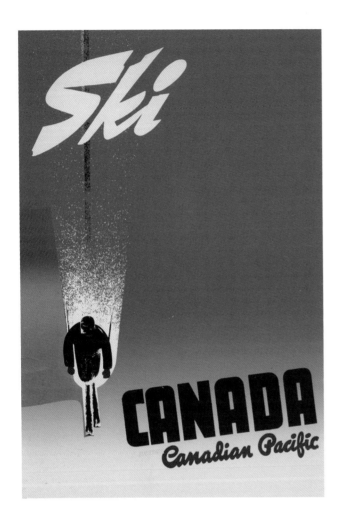

SKI CANADA

The impression of speed is expertly conveyed in Peter Ewart's 1941 poster (left). Today, downhill racers reach speeds of up to 90 miles per hour, requiring not only extreme strength, stamina, and courage, but also excellent technique. The amateur can nonetheless get a buzz out of the sport at far lower speeds—the magic of dancing on snow, getting a good rhythm going, can be as satisfying as breaking speed records. Another version of CP's poster (right) welcomed U.S. citizens to ski in Canada.

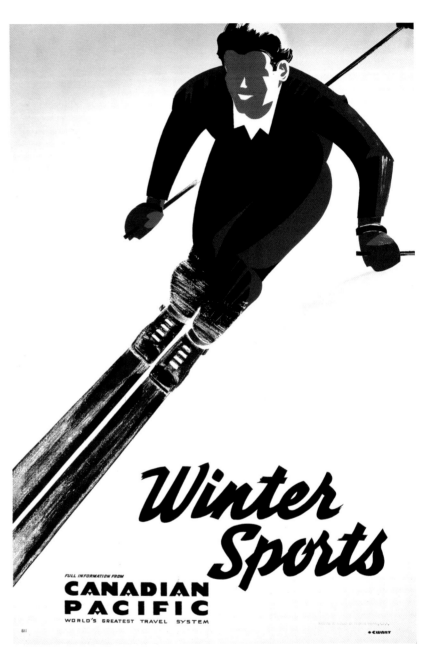

⊖ CANADIAN PACIFIC

Alfred Dehn's image for CP shows a lone skier in beautiful scenery, where the feeling of space and silence is miles away from the normal world. The earliest surviving Canadian ski was used in wolf hunts in the 1870s.

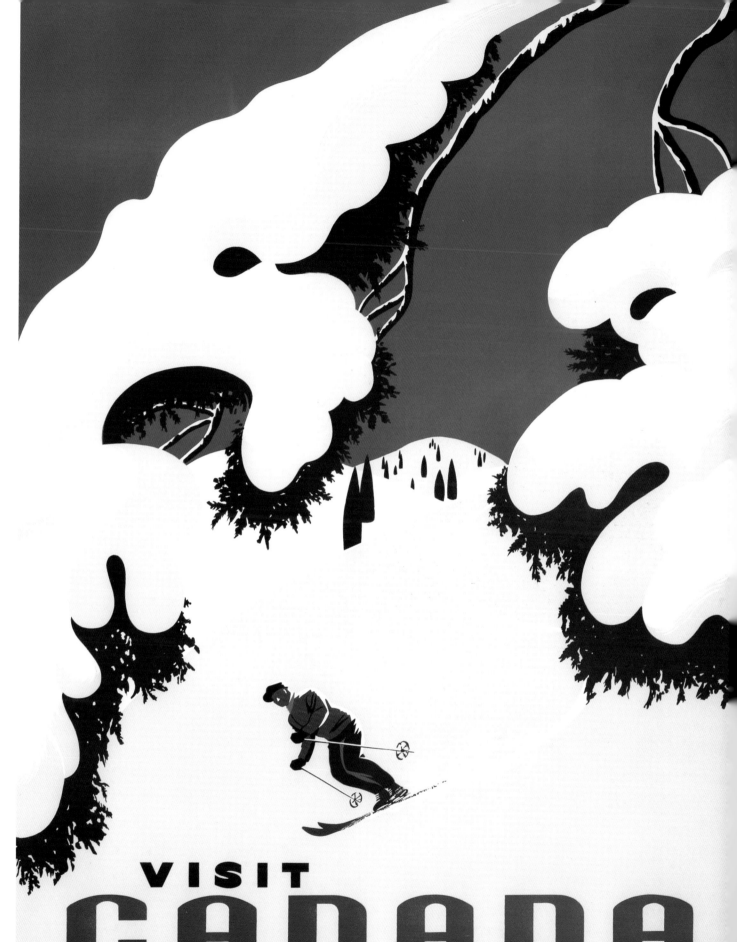

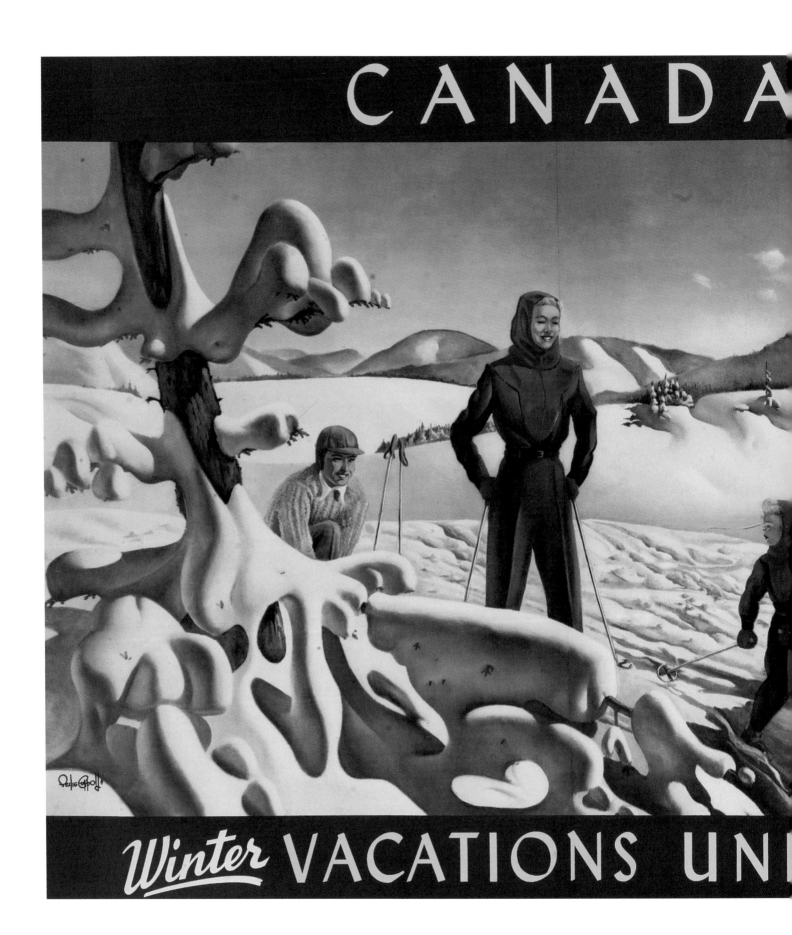

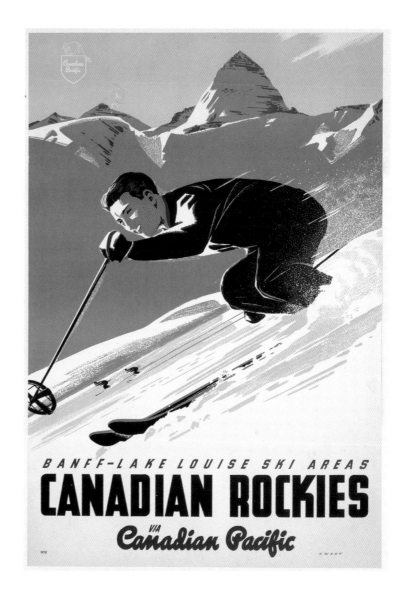

← WINTER VACATIONS
Canada, the second biggest country in the world, proudly boasts some of the finest powder snow in the world, as can be seen in Leslie J. Coppold's 1940 poster. Today, British Columbia's Rocky Mountain resorts include Whistler–North America's top skiing and snowboarding center.

↑ BANFF–LAKE LOUISE
Peter Ewart studied commercial illustration in Montreal and New York, and created many of CP's memorable skiing images. Banff and neighboring Lake Louise, set among spectacular rugged wilderness, now a National Park, open up a spectacular scenic skiing domain, worthy of all superlatives.

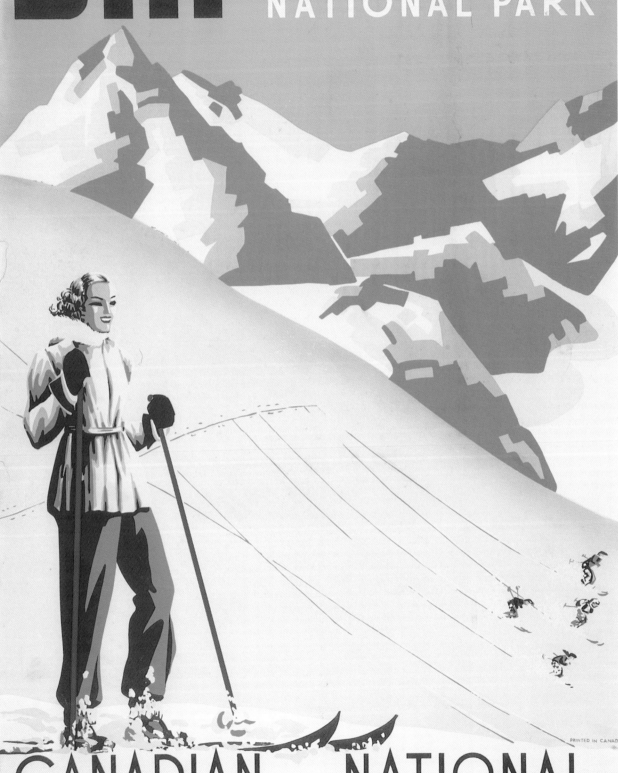

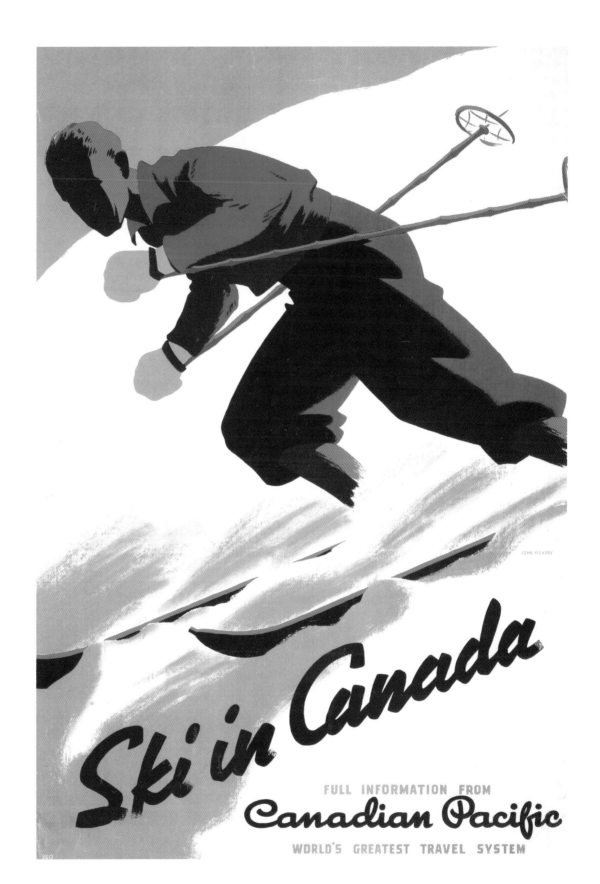

← JASPER NATIONAL PARK
National railways or airlines other than CP used advertising to tempt city dwellers to explore the wilder parts of the country. Deep in the park, there are just elk, deer, snow, and open skies.

→ SKI CANADA
John Vickery's poster for Canadian Pacific from 1937 was also published in French and an alternative English version, with different wording, was issued for the Lac Beauport district of Quebec.

Ski in Canada

FULL INFORMATION FROM
Canadian Pacific
WORLD'S GREATEST TRAVEL SYSTEM

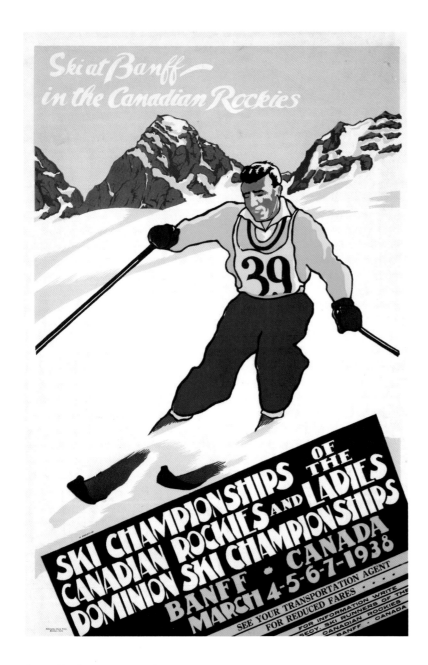

BANFF SKI CHAMPIONSHIPS
By 1936 skiing was popular
enough to hold competitions,
and the terrain—and relative
proximity to Calgary—of Banff
was chosen venue for the
Dominion Championships.
The surrounding wildlife,
for elk or bears can still
be seen, must have been
quite surprised.

⊕ BANFF
In the heart of the Rockies, the
Banff Springs Hotel was one of
CP's fairytale chateau hotels.
Its unique "blend of opulence
and seclusion" was opened
in 1888 and altered in 1928.
Van Horne, founder of CP,
recognized the tourist
potential of Banff's hot springs.
Norman Fraser's poster of
1939 shows the extraordinary
contrast of civilization in
the wilderness.

⊕ WINTER SPORTS AT BANFF
A menu cover designed by
Charles Greenwood in 1928 for
Canadian Pacific promotes the
newly discovered winter sports.
Skiing is inset but skating was
then the main attraction.

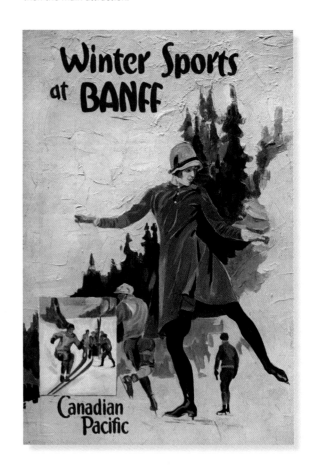

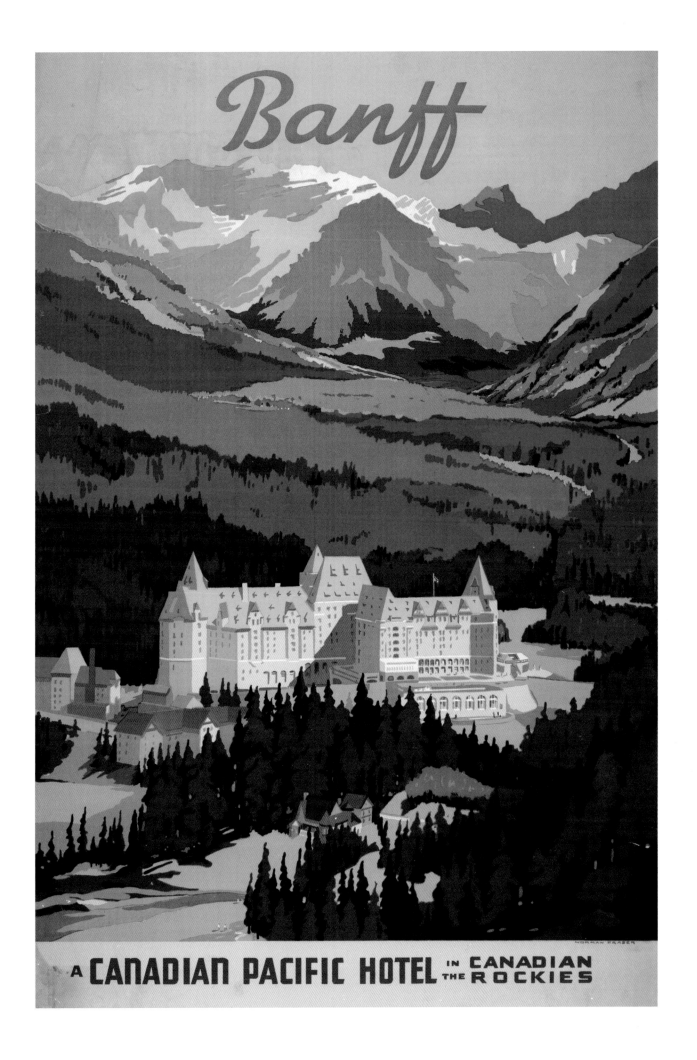

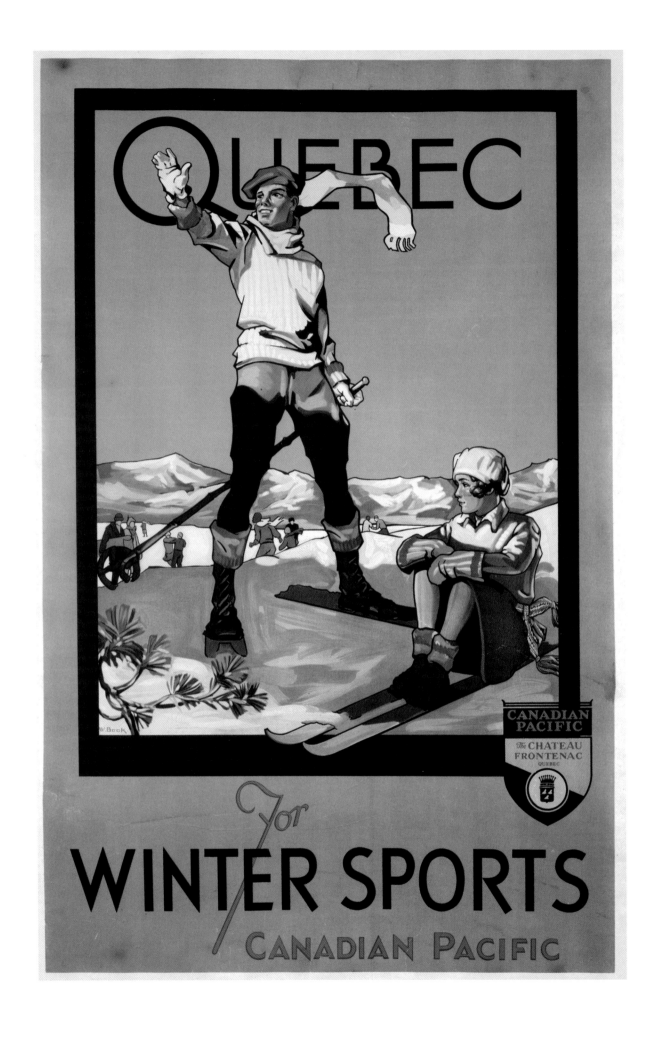

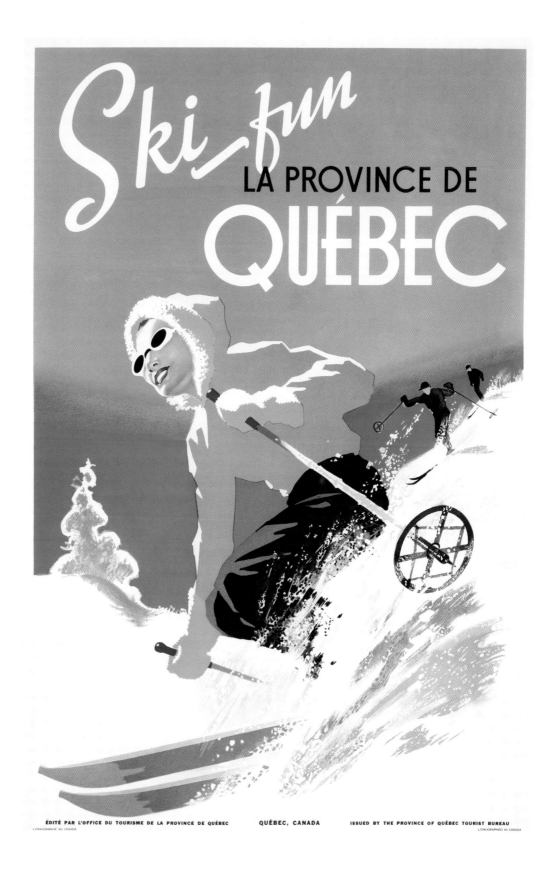

← QUEBEC
Canada's first ski tow was installed at Shawbridge, Quebec in 1932, spawning many others across the country. Book's design for CP from fractionally earlier, shows carefully co-ordinated period clothing.

→ SKI FUN QUEBEC
The province of Quebec, both English- and French-speaking, includes not only the scenic Laurentians but also Mont-Sainte-Anne and more recently, Stoneham. With deep snow and fine conditions nearby, Quebecois need not travel to the Rockies.

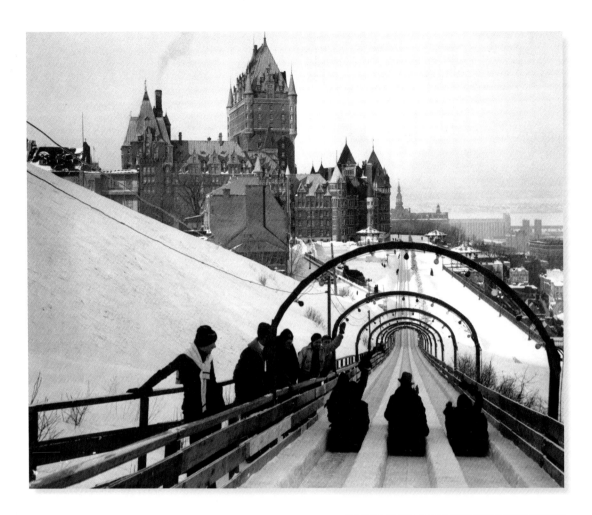

CHATEAU FRONTENAC
The historic walled and fortressed Quebec City contains the first CP building to feature distinctive chateau-style architecture–the Chateau Frontenac Hotel, which opened in 1893. A roll-call of foreign royalty and world leaders have visited. Here we see the triple-chute toboggan slide on Dufferin Terrace, with the hotel as backdrop.

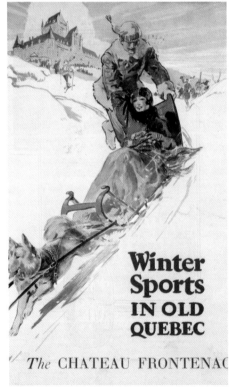

Winter Sports IN OLD QUEBEC

The CHATEAU FRONTENAC

⬅ OLD QUEBEC
Associations with "Old Quebec" were soon incorporated by graphic artists into their designs, targeting the new market for winter sports. The Chateau Frontenac offered the following winter sports in the late 1920s: skating, curling, ski-jump on Citadel Hill, hockey, skijoring, cross-country skiing, snowshoe, bob-sledding, sleigh drives, and husky dog-sledding, as shown here.

➡ LAC BEAUPORT
The Lac Beauport area is just 15 minutes north of Old Quebec, where skating and skiing have been popular since the 1930s. Thomas Hall's poster dates from around 1938, and shows a more streamlined skier, heralding continuing progress in skiwear and equipment.

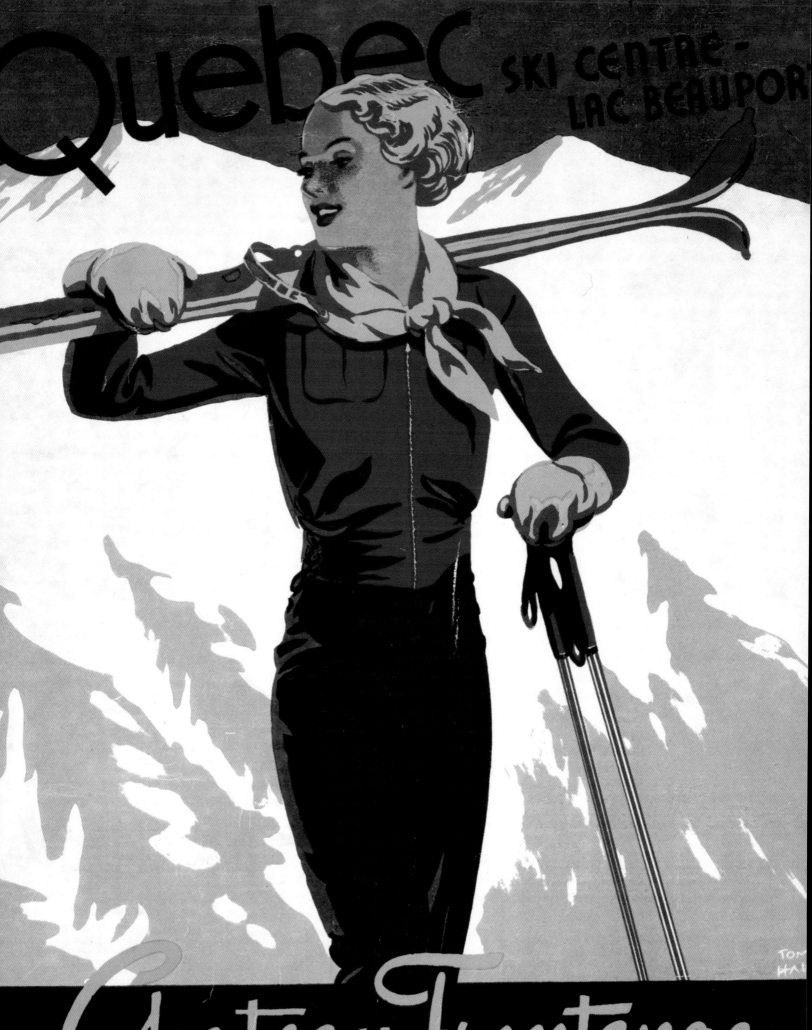

TOURIST OFFICES

SCANDINAVIA

US/UK: www.goscandinavia.com

Norway
US: www.visitnorway.com/us
UK: www.visitnorway.com

Swedish
US/UK: www.visitsweden.com

Finland
US: www.gofinland.org
UK: www.visitfinland.com

AUSTRIA

US: www.austria.info/us
UK: www.austria.info/uk

Alpbach
Email: info@alpbachtal.at
Web: www.alpbachtal.at

Badgastein
Email: info@gastein.com
Web: www.gastein.com

Igls
Email: igls@innsbruck.info
Web: www.innsbruck-igls.at

Kitzbühel
Email: info@kitzbuehel.com
Web: www.kitzbuehel.com

Lech and Zürs
Email: info@lech-zurs.at
Web: www.lech-zuers.at

Salzburg
Contact: www.salzburg.info/en/contact_us
Web: www.salzburg.info

Seefeld
Email: info@seefeld.com
Web: www.seefeld.com

St Anton
Email: info@stantonamarlberg.com
Web: www.stantonamarlberg.com

Tyrol
Email: info@tirol.at
Web: www.tyrol.com

GERMANY

Berchtesgaden
Email: info@berchtesgadener-land.info
Web: www.berchtesgadener-land.info

Garmisch-Partenkirchen
Email: tourist-info@gapa.de
Web: www.gapa.de

FRANCE

Alpe d'Huez
Email: info@alpedhuez.com
Web: www.alpedhuez.com

Chamonix
Email: info@chamonix.com
Web: www.chamonix.com

Megève
Email: megeve@megeve.com
Web: www.megeve.com

St. Gervais
Contact: www.saintgervais.com/en/contact
Web: www.saintgervais.com

Val d'Isère
Email: info@valdisere.com
Web: www.valdisere.com

ITALY

Cervinia
Email: info@cervinospa.com
Web: www.cervinia.it

Cortina d'Ampezzo
Email: cortina@infodolomiti.it
Web: www.infodolomiti.it

Courmayeur
Email: info@comune.courmayeur.ao.it
Web: www.comune.courmayeur.ao.it

Sestriere
Email: info@comune.sestriere.to.it
Web: www.sestriere.it

Valle d'Aosta
Email: info@turismo.vda.it
Web: www.regione.vda.it

SWITZERLAND

Adelboden
Email: info@adelboden.ch
Web: www.adelboden.ch

Arosa
Email: arosa@arosa.ch
Web: www.arosa.ch

Crans-Montana
Email: info@crans-montana.ch
Web: www.crans-montana.ch

Davos
Email: info@davos.ch
Web: www.davos.ch

Grindelwald
Email: touristcenter@grindelwald.ch
Web: www.grindelwald.com

Klosters
Email: info@klosters.ch
Web: www.klosters.ch

Mürren
Email: info@jungfrauregion.ch
Web: www.mymuerren.ch

Pontresina
Email: pontresina@estm.ch
Web: www.pontresina.ch

St. Moritz
Email: stmoritz@estm.ch
Web: www.stmoritz.ch

Villars
Email: information@villars.ch
Web: www.villars.ch

Wengen
Email: www.wengen.ch
Web: www.wengen-muerren.ch

Zermatt
Email: info@zermatt.ch
Web: www.zermatt.ch

EAST AMERICA

Cannon Mountain
Email: info@cannonmt.com
Web: www.cannonmt.com

Killington
Email: info@killington.com
Web: www.killington.com

Lake Placid
Email: visitorservice@lakeplacid.com
Web: www.lakeplacid.com

Mount Cranmore
Email: info@cranmore.com
Web: www.cranmore.com

Pico
Email: info@picomountain.com
Web: www.picomountain.com

Stowe
Email: info@stowe.com
Web: www.stowe.com

GAZETEER

Woodstock
Email: email@woodstockinn.com
Web: www.woodstockinn.com

WEST AMERICA

Alta
Email: info@alta.com
Web: www.alta.com

Aspen
Email: contactus@aspensnowmass.com
Web: www.aspensnowmass.com

Beaver Creek
Email: info@vailresorts.com
Web: www.beavercreek.com or www.vail.net

Lake Tahoe
Email: info@vailresorts.com
Web: www.virtualtahoe.com or www.skiheavenly.com

Mammoth
Email: 800MAMMOTH@mammoth-mtn.com
Web: www.mammothmountain.com

Squaw Valley
Email: squaw@squaw.com
Web: www.squaw.com

Sun Valley
Email: reservations@sunvalley.com
Web: www.sunvalley.com

Vail
Email: vailinfo@resorts.com
Web: www.vail.com or www.vail.net

Yosemite
Email: yosecom@dncinc.com
Web: www.yosemitepark.com

CANADA

Banff/Lake Louise
Email: info@SkiBig3.com
Web: www.skibig3.com

Jasper
Contact: www.jasper.travel/contact
Web: www.jasper.travel

Mont Tremblant
Email: info_tremblant@intrawest.com
Web: www.tremblant.ca

Quebec
Contact: www.quebecregion.com/en/contact
Web: www.quebecregion.com

Whistler
Email: wbres@whistlerblackcomb.com
Web: www.whistlerblackcomb.com

SKI MUSEUMS

EUROPE

Holmenkollen Ski Museet
www.holmenkollen.com

Olympic Ski Museum, Lausanne
www.olympic.org/museum

Sports Museum of Switzerland
www.sportmuseum.ch

AMERICA

Colorado Ski Museum and Hall of Fame
231 South Frontage Road East
Vail, CO 81657
www.skimuseum.net

New England Ski Museum
135 Tramway Drive
Franconia, NH 03580
www.newenglandskimuseum.org

US National Ski Hall of Fame and Museum
610 Palms Avenue
Ishpeming, MI 49849
www.skihall.com

Vermont Ski and Snowboard Museum
One South Main Street
The Perkins Building
Stowe, VT 05672
www.vtssm.com

CANADA

Canadian Ski Hall of Fame and Museum
Musée canadien du ski
317 Chemin du Bord-du-Lac,
Pointe-Claire, QC, H9S 4L6
www.skimuseum.ca

See also
www.skiinghistory.org/resources/ski-museums-world

SELECT BIBLIOGRAPHY

Allen, E. John B., *From Skisport to Skiing* (University of Massuchusetts Press, 1998)

Bibliothèque Municipale de Chamonix, Cent Ans d'Affiches à Chamonix (Editions Clouet, 1991)

Choco, Marc H. and David L. Jones, *Posters of the Canadian Pacific* (Firefly, 2004)

D'Egville, A. H., *Modern Ski-ing* (Edward Arnold & Co., 1927)

Dedeyan, J-M and J-C Ligeon, *Il Etait une fois Megève* (Editions Champs Elysées, 2001)

Engen, Alan K., *For the Love of Skiing* (Gibbs-Smith, Salt Lake City, 1998)

Flower, Raymond, *The Story of Ski-ing and Other Winter Sports* (Angus & Robertson, 1976)

Foto Ghedina, *Ti ricordi com'era Cortina?* (Cortina, 1999)

Gill, Chris and Dave Watts, *Where to Ski* (Boxtree, 1995)

Hardy, Peter and Felice, *The Good Skiing and Snowboarding Guide* (Which Books, 2005)

Hillier, Bevis, *Posters* (Weidenfeld & Nicolson, 1969)

Hobson, Clive, *Skiing USA: The Insider's Guide* (Fodor's Travel Publications, Inc., 1995)

Hussey, Elisabeth, *The World's Greatest Ski Holidays* (Proteus, 1982)

Lunn, Arnold, *The History of Ski-ing* (Oxford University Press, 1927)

Lunn, Peter, *The Guinness Book of Skiing* (Guinness Superlatives, 1983)

Rayner, Rolf and Robert Guy, *The Story of Skiing* (David & Charles , 1989)

Richardson, E. C., *The Ski-Runner* (1909)

Riddell, James, *The Ski Runs of Austria* (Michael Joseph, 1958)

Riddell, James, *The Ski Runs of Switzerland* (Michael Joseph, 1957)

Ring, Jim, *How the English Made the Alps* (John Murray, 2000)

Samuel, John, *The Love of Skiing* (Octopus, 1979)

The Good Skiing and Snowboarding Guide (2005)

Weill, Alan and Isabel Perry, *Roger Broders Travel Posters* (Queen Art Publishers, NY)

Wyder, Bernard, *Affiches Valaisannes* (Rotten Verlag, Mediathèque Valais 2004)

THE BEEKLEY COLLECTION OF SKI POSTERS

by Nicolette Tomkinson

As poster specialist at Christie's, a combination of increasing demand from clients for ski posters, the impact of the visual images and a personal passion for the sport, gave me the idea of a specialist Ski Sale. From the inaugural sale in February 1998 until today, the market has continued to grow, reaching a peak in 2008, when the sale realized over three quarters of a million pounds for the first time.

I first met Mason Beekley at the inaugural Christie's specialist ski sale in 1998. By this time, Mason had already amassed the world's largest known library of ski books (2,000 volumes), plus a huge collection of pictorial art and sculpture, and wished to boost his poster collection. He sought advice and guidance from me as to which posters he should buy, and was a major patron of the early sales, helping to establish and define the auction market. He also bought American ski images from Swann Galleries' February sales in New York. As a result of his trips to London, Mason became a good friend, and in April 1999, I viewed his collection in New Hartford, Connecticut. The collection was then housed in a beautiful purpose-built private museum, Ski Aerie, next to his home. Mason's passion for ski history was clearly evident, and the visit revealed without question the finest private collection of ski posters that I have ever had the pleasure and privilege to view.

Following Mason's death in August 2001, the W Mason Beekley Collection is cared for by the Beekley Family Foundation, Hartford, Connecticut. It is currently housed in a climate-controlled storage facility in Colorado and future exhibitions are planned. The collection contains examples of the finest Swiss artists working in the early part of the twentieth century, notably Emil Cardinaux (1877–1936), Burkhard Mangold (1873–1950), Hugo Laubi (1888–1959), Herbert Matter (1907–84), and Martin Peikert (1901–75). A group of classic Art Deco railway posters by French artist Roger Broders (1883–1953) with typically bold, angular, clean lines represents a spectacular phase in the history of modern advertising.

Two of the earliest posters in the Beekley collection, both featuring Chamonix, are Abel Faivre's (1867–1945) *c.* 1905 skiing lady and Francisco Tamagno's (b. 1851) *c.* 1900 skiing couple. Both are highly sought after by collectors, as they are a perfect visual reminder of the early ski equipment and fashion on the slopes. Representative of the emerging resorts in the United States is the artist Sascha Maurer (1897–1961), who was recruited by the New Haven Railroad to design many of its now most popular images. Maurer himself loved to ski, and his dynamic designs command the highest prices at auction, as his images powerfully convey the exhilaration of the slopes.

The railway company or tourist office provided the standard text panel that often formed the lower portion of the poster. The designer was then able to use artistic license to capture the essence of the location or the pleasure of skiing there in his/her own style. Besides France and the United States, other countries embracing poster art to promote their winter resorts included Austria, Finland, Germany, Italy, Norway, Poland, and Sweden. It was common in many countries for print runs to be extended, so that the public could purchase copies of the posters. Hence, today we have been left with a huge range of artistic styles chronicling the history of the sport—changes in techniques, in equipment, and in the resorts themselves, in Europe and North America.

The market for ski posters continues to grow, as they are still a comparatively inexpensive way of decorating a home or chalet. Skiers looking for ways to brighten up their mountain homes regard ski posters, with their strongly nostalgic character, as the perfect

PALACE HOTEL

ST. MORITZ
IN SWITZERLAND

WOLFSBERG ZURICH

In 2004, an original of Emil Cardinaux's poster of the Palace Hotel, St. Moritz, 1920, raised the world-record price for a Swiss ski poster at auction—£23,900 ($45,410).

choice. They are also a uniform size, usually 40 x 25 inches (102 x 64 cm) and 50 x 351/2 inches (127 x 90 cm) and work well in both traditional and contemporary interiors.

Although artists are important in this market, resorts take priority. There was fierce competition to produce posters that portrayed one's area as the most stylish place to stay. Hence, five-star hotels were regularly featured in the posters, as well as fashionable ladies enjoying the winter air. The elegantly chic, internationally renowned resort of St. Moritz (which has more five-star hotels than any other ski resort) always commands the highest prices. Fittingly, the iconic 1920s Palace Hotel poster (left) by Emil Cardinaux holds the world-record price for a Swiss ski poster at auction, fetching £23,900 ($45,410) in London in February 2004. The deserted slopes of the Art Deco posters often suggest a golden age of skiing that has long disappeared. Some resorts, including Chamonix, are proud of their place in advertising art and use reproductions of the original posters on everyday items such as ski passes, thus raising the profile and demand for the originals.

Skiing was not the only winter sport promoted on these posters. Many resorts used them to advertise bobsledding, ice hockey, ice skating, climbing, and the virtue of fitness in the mountain air. The ski lifts and cable cars were also favorite subjects for the poster artists, as such technology was a major selling point. The only way to ski down the mountain in the early days was to walk up it first.

Thanks to the Beekley Family and the Beekley Family Foundation for providing access to posters in the Beekley International Collection of Skiing Art & Literature.

Nicolette Tomkinson is Director of the Vintage Posters Department at Christie's South Kensington, London. Information about the annual Ski Sale can be found at www.christies.com and Swann Galleries at www.swanngalleries.com.

The Beekley Family Foundation have kindly agreed to provide access to posters in the Beekley International Collection of Skiing Art & Literature.

ACKNOWLEDGMENTS

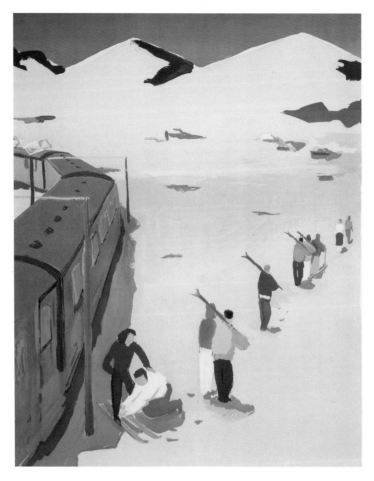

Hans Jegerlehner: *Zum Wintersport mit der Eisenbahn*, 1950 ("To winter sports with the railway").

Grateful thanks are due first and foremost to T. J. Chase, curator of Mammoth Ski Museum, home of the Mason Beekley Collection between 2001-2010. Thanks also to Aaron Horowitz for photography. The author wishes to particularly thank Elisabeth Hussey, a former editor of the Ski Club's *Ski Survey*, who worked for many years with Sir Arnold Lunn, for imparting her enthusiasm for skiing history. Thanks are also especially due to Nicolette Tomkinson, of Christie's Vintage Poster Department, London and Nicholas Lowry, of Swann Galleries in New York, for all their help and advice; to Caroline Crichton Stuart of the Ski Club for access to historic material, to Philip de Bay for photography, to Clare Malim and Jan Siegl for European assistance, and to Dudley Doust for his sporting comments.

All poster images are courtesy of the Beekley Family Foundation, Hartford, Connecticut, except:
Beatrice Müller, Artifiche AG, Zeltweg 10, CH-8034, Zürich, http://www.artifiche.ch: 14t, 15, 24, 25l, 29r, 37r, 50, 51, 52t, 53, 54, 55r, 58, 59, 60l, 62, 64t, 66l, 67, 70, 74, 81, 85, 89, 90-91, 93, 94l, 94r, 95, 97, 98r, 100, 101r, 159; Canadian Pacific Railway Archives: 142 (A 6147), 143l (A-18102-2), 144l (A 6541), 144r (A 6647), 147r (A 6176), 150r (BR. 180), 151 (A 6510), 152 (A 6120), 154b (A 19949), 155 (A 6131); Christies' Images, London: 6, 21t, 29l, 36, 39, 42tl, 42tr, 48l, 56t, 63l , 68, 71, 75, 76, 88, 98l, 101l, 103l, 110l, 133r, 146-7; By permission of Helga Maurer Wagner, heir to the copyright estate of Sascha A. Maurer:106, 109, 111, 112l, 113, 116l, 120, 121, 123; New England Ski Museum: 1, 104–105, 107t, 116r;

St Anton Office of Tourism: 31; Swann Auction Galleries, New York: 107b, 109, 113, 116l, 119, 144l, 148.
Copyright © ADAGP, Paris and DACS, London 2006: 15, 46, 52t, 57, 59, 60r, 62, 63r; © DACS: 38, 40, 42tl, 43, 67, 101r, 133r. Copyright © Canadian Pacific for all posters bearing their Trade-marks.

Black & white photographs:
Alpine Club Photo Library, London: 47r; Aspen Historical Society: 126t, 126b, 133l; Author's Collection: 48t, 52b; Canadian Pacific Railway Archives: 143r (M 611), 154t (NS 24098); Foto Ghedina, Cortina: 64b, 66t; Elisabeth Hussey Collection: 8l, 8r, 9tr, 13; *Il était une fois Megève* (Editions Champs Elysées/Photo Morand, DR): 47l, 56b; *Il était une fois Megève* (Editions Champs Elysées/Photo Tops-Socquet): 14bl, 49b; IOC/Olympic Museum Collections: 42b; Erna Low: 12br, 14br; Museum of Costume, Bath/Courtesy of Bath and North East Somerset: 12bl; New England Ski Museum: 108b; St Anton Office of Tourism: 27b, 31; Ski Club, London: 9b, 10, 11bl, 12t, 18b, 21b, 28b, 78b, 79r, 92b; Sun Valley Company: 137

The publishers acknowledge the assistance given by Erna Low, the original ski specialist since 1932. www.ernalow.co.uk